THE CHRISTCHURCH *Fusee* CHAIN GANG

Who They Were; What They Did;
How They Lived

THE CHRISTCHURCH *Fusee* CHAIN GANG

Who They Were; What They Did;
How They Lived

SUE NEWMAN

AMBERLEY

Hart's Great Exhibition 1851 entry and Bronze medal-winner.
(courtesy Charles Frodsham & Co.)

First published 2010

Amberley Publishing
Cirencester Road, Chalford,
Stroud, Gloucestershire, GL6 8PE

www.amberley-books.com
Copyright © Sue Newman, 2010

The right of Sue Newman to be identified as the Author
of this work has been asserted in accordance with the
Copyrights, Designs and Patents Act 1988

All rights reserved. No part of this book may be reprinted
or reproduced or utilised in any form or by any electronic,
mechanical or other means, now known or hereafter invented,
including photocopying and recording, or in any information
storage or retrieval system, without the permission in writing
from the Publishers.

British Library Cataloguing in Publication Data.
A catalogue record for this book is available from the British Library.

ISBN 978 1 84868 441 6

Typesetting and Origination by Amberley Publishing
Printed in Great Britain

CONTENTS

Acknowledgements 7

Chapter One: Christchurch: 'An engaging combination of scenes …' 11
Population and Employment; Politics; Living Conditions; Health; Transport; Education; Dialect.

Chapter Two: On the Breadline in Christchurch 27
Trade – Smuggling; Wages; Prices; Common Rights; Charity; Self-help; the Workhouse and Parish Relief; Enclosures; Game Laws; Other Crimes, and Punishment.

Chapter Three: The Christchurch Fusee Chain Workers and the Pit Site. 68

Chapter Four: A Brief History of Timekeeping 84
The Ancients; Sunlight and Shadows; Waterclocks; Sandglasses; Incense Sticks; Candle Clocks; Mechanical Clocks; Watches.

Chapter Five: The Fusee and the Chain 111
What it was and how it was made; Chainmaking.

Chapter Six: The Christchurch Fusee Chain Manufacturers 124
Cox & Co; Jenkins and Son; W. Hart & Son. Rose Andrews: the Last Chainmaker.

Chapter Seven: Other Christchurch Occupations 177
 Silk Stockings; Glove-making; Straw bonnet-making;
 Flax-Spinning; Mantua-Making; Fishing; Agriculture; Brewing.

Appendix: The Chainworkers in the Christchurch Censuses 1841-1891.
 And who they were, gleaned from newspaper references,
 crime and workhouse records. 213

Bibliography 251

Index 254

Author's note

The abbreviations used within the footnotes are as follows:

CT *The Christchurch Times*
DHC The Dorset History Centre
DRO The Dorset Record Office (previous name of above)
HRO The Hampshire Record Office
SJ The *Salisbury Journal* (later, The *Salisbury and Winchester Journal*)

ACKNOWLEDGEMENTS

Many people have provided advice, information, material and other assistance in the course of writing this book. If I have omitted anyone from the credits which follow I ask them to put it down to decrepitude and not ingratitude!

Diana Aldridge, Rosemary Barnes, the late Bob Burns, Alison Carter, Perry Clayton, Barry Cox, Trevor Evans, Steve Filce, Alan Footner, Charles Frodsham & Co., Jim Habgood, Joe Hurst, Sarah Levitt, Tony Mercer, Dennis Moore, Elliot Newman, the late Rita Shenton, Reg Stones, David Thompson, Mike Tizzard; the staff of the Red House Museum, the Hampshire County Museums Service, Basingstoke Museum, Milestones Museum at Basingstoke, the Hampshire Record Office, the Dorset History Centre, Reading Archives, Coventry City Archives, and the Prescot Museum.

This book was kindly sponsored by Dr A. Somerville-Ford of ICM, Christchurch.

N.B. Copyright of British Library images belongs to them and further reproduction is prohibited.

Fusee chain tools. (courtesy the Hampshire Museums Service)

Punch and die holder

Map of Christchurch, probably 1920s, soon after fusee chainmaking ceased.

CHAPTER ONE

CHRISTCHURCH: 'AN ENGAGING COMBINATION OF SCENES ...'

Christchurch may fairly be called, if not actually the birthplace, then at least the nursery of the English fusee chain industry. Yet at the time it was just an impoverished and inconsequential market town on the coast of south-west Hampshire, a straggling collection of mud-walled cottages interspersed with the odd farm and plenty of alehouses, inhabited by a rather downtrodden and ill-paid population of farm labourers, fishermen and minor traders. Perhaps those very circumstances played a part in the success of its only factory product in that era, for its inhabitants, capitalising on the town's topographical advantage of the proximity of the English Channel and the deserted heathland surrounding it, were almost to a man otherwise engaged in the illicit smuggling trade at which they had long ago become adept. The only claim to fame which the town had was the enormous and imposing ecclesiastical edifice in its midst, the Priory Church, towering over the decaying hovels clustered around it, and which with the castle ruins was usually the only building thought sufficiently interesting to be described in early guide books and travel writings. Indeed, Daniel Defoe dismissed it with contempt in 1724 as 'a very inconsiderable poor Place, scarce worth seeing, and less worth mentioning in this Account'[1] Nevertheless, its qualities were appreciated by a more discerning travel writer a Mr T. Baker:

> Though fashion has not made it a watering-place, and though it possesses none of the recommendations of modern dissipation, it is by no means unworthy a visit from the traveller or the antiquary. Neatly paved streets and elegant mansions it cannot boast of; – it has, however, what pleases far beyond these, – an engaging combination of scenes. [*A Companion Tour Round Southampton* T. Baker 1799]

1 Defoe, Daniel *Tour thro' the whole Island of Great Britain ... by a Gentleman.*

This visitor from over two centuries ago did not go on to specify or illustrate those pleasing scenes, so we must speculate.

From his vantage point on the brow of the medieval, five-arched, stone Great Bridge which crosses the Avon and leads the eye from Castle Street to Bridge Street in one smooth transition, Mr Baker might have focused his attention for a while on the far more ancient and hallowed stone of the church, the surviving element of a powerful monastery, and perused its great length and river-bound setting with admiration. In its foreground his attention would next be caught by another of history's romantic relics, the castle. It stands forlornly on its grassy mound, battered but picturesque in its ruin, the price it paid for harbouring Royalists in the Civil War. Next to it but lower down, in the former bailey grounds, our bewigged and bestockinged visitor may have mused on the roofless and ivy-clad Constable's House, with its circular Norman chimney still reaching for the clear skies above, and its rear wall lapped by the slow-moving waters of the Mill Stream on their way to the old mill on the quay out of view. Wresting his no-doubt enchanted gaze away from these antiquities, dimly aware of the distant low rise of the promontory of Hengistbury Head seaward, our observer, in turning, would have registered the low thatched cottages and smarter new brick villas abutting the winding, gravelled highway, before looking across in the other direction, inland, onto the river meadows stretching across the great common of Millhams, rich pasture land dotted with the townspeople's cattle and intersected by the broad river, nearly at the end of its long journey, carrying its precious living cargo of trout and salmon ...

'An engaging combination of scenes ...'
(*A Historical and Descriptive Account of the Town and Borough of Christchurch*)

Our hope for Mr Baker is that he was not jostled from his unwise choice of position on our bridge – edged as it was with just a low parapet – by a large flock of sheep driven by a shepherd, and loudly bleating in protest, and which then refused to move on. The cries of anger and frustration of the Revenue men thus prevented from pursuing the wagon loaded with contraband which had just passed over that very bridge may have disturbed the peaceful scene. Or maybe the anguished cries of a ragged and emaciated young man, caught in a gin trap in the nearby fields, only out to get a rabbit for the pot, may have spoilt the serenity somewhat. We must hope it did not. We must hope he returned home with his impressions unsullied, perhaps on the Emerald Coach from the Old George Inn in the market place, checking the time of its arrival against his fob watch newly purchased from the enterprising local clockmaker, Mr Cox, with its ingenious and intricate fusee chain to regulate the mechanism in its jewelled interior, made, the maker assured him, in that very town ...

For a moment, speculation must be cast aside, to be replaced by some idea of the characteristics of the little town which features so prominently in this study.

POPULATION AND EMPLOYMENT
The actual population at the outset of the period under consideration, which commences around 1700, is unknown, but a Visitation Return for 1725 estimates some 4,000 for the entire parish. In the previous year, 1699, only three more people had been born than had died – a virtually static population. That was nevertheless an increase on an earlier yearly average increase between 1691-1700, which was just over two. Half a century later, a more impressive 181 people had been added to the population in a ten-year period, but that had once more slumped down to a mere 84, or just around eight people every year between 1771 and 1780[2]. Christchurch was hardly a boom town in the seventeenth and eighteenth centuries.

The first accurate head count for the parish derives from the national census of 1801, from which we learn that it was home to 3,773, making the 1725 estimate by the vicar appear rather too generous. In 1811 the population had increased to 4,149, an average of 37 extra people each year: this early nineteenth-century population growth was characteristic of the period and was reflected nationally. Thirty years later, before Bournemouth

2 *Hampshire Repository* 1799.

appeared on the heath to the west of Christchurch, within the same parish, nearly 6,000 inhabitants are counted. In another thirty years, to 1871, the population had risen to 9,475, much of which increase may be accounted for by Bournemouth's growth. So, in the period from 1700 to 1900, there was a total population in the parish of around 3,500 at first, and 32,941 at the close (1901 census) – almost a tenfold increase. At the time of writing the population of the borough alone is about 50,000. All figures relating to numbers employed in the various industries subsequently described do, of course, have to take into account the total population of the time.

The size of the parish was immense, stretching to the edges of Poole in the west and [New] Milton in the east, amounting to over 20,000 acres and encompassing nineteen hamlets[3]. For our purposes, the main interest is in the town itself, and fortunately a statistical description is provided in 1810[4], fairly close to the commencement of the chainmaking industry about twenty years earlier. From it we get the picture of a very small town, just 290 inhabited houses, and 1,410 people. Bearing in mind that most houses were small cottages, this figure of around five people to each house conjures up quite crowded conditions. Of these, 150 were employed in agriculture and 420 in 'Trade or Manufactures'.

A return for 1831 for the town providing exactly the same information reveals that the number of houses had increased from 299 in 1810 to 423 (inhabited), lived in by 1,966 people, an occupancy level unchanged from two decades earlier. In fact, almost all the houses were occupied by one family, the primary pattern for the town and a reflection of its essentially rural character – no multi-occupancy found. This time, the number of farm labourers had plummeted to 25 in the town itself, and employment was instead found (by males) in the 'retail trade or handicrafts as master or workman', in which 225 men were engaged. Twenty others were classed as professional, wholesale merchants or bankers and capitalists, who between them employed a further 102 men in the town. Another class counted was servants, of which there 97, almost all of them female. Those compiling the figures were asked to provide numbers of males employed in manufacturing or machinery, and the tally was five, all of them in fusee watch chain manufacture, and there was no other employment provided in this manufacturing category in the entire parish. The fusee watch chain industry

3 *Victoria County History.*
4 Vancouver *General View of the Agriculture of the County of Hampshire.*

can therefore most fairly claim to be the town's sole manufacturing concern. Had the female populace been included in the statistics, it would have been a three-figure number and a vital piece of information. The contrast between the 1811 and 1831 returns reveal the effects of the arrival of the machine age, the town of Christchurch exhibiting a shift to trade and commerce, although it was not in a position to develop any manufacturing base of any appreciable size, apart from the sole example of the chainmaking.

The Commutation of Tithes Act gave rise soon after this to a huge overhaul of the ancient manorial system and very useful maps and schedules were drawn up all over the country minutely cataloguing land ownership and occupancy. These were preceded by investigations of each parish by Tithe Commissioners. Their report for Christchurch was produced in 1837, from which the following is extracted:

> There are still 4,000 acres of commons unenclosed, of very inferior quality, being a light, flinty soil on a chalk formation and producing furze, fern, heath and turbary. There are 500 acres of woodland, but the trees are of stunted growth and the underwood is of the lowest description, consisting chiefly of hazel, maple and thorn with little or none of ash or oak.

From this it would appear that even the traditional means of sustaining life by recourse to the land were subject to considerable disadvantages: Nature was none too helpful to the Christchurch labourers.

Going on to remark that the parish is 'one of the largest in the kingdom', the Commissioner goes on to deplore the manner in which the Diocese of Winchester had sold the tithes but failed to use the money obtained for the support of the vicar, thus rendering him 'totally precluded from affording that relief to the poorer classes of his parish' which the 'dignity' and 'responsibility' of his office demands. In fact, it was a 'pauper vicarage', said the forthright Commissioner.

POLITICS

Only two years earlier, another aspect of the 'system' in Christchurch had been castigated by another Commissioner pursuing another enquiry, on that occasion into the 'abuses of the corporation'. Almost mirroring the comments of the Tithe Commissioner, the resultant report revealed that the Corporation had virtually run out of funds.

We have also been deprived of a Mayor and magistrate during the last forty years, until the passing of the Reform Bill, the patron having taken care to elect a Mayor from those Burgesses who resided at a distance from the town, frequently one of his own family or a particular friend, the office being performed by a deputy in the town who had no power to transact business such as electing officers etc, without the presence of the Mayor. The income of the Corporation is now not more than £70 per annum. This the deputy always received, placing it in his own purse ... [5]

The Commissioner should have taken comfort from the relative improvement in the political situation. Just over a century earlier a burgess, Richard Holloway, was actually abducted to prevent him voting in the election of the Mayor, carried around the New Forest for four days, then left in Winchester Jail on a trumped-up debt charge for which bail was refused for another three days. Writing his account of the extraordinary incident in 1727, Mr Holloway begins with the following heartfelt appeal:

GENTLEMEN,
My late Imprisonment for Purposes that will appear very plain to you by the Affidavits hereunto annexed, was an Attempt in its own Nature so barbarous, and in its Effects so destructive to all our civil Rights, that I look on it as my Duty to make it thus publick. *However Great* the Authors of this fact may be, they ought to expect to receive the due Reward of a general Detestation, as I doubt not a particular Satisfaction to myself and family from the Justice of that *Honourable Court*, in which a Prosecution is already commenced. What has been mine, may another time be your own Case, unless an exemplary Punishment equal to the Crime be now fixed on the Offenders. Think of the Apprehensions I must be under, deprived of *Liberty*, so dear to every *Britain*, and turned from Wood to Wood, in a wild Forrest, without knowing but the next Tree that offered to my View, was designed for my Execution: a Wife at Home in Fainting Fits on this Occasion, and my Children and Friends fearing that *those Persons* who would go to such lengths to deprive a Corporation of the Privileges they have many Ages enjoyed, might find *private means* to secure their Point, and myself from complaining.[6]

Desperate attempts were made to find Mr Holloway: all the neighbouring market towns 'publickly cryd' for news, and a hefty reward was offered

5 SJ 31 January 1834.
6 HRO 15M84/Z3/34.

for information of his whereabouts, but he missed the vote.

For the 'man in the street' with whom we are concerned, the political skullduggeries exampled above would have had little relevance. But the officials elected at the Court Leet along with the mayor had considerable powers over their daily lives. The hayward would be seeking them out to demand a payment from them if their animals strayed and were impounded; the constables would be quickly on the scene to take action against any transgressors; and the aletaster was there to ensure that what they drank was of the correct strength.

It was not until the end of the period which concerns us that the ordinary man had any say in the election of the people who governed the town, and that was when a new charter was granted, creating a modern Corporation in 1886. Long before this time, the ancient Court Leet's annual election had made the town a laughing stock for being perpetuated so far into the modern era.

Living Conditions

The houses the people lived in were frequently owned by one or other of the Lords of the Manor, and were called 'copyhold', held on a lease of several lives, a system which had an inbuilt dilapidation factor since when the lease was approaching its expiration the tenants often failed to make the repairs needed. This led to 'the appearance of great ruin' of affected properties in the housing stock[7]. The same source records the use of such building materials for cottages as mud or cob made from chalk, straw and clay with animal manure, mixed by horses treading it all together, to make the walls, which could be as much as 22" thick. These rudimentary buildings were completed with thatched roofs, usually of reed from the rivers, although straw was also used. Although this was the most common building type in Christchurch in the eighteenth century, the incidence of fire was so high that few have survived. By the early nineteenth century the regional newspaper hailed Christchurch as 'this town of fires', and local agents posting sale notices in its pages for new houses were careful to point out they were constructed from brick with slate roofs.

The old cottages would have been lit with tallow candles or rush lights. The latter were the cheapest source of domestic light, produced from

[7] Vancouver op. cit.

soaking the core of rushes in meat fat. Many a poor hovel in the town would have carefully collected the fat from the family roast, and sent the children down to the river for the rushes. That was ideal when the poor family had the means to eat meat; the decline in their relative income in the lean years after 1800 forced them to abandon this cheap light source and purchase more expensive candles. Of these, the tallow candles were the least expensive, and pig fat the cheapest animal fat from which they could be made. Unfortunately, pig-fat candles gave off a nasty black smoke, and smelt terrible. They were also prone to rot and attracted rats. Since 1709 it had been illegal to make candles in the home without a licence; so they were bought from tallow chandlers. In 1784 William Newman is listed as a tallow chandler in Christchurch. For the impoverished fusee chain workers, a good source of light was vital, which is why it was common in the town to see cottage windowsills converted to workbenches.

Gas did not arrive until 1852, and the quality was for many years diabolical and the subject of frequent complaints in the press from the letter-writers. Prior to the arrival of gas, the streets were unlit, and until 1835, unpaved. In some places, notably Sopers Lane, which led to a ford across the Stour, they were little more than 'sump holes', a mire of mud, which in summer got so dusty that to remedy the situation the gutters were from time to time deliberately blocked and the resultant puddles collected and thrown onto the road. The task was later performed once a week by a sweeper, using a water cart drawn by a donkey[8]. Wick Lane was another quagmire, leading to Quomps which was a swamp; that is, apparently, the derivation of its strange name. Even as late as 1886, the conditions for pedestrians and wheeled vehicles alike was most unpleasant:

> The state of the pavement existing both in the Borough, Bure and Street tithings [i.e. the town centre] has long been a disgrace to the town ... the condition of the footpath from the top of the town to the station is very bad indeed. In summer it is given up by the greater number of people and the main road used as preferable for walking. The Board [Highways] are supposed to see to the cleaning of the gutters and roads, but this is not attended to properly. At West End and Bargates the gutters are like a duck pond, green and stagnant, and the road sweepings allowed to lay in heaps together. The only staff possessed by the Board for the purpose of collecting the sweepings is a man with a donkey and cart ... The Board has

8 Lane, Marjorie P. *Christchurch.*

power to do scavenging and removal of house refuse but not exercised, it is presumed on account of the expense and consequently of voting power against such a proposal.[9]

The water supply was similarly antiquated, with numerous private wells for the better classes, and six wells and five pumps for the working class who are the subject of this work. Three of the five pumps were in the Pit area where most of the chain workers lived; the 1886 report records that the one at West End was 'in a very bad state – ten houses receive their supply from it,' and it was frequently out of repair. Some people used the Mill Stream for water, or bought it from a water-carrier – literally selling it by the bucket, from the town pump which had been installed in 1732. Wells were frequently contaminated, sometimes from raw sewage percolating into them from above ground. Five hundred people depended on that pump, all of whom were at risk of typhoid or cholera. Mains water did not arrive until 1895, but was not taken up by those who could not afford the charges. As for the disposal of human waste, that was achieved by earth closets, with the 'night soil' collected each day, a facility which many houses shared with others in the same street.

Health

The appearance of Inspectors of Nuisances following the Public Health Act of 1875 resulted in many revelations of defective or even overflowing privy vaults – at West End, Bargates, for example; drainage from houses flowing into the street (Bargates); cesspools 'in such a state as to be injurious to health' (Barrack Road); overcrowding to the extent of being 'dangerous to the health of the inmates' (Pit); accumulations of manure and 'privy soil' (Millhams Street and West End); water closets 'so full and foul' (Pit) as to be a health risk; accumulations of ash and refuse (Pit); pools of sewage in the garden (Stour Road); filth 'draining into an adjacent watercourse' (Park Place); a 'cesspool overflowing into a stormwater drain' (Stanpit); stench from pigsties, and even 'entrails and other portions of slaughtered animals lying unburied in proximity to the public highway' – all extracts from Nuisance Abatement Orders. That so many related to the poorer areas of town, such as Pit and Bargates, is another indicator of the insanitary conditions in which its occupants, many of them fusee chain workers, lived.

9 Humphries, N. A. 'The Incorporation of Xch'.

It will come as no surprise that these areas were subjected to sporadic outbreaks of infectious disease, of which the most frequent was smallpox. Statistics for the incidence of disease in the town in the eighteenth century do not exist, but much may be deduced from the entries in the accounts of the Overseers of the Poor. The earliest of these to survive refer to a barn in Quay Road (on the site of the present art gallery at the museum) which was purchased for conversion to a workhouse in 1745. It was basically a rudimentary shelter, and seemed to have been deployed principally for cases of infection, for a watch was set on the building, it was reported in 1757, 'to prevent the smallpox from spreading', and other entries refer to people with the disease sent there. Not everyone affected had to go into the barn; the parish paid for nursing care for the sick poor in their own homes as well. The treatment was unusual: two such victims were provided with not only basic provisions such as butter and milk, but cochineal, cinnamon, saffron, pomegranate, liquorice and sugar candy. Perhaps that was a surviving example of the old belief in the efficacy of warding off infection with strongly scented unguents or herbs.

Soon after, in 1769, the parish built a special 'pest house' away from the town, up on St Catherine's Hill to the northwest. It was only a small building of perhaps two rooms, and the parish surgeon and apothecary attended people there. Whatever care he could give must have been merely palliative, but nevertheless those incarcerated were kept warm and supplied with basic food and the usual beer which almost everyone drank as a matter of course at the time, rather than the contaminated well or river water.

From an early history of the town written in 1813, it would appear that because so few people had been inoculated in the parish in the preceding century, smallpox had 'several times been very destructive to the inhabitants'. The number of burials, which rarely exceeded 75 people a year, was in 1793 twice that number, and almost every one of them was of victims of this disease.[10] Once more, in 1801, smallpox was 'extremely fatal', and the effect in the workhouse was to so lower the immunity of the inmates that a further twenty of them died from a 'malignant fever' which followed in its wake.

Attempts had been made in 1767 by local men, John Jordan, Thomas Slaughter or Slatter, and William Larder, to inoculate the townspeople, but the vestry fiercely resisted this measure, fearing that inoculation carried the

10 Bingley, Revd W. *History of Christchurch*.

risk of introducing the contagion. The churchwardens and Overseers of the Poor slapped a notice in the press threatening to remove from the parish anyone who accepted inoculation and were found in the houses used for the purpose (Barnfield and Beech House). A counter-notice appeared from the men, now described as Slatter and Duke, surgeons[11], claiming to have successfully inoculated over 1,000 people without the loss of one through smallpox. 'We assure those who desire to put themselves into our care, that no Regard is to be paid to the advertisements from Christchurch,' their notice defiantly concluded. Our vestry officials appear to have weakened in their resolve, for at the end of 1768 William Larder was still advertising his services from Beech House, and the Barnfield 'practice' now operated under the names of Mathews, Druitt and Dollin [12]. The name Druitt is significant in that he was almost certainly Philip Druitt, later the parish's own surgeon, who was in 1801 instructed by the selfsame vestry, having 'taken into consideration the most proper measures to be adopted relative to the Smallpox', to 'forthwith inoculate at the expense of the parish such poor Inhabitants together with their Children ... as are not able to pay the expense of Inoculation themselves'.

The general introduction of inoculation in the first quarter of the nineteenth century was a major medical advance; a local doctor, Dr John Goddard, was in 1807 once again by order of the vestry employed to treat the poor of the parish free of charge. The fears of the vestry were not groundless: a baby's death in the parish register of that year is attributed to 'cow pox'. The smallpox question was again debated in vestry in 1826, and a vote taken on the wisdom of once again providing free protection to the poor against smallpox, this time by the safer method of vaccination; it was lost 20 votes to 19.[13] Nevertheless, in a renewed outbreak in 1827, the following interesting observation appeared in our reliable local paper, the *Salisbury Journal*:

> That pestilence the Small Pox is raging at Christchurch with virulence, and we regret exceedingly that individuals should promote the loathsome disease by inoculation. If any proof were wanting of the efficacy and safety of vaccination, the following fact (among many) should demonstrate it: Mr Norris, schoolmaster, had five of his children vaccinated four of five years

11 SJ 26 October 1767.
12 SJ 28 November 1769.
13 Druitt, Herbert *Christchurch Miscellany*.

since; upon three of them it took effect, upon the other two it did not; he has recently had the same children inoculated for the small pox and kept them together; upon the three who experienced the effects of vaccination, there is not the least appearance of small pox, but the other two children, upon whom vaccination had no effect, are now much afflicted with the small pox.[14]

Dr Druitt and Dr Goddard were the parish doctors, available to treat paupers receiving relief from the overseers. More serious medical cases would need admittance to the parish workhouse (after 1835, the union workhouse), where limited medical attention was provided, largely consisting of supplies of wine or brandy for remedial purposes. It is too easy to find this amusing: these were days before anything better was available to deaden the senses. Not until 1848 did chloroform reach Christchurch, when it was successfully used by a dentist in a tooth extraction.

Another greatly feared pestilence was cholera, which in the nineteenth century swept the country to such an alarming degree that the College of Physicians circularised various towns with advice to prevent it, backed up by the Board of Health urging the parish authorities to cleanse the streets and remove all filth and damp. That year, 1848, the Board of Guardians, the successors to the Overseers of the Poor, issued their own circular providing much needed precautions to take against cholera. The press pointedly commented that 'We hope this will induce the removal of pestilential matters… we could mention several spots, but refrain from doing so in the hope that they will be improved without being brought more publicly forward.'[15] The Pit site is likely to have been the principal blackspot. On that occasion the town escaped the epidemic.

A terrible disease which today has almost entirely receded from the public consciousness, but was ever present in the eighteenth and nineteenth centuries, was rabies. Dogs in an advanced stage of fatal affliction to man and beast were a danger to farm animals and people alike, but it was appreciated that the only method of control was to shoot any animal which had been bitten. This had to be done in 1808, after which the local magistrates took the precaution of ordering all dogs to be confined by their owners. The ever-topical *Salisbury Journal* printed a letter in 1812 describing the dreadful symptoms of this fatal disease at Imber in Wiltshire, in a boy of 15, who had

14 SJ 24 September 1827.
15 SJ 26 October 1848.

been bitten by a rabid dog. From this account it would appear that immersing the victim in the sea as soon as possible was considered beneficial, but had no lasting effect and his health inevitably deteriorated. At first the symptoms were of general malaise: pain in the stomach and a sore throat, bloodshot eyes, and a desire for a drink which when brought evinced a response of 'indescribable horror'. The doomed young lad 'once attempted to swallow a teaspoon of water, but was near three minutes in the act ... during which the spasms in the throat were very violent, and the water descended at last with a force as though it had been thrown from a syringe'. The victim was aware that his carers thought he was going mad, and feared attempts would be made to end his life, pleading in terror not to be shot. Before long his attendants had to confine him in chains, he then grew delirious and raving, so violent that it was feared he would cause the collapse of the cottage walls to which he was chained. In the space of a few more hours he was in agony from spasms which threatened to suffocate him, salivating copiously and unable to swallow, until death mercifully released him later the next day.[16]

It was to take a further three quarters of a century for the Christchurch Borough Rabies Order, under which all dogs had to be muzzled, to be brought in to combat the scourge of this terrible disease.

There were other fatalities from causes other than disease or illness: fires, road accidents and suicides claimed a fair number of local people. In the days of open hearths and voluminous clothing, many children left unsupervised died when their clothes caught fire. Transport accidents were unusually common and frequently fatal, usually when the driver or passenger somehow fell off a cart and went under the wheels, or it became unstable and toppled, or the horse bolted.

Transport

For the ordinary person the horse and cart was, of course, the usual mode of transport, other than walking. Not for them the post or stage coach which transported people to the surrounding towns and villages and ultimately to London, nor would the majority of them have had the means to keep their own horse. The arrival of the railway between Dorchester and London in 1847 would have had little direct bearing on their lives either, the journey necessitating a carriage ride to Holmsley station seven miles away, the

16 SJ 18 August 1812.

nearest station to the town until the new direct line of 1862 brought the railway through Christchurch.

Not until the twentieth century did a mode of transport arrive in Christchurch cheap enough to be affordable by the masses – the tram, enabling the frontiers of the world as experienced by the poorer sections of the community to be pushed back further than the parish boundary, an almost physical barrier by which the laws of settlement had for so long so tightly confined them.

Education

Compulsory education began, of course, only after the Education Act of 1870, and it had serious implications for the poorest members of the community who needed the economic input from everyone in the family. Many such families would have keenly felt the impact of losing a child fusee chainworker, for instance.

Evidence that the so-called lower classes did have some rudimentary education comes from the fire claims of 1825 after the cottages in the Pit site were destroyed by fire. Several have been reproduced in Chapter 3. Yet many people could not sign their names in the marriage registers. Those who were literate were likely to have learned to read and write at Sunday Schools, which were introduced by Robert Raikes in Gloucester in 1780 and spread rapidly countrywide. Their purpose at the outset was to promote literacy; only after this became the responsibility of the state did the schools concentrate on religious inculcation. By that time, there were some forty Sunday School teachers in the town, with over two hundred pupils at any one time, which must have had a major beneficial impact on the education of the poor. Those who could afford it were able to attend the day school of the Congregational Church in Millhams Street, which commenced in 1818. A National School, situated in the High Street, supplemented the provision for schooling in 1828, but all these establishments required a contribution from those attending. A penny or two a week was all it was, but even that could sometimes not be spared.

A lucky few could have obtained free places at the town's Grammar School, held in St Michael's Loft at the Priory Church; others may have been able to scrape together the odd penny to attend some 'dame school' in the town, such as that recalled by Joseph Cutler, born in Bargates to a poor family, his father being a fisherman and rabbit dealer. He attended a school

kept by a poor old woman, at the back of Messrs Pain and Sons [in the High Street], and afterwards an Infant School, but his literary attainments at these seats of learning cannot be said to have been of a high order, 'for,' says he, 'I left school not having mastered the alphabet or reaching three times three of the multiplication table'. His love for school appears to have been in proportion to his advancement, as it was no unusual sight to see him and his brother like a couple of willful ponies being driven to school, bound by reins of worsted threads and guided by the old grand dame, whose authority appears to have been so great as to utterly extinguish any hope of escape from bonds so slender. [17]

Attaining academic prowess, it would seem, would have been an unlikely achievement in the Christchurch of the period under review.

Dialect

Perhaps these fragmentary or absent educational experiences accounted for the pronounced country accent, said to have been about half a century behind that of the town's well-to-do neighbour, Lymington. Revd Richard Warner, born nearby around 1767, recalled 'a sort of mongrel language', featuring old-fashioned words such as 'peason' and 'housen' – both old forms of plurals dating back to Saxon times: 'children' is one of the few to have survived. There was much 'thee' and 'thou' made use of, and 'beest' instead of 'be'; also 'beant' for 'was not'.[18]

Christchurch was not, it has surely been amply demonstrated, in any way sophisticated. The influx of fabulously wealthy and aristocratic visitors in the late eighteenth century to the new 'watering place' of Mudeford on the eastern edge of the town, must have dazzled and perhaps shocked the rather backward inhabitants, whose entire universe was contained in the sparsely populated rural parish in which they lived their simple lives. To them, the principal objective of their lowly existence was the ever-pressing need to make a living. Fine clothes, fashionable houses and stimulating entertainment were all foreign to them. This was not to say that they were not alive to new opportunities: they had to be. Exploiting what advantages came their way was one strategy to survive in an indifferent world. If it meant running the gauntlet of the Revenue men each night to make a 'run'

17 Cutler, Joseph *Autobiography*.
18 Warner, Revd R. *Literary Recollections*.

of smuggled brandy and silks for the gentry, so be it. They would do it. If they were called upon to squint through eyeglasses to fiddle around with little metal links and wires to make steel chain for gold watches, they would do that too. And take their pleasures where they may, in the beerhouses and ale taverns which thrived in every street, lane and alley which formed the town of Christchurch.

CHAPTER TWO

ON THE BREADLINE IN CHRISTCHURCH

Writing in 1753, Dr Richard Pocock[1] stated that the town depended on 'a trade with Newfoundland, a small fishery, and a manufacture of druggets, shalloons, woolseys and of knit silk stockins (sic) and gloves'. Druggets was a cloth used for clothing, made from all wool or a wool/silk or wool/linen mixture. It was quite a coarse sort of cloth, and narrow in width. Shalloon was another woollen cloth, closely woven, and used for lining clothes. Woolsey refers to linsey-woolsey, yet another type of woollen cloth (sometimes mixed with flax), used to make clothes, but of a coarse, inferior quality. Paupers in the workhouse wore outfits made from linsey-woolsey.[2] The Pocock reference suggests the existence of a domestic weaving industry, probably in connection with the clothiers who are known to have had a presence in the town at the time. The gloves may also have been woollen, or worsted; the silk stockings are extensively discussed in Chapter 7.

The earliest trade directory, printed in 1784, lists 56 traders, amongst whom are a good representation of the building trade: a chairmaker, a tallow chandler (for candles), a clockmaker (Robert Harvey Cox) and an ironmonger to supply domestic needs; four carpenters, three bricklayers, a plumber and two glaziers; four shoemakers, three drapers, three tailors, a staymaker and two milliners to cater for clothing requirements; a farmer, a baker, a butcher and three grocers to supply the necessary foodstuffs; a maltster and a brewer to make the drink to accompany the food and a cooper to make the barrels to store it; and a wine merchant to supply something more superior.

There were thus plenty of shops and other suppliers to cater for every

1 Pocock, Dr R. *The Travels Through England.*
2 Newman, Sue *The Christchurch and Bournemouth Union Workhouse.*

requirement, and the range of goods on offer is occasionally glimpsed when one of them closed and the stock sold at auction. Here is an example of the contents of the shop of an ironmonger in 1814:

> About 18 Dozen stained and other chairs and stools, 400 Bundles of chair Rushes, 130 Bundles of Copper Rushes; and 70 Bundles of Flags, the remaining part of the STOCK-in-TRADE, belonging to Mrs ELIZABETH HOLLIWAY, of Christchurch, chair-maker, ironmonger &c, declining business; comprising a good assortment of about 500 lots of ironmongery, brass work, japanned goods, tin ware &c, in paper tea-trays, bread knife and snuffer, trays, bottle jacks, fenders, fire-irons, fire guards, sham stoves, ivory handled and other knives and forks, copper teakettles, coal hods, coal scoops, warming pans, tea urn, liquor bottles in morocco stands, handsome two-light shop lamp, steel cats, good mortice, iron rim and the various kinds of locks, sorted hinges, scythes and stones, reap hooks, bill hooks, wine snuffers, hammers, augers and various tolls, nails, brads &c, tinned iron fountain, boilers, teakettles and sauce-pans, quantity of tin ware, rope and other mats, mops, brushes &c &c.[3]

Travel in 1784 was provided for by a post-chaise, with a choice of two saddlers to kit out the horse and a wheelwright to make or repair the wheels for all sorts of vehicles, from farm carts to carriages. Four blacksmiths, that most essential of all craftsmen, could be called upon for all metal items, from wheel rims to horseshoes and iron buckets. All in all, this list, which is unlikely to have been comprehensive, indicates that Christchurch was then a self-sufficient town as far as basic provisions were concerned.

Another source for such information are the apprenticeship records for Clingan's Charity (see below), which commenced in 1734 and chart the varying demands for goods and services through the subsequent years. By far the most common calling was that of cordwainers and shoemakers, to which about 65 children were apprenticed over approximately one hundred years. This was closely followed by a demand for mantua-makers, who made ladies' gowns and cloaks (about 33) and tailors, for the male equivalent (29). This would indicate that a considerable amount of clothing and footwear was made locally, and perhaps enough was made to be traded. Sixteen boys were apprenticed to be mariners in the same period.

Bingley cites 'a considerable trade in salt' from the northeast part of

3 SJ 18 April 1814.

Hengistbury Head, but these saltpans at the time of his manuscript history, 1813, had nearly filled up. Such trade may well have been important in the preceding century, although it is more usually connected with Lymington and Keyhaven to the east. He also mentions the fishery, of which the most important component was salmon, which fetched high prices in London. It is of interest to note that he remarks that almost none of the fish caught was consumed locally. The 'coasting trade', he adds, is but 'trifling', because of the shallowness of Christchurch's harbour, and was confined to sloops taking beer to Portsmouth and coal or limestone being brought back. These coasters came to unload at Town Quay. Another landing place used to be on the Avon near Town Bridge. The Haven at Mudeford was also greatly utilised for importation. The exploitation of the ironstone found in abundance at Hengistbury Head was commenced in earnest about 1850, providing employment to local men but seriously and permanently compromising the stability of the coast of this promontory; it was taken by barge to Wales.

The major trading link with Newfoundland was mainly in the fishing industry, but furs were also brought back and children from the workhouse were on occasions sent there as apprentices. A manuscript held in local archives[4] states: 'When the colony of Newfoundland was in its infancy not only did Christchurch furnish the colony with a great number of emigrants, but it was supplied with woollen goods principally from the locality.' These goods were likely to have included worsted gloves and stockings, knitted by the townswomen (see Chapter 7). The writer notes that: 'The name of one of our local tradesmen was celebrated as a gunsmith all over the locality.' (Probably Caleb Butler.)

SMUGGLING

The foregoing has so far ignored what could not officially be disclosed, entered in trade directories or recorded in account books, but was the mainstay of a populace who had all the ingredients needed to make a success of it: a scarcity of natural resources to exploit, resulting in an illpaid labour force with little dependable or regular employment prospects; a coastal situation just across the Channel from France and the Channel Islands; fishing skills and equipment in abundance; and a wild and deserted heathland or forest hinterland for cover – this economic godsend was smuggling. Smuggling is widely accepted as being the principal local

4 Untitled, anonymous.

'industry', involving everyone, from fishermen to farmers, labourers to lords. Many other excellent publications detail the daring deeds, occasional violence and corruption, and the clever subterfuges which characterise the illicit trade; for our purposes it must suffice to elucidate the contribution which smuggling made to the local economy and way of life.

By 1714 a contemporary account by Daniel Defoe reveals that the illicit trade was already 'the reigning commerce of this part ... of the coast'.

The cause of smuggling was, of course, the heavy duties on such items as tea, spirits, tobacco, lace and silks. An increasing number of imported goods became subject to duty: by 1787 this numbered 1,425 categories. Once evasion of the duty became widespread, it became impossible to trade honestly: there could be no competition with the prices for which contraband could be obtained. Legitimately obtained tea was sold at 7s per pound, but contraband was only 2s. Smuggling was highly rewarding; those living on the coast were able to participate in the many aspects of an operation which serviced an extensive inland demand. Not only the obvious fishermen and mariners were involved, but also farmers, who could provide horses and wagons, and whose farm buildings and hayricks etc were ideal hiding places; and publicans who could purchase their supplies direct. The first Earl of Malmesbury (1746-1820), a major local landowner, observed: 'All classes contributed to its support. The farmers lent their teams and labourers, and the gentry openly connived at the practice and dealt with the smugglers'. The farming folk were also adept at arranging for the two main river bridges on the routes out of the town both east and west to be blocked from the pursuing Revenue men by flocks of suddenly obstinate sheep. Several writers on the subject even allege that it was the lucrative smuggling trade which was the cause for all the various proposed harbour improvements coming to nothing: it would not be in the interests of local people to facilitate the Revenue cutters being able to pursue them through the Run and into the harbour.

The Revd Richard Warner[5] recalled seeing as a schoolboy from a window of his schoolroom in the Priory Church in the late 1770s between two and three hundred men on horses laden with tubs accompanying a convoy of up to thirty wagons loaded with kegs of spirits. This immense procession took place under the gaze of the Revenue men themselves, their numbers powerless to effect any action, should they have been motivated to have

5 op. cit.

done so. They were, in fact, largely subverted by the smugglers: typically, on this particular occasion, the young boy witnessed the reward given for their good-humoured forbearance: a 'voluntary toll' of part of the contraband, given pro-rata to the size of the run.

The cheek of the local smugglers was boundless:

> Thursday se-nnight [i.e., week], at night, 2,500 tubs of spiritous liquors and about ten tons of tobacco were landed on the beach near Christchurch. A boat full of men belonging to a Customs-House cutter, upon going to make a seizure of the vessel and cargo, on its approach to the shore were very cordially invited to board by the crew, and their boat being hoisted in after them, they were unexpectedly entertained … till the landing of the goods was completely effected and the whole was carried away from the shore.[6]

That so many were involved is hardly surprising, given the rewards. In this period, an agricultural labourer might earn in one night from smuggling what would have taken him a week in honest employment. The vicar, the Revd William Jackson, did his level best to denounce the trade from the pulpit, but his warnings about eternal damnation met with the very worldly response from his parish clerk: 'Then the Lord have mercy on the town of Christchurch, for who is there here who has not a tub?'.

And that was a question well worth asking. Some answers come from a surprising source: the ledgers of the local builder, John Pillgrem. Ironically, the same man was given the government contract for the barracks in the 1790s, built for the dual purpose of defence against a feared invasion from Napoleon and an attempt to suppress smuggling. He was a well respected and competent builder, if he were not he would not have been engaged by Sir George Rose to rebuild the King's Arms Hotel, yet the accounts show that he was as a matter of course dealing with the smuggling fraternity. He was not only supplying building materials for his clients, but spirits: five quarts of brandy for William Ginn at 5s 5d in 1780; four gallons of gin for £1 and the same quantity of rum for £1 4s for the landlord of the White Hart Inn in 1785; a cask of gin for £1 14s 6d for his own son in 1790. More intriguingly, he was working on boats, some of which are described as 'marsh tubs'. These were shallow, flat-bottomed boats worked like punts, capable of maneuvering at the edge of the harbour where boats with keels,

6 SJ 28 December 1790.

such as those of Revenue Officers, could not. The false bottoms were likely to have been suitable for hiding tobacco. One of Mr Pillgrem's clients for this item was none other than one of the most crafty and notorious of the local smugglers, John Streeter of Stanpit in the town, for whom he made such a vessel in 1788 complete with false bottoms. The only possible reason for this feature must be smuggling. In 1802 he itemises: 'Paid Streeter for a tub (of spirits) and tobacco, £2 8s', and he had earlier paid one Elias Button, likely to have been Streeter's brother-in-law, the sizeable sum of £4 11s for 'carridge of B' – meaning brandy. Other modifications of marsh tubs were made for Mrs Cook, wife of John Cook of the town, who owned a chain of over twenty public houses on the south coast. Between 1790 and 1795 Mr Pillgrem repaired or fitted false bottoms in these boats for them, and did the same work for John Spicer who bought the chain after John Cook's death: in a note pinned to the account book is:

> Particulars of Mr Spicers Marsh Tub no allowing any profit not including elm curbs. 30 days labour, carridge of 34 double and a half best red deal into house and journey to Pool. Total £14 0s 6d

After John Cook's imposing Georgian home, Square House in the market place, was demolished in 1959, tunnels were found under the foundations. Tunnels were, though, commonly found at various places in the town, but are by tradition and commonsense associated with the concealment of contraband and underground communications.

The evidence from John Pillgrem's ledgers demonstrates how the practice of smuggling was completely assimilated in the economy of Christchurch, with just a hint at disguise, when referring to spirits as 'B--' or 'G--' etc. That in any case confirms the reference is to contraband. There is no attempt to disguise the work done on false-bottomed boats. The extent to which the local customs officials were compromised is indicated by the extraordinary fact that John Pillgrem was also one of the 'sitters' for the Revenue Service, or coxswain. Foot in both camps.

Wages
At this juncture the smuggling contribution to the economy must be left behind, and the legitimate wages and expenditure of the working people explored. Whilst unofficial earnings are for this purpose set aside, it must still be borne in mind that for a great many Christchurch families they formed a vital supplement to their limited budgets.

Wage levels in about 1767 were around 7s 6d a week, or about 1s a day, but the rest of the family would be able to add to this sum, especially since the children did not attend schools (hence the value to families of the opportunity afforded to children by the chain industry).[7] The means by which the earnings of the main breadwinner were supplemented are explored in Chapter 7.

A manuscript source[8] of reminiscences about Christchurch states that items in the Corporation Chest show that in 1778 a labourer earned 4d a day and a skilled person 7d to 1s, which seems very low: if it is correct, dire poverty must have been the result. There is certainly considerable evidence for such widespread destitution: in 1763, for instance, the Overseers complained of 'the burthen of a numerous poor'[9] A barrel of beer then costs 4d, or a day's wage for the labourer, and it would cost 1s 4d to pay a thatcher to roof a cottage. Stone for building cost just 1s a ton, making the construction of a home relatively cheap. Wages and bread prices derived from Quarter Session records in the same year indicate that a highly skilled farm labourer was paid nine guineas a year – or under 4s a week, but board and food might be provided free at that rate, giving a figure in effect of 1s a day to the agricultural worker.[10] A woman earned a mere 6d. After the end of the Napoleonic wars in 1815, wages of such workers stabilised at about to 1s to 1s 6d a day, and on such wages it was necessary for the whole family to find some form of employment.

In attempting to understand the subsistence level of earnings, much can be gleaned from the settlement examinations conducted by local magistrates to determine which parish was responsible for a person seeking parish relief. The earliest example (illustrated)[11] is from 1739, concerning Robert Tarrant of Purewell in Christchurch, a seafaringman (and therefore undoubtedly also a part-time smuggler). He earned just £5 a year as a servant to a local farmer to begin with, eventually being paid £6. The first figure represents about two shillings a week. On that, he had to support a wife and two children.

A slightly later example comes from Milton (New Milton, just east of Christchurch), and dates from 1747. This man, Moses Gattrill, tells the magistrates that:

7 *Victoria County History.*
8 Anon, op. cit.
9 HRO 7M54/262.
10 Child, Melville T. H. *Farms, Furs and Felonies: Life on the Hampshire and Wiltshire Border 1760-1830.*
11 HRO 56M83/PO25/2/5.

The examination of Robert Tarrant. (HRO 56M83/PO25/2/5)

he was born in the parish of Christchurch as he was inform'd and believes and where he lived till he was ten or twelve years of age; that he afterwards lived as a Covenant Servant at several places in the parishes of Milton and Hordell. And ... that about a week before Lady Day in the year 1742 he ... did agree with Mr Charles Brander in the parish of Christchurch ... to serve him as a covenant servant for one year then next ensuing for the wages of five pounds five shillings...

Moses therefore worked for his employer, who was a wealthy and influential member of the local gentry, for only slightly more per week. Presumably both these men had food and board allowed.

The next illustration is the examination of Mary Wood at Poole in 1789.[12] She was described as a vagabond, which meant that she was so destitute she was driven to beg. Her earnings in Christchurch as a servant were just 55s for the whole year (£2 15s), or about half the male wage.

It is no wonder that the vestry in Christchurch met to consider the situation in 1795, and decided to increase the wages of labourers to 9s a week 'during the present high price of wheat'. For that princely sum these men had to work twelve hours a day in the summer, with an hour and a half meal breaks, and twilight to twilight in winter. Bread was then so expensive that recipes were devised which added potatoes to wheat flour to make loaves. The parish, with the best of intentions, sought to subsidise wages when the price of bread rose. The effect of this was to enable local farmers to reduce wage rates in the knowledge that the parish would make up the difference. Thus even greater numbers were pauperised, or thrown on the mercy of the overseers. It was a national and not merely a local phenomenon.

A detailed study of local economic conditions was made by Vancouver in 1810.[13] He quotes labour rates at 9s in the winter and 12s in the summer, for working the hours referred to by the vestry resolution in the preceding paragraph, although piecework in the summer could extend the hours of work from 5am until 7pm. The harvest and haymaking were times of better pay, 2s per day being the norm, and drink, food and board often provided in addition. Women and 'stout boys and girls' were paid 8d a day, with a beer allowance; even the 'feeble' worker could earn 6d. More skilled workers, such as thatchers, earned 2s 6d a day, plus board at the farmhouse (these men would have been making the hayricks rather than roofing). There were

12 DRO PE/PL:OV2/3/84.
13 Vancouver, op. cit.

> **Town & County of POOLE.** THE Examination of *Mary Wood Singlewoman a* ~~Rogue and~~ Vagabond, taken on Oath before *Two* of his Majesties Justices of the Peace in and for the said Town and County, this *Twelfth* Day of *February* in the Year of our Lord *1789* Who on *her* Oath saith, That *she hired herself to James Knapp in the parish of Christchurch in the county of Hants for a year at the wages of fifty shillings which year she served & received her wages. And this Examt saith that she has done no Act whatever to gain any subsequent settlement to the best of her knowledge & belief.*
>
> *Sworn at Poole aforesaid this Twelfth day of February 1789 before us*
>
> The Mark of Mary + Wood
>
> George Garland Mayor
> Jno Hyde

The examination of Mary Wood. (Poole, St James' Parish archive)

different rates of pay for the various agricultural processes, such as thrashing, reaping and binding, 'shocking' or making stooks, raking, mowing, hoeing and so forth. The list makes fascinating reading, giving the price paid for the most humble task, even for gathering stones (6d for four heaps, but no specification for the size of the heap!).

Whatever may have been the earnings of the rural labourer and his town equivalent, it was becoming harder and harder to live on it as prices rose remorselessly.

Prices

The cost of food in 1731 was 3d per pound for beef, and 1d a pound for bread. For those unfamiliar with pre-decimal money, there were twelve pence in a shilling and twenty shillings in a pound.

Further evidence for prices is given by Vancouver in 1810: citing 'shambles' meat – the lowest grade bought from open stalls, such as used to exist by the market house in Christchurch's marketplace – at 7d per pound, the author goes on to itemise the diet of the workforce, which relied on wheat bread (wholewheat for the 'peasantry', but for the farmers themselves, the bran removed), supplemented by gleaning from the fields. (There are references in the Christchurch court records of the 1850s to gleaning still being practised in the large open field of Portfield, although it was a right removed from land previously common which was enclosed.) Vancouver underlined the importance of bread and beer in the diet of the labourer and his family, and the deficiency of meat, to which he attributed 'several pernicious habits, particularly the use of spirits, and what has of late increased to a very injurious degree, of Tea as a substitute', which he believed impaired the nerves. It is probable that this commodity was easily obtainable very cheaply in the smuggling circles of Christchurch. Nerves must have been uncommonly bad in the town. Contemporary accounts of the diet of the poor indicate that the tea drunk was of the cheapest variety and the weakest strength, and resorted to because such people had been deprived of the option of milk because they had lost the right to keep 'milch' cows on the commons.[14]

The same source has much to say about other aspects of the domestic economy at this time: how the poor were entitled to 'snapwood' for fuel, which meant fallen branches and those which were brittle enough to be

14 Hammond, J. L. and Barbara *The Village Labourer.*

snapped off; how turf from the commons could be collected for the same purpose, or bought for 6d a thousand turfs; furze could also be collected from the same commons, an especially abundant source around Christchurch (upon which heathy ground Bournemouth sprang up).

The anonymous manuscript source referred to previously says that in 1822 beef cost 3d per pound, mutton 2d. If so, this must have been a result of economic depression; the price of beef had been that in 1731 nearly a century earlier. The *Victoria County History*'s figures for the end of our period, around 1850, give wage rates in agriculture as still 8s to 10s a week, commenting: 'Considering that in the seventeenth century [the labourer] was in some parts getting nearly as much as the lower figure, it is impossible to imagine how in the middle of the nineteenth he was content with such beggarly pay.' The answer was that he wasn't, or could not have been. The success of the smuggling trade, supplemented by whatever could be got from poaching on the local estates, was all that saved these labourers from destitution.

One indicator of the rise in prices through the eighteenth and nineteenth centuries is the cost of wheat per quarter (ton). Whilst this fluctuated according to the harvest, which depended on weather conditions and pest attacks, it can broadly be seen to have risen from a 1700 baseline of 40s, largely maintained, until reaching the incredible price of 113s 10d in 1800. Whilst it did fall back, in the first decade of the nineteenth century grain cost nearly three times as much as it did in the last decade of the eighteenth century, and remained at twice the 1700 level more or less for roughly the first quarter of the nineteenth century. The biggest factor in forcing up the cost of this staple food was the Napoleonic wars, which brought a halt to imports of grain and other foodstuffs. Towards the close of the century prices dropped, finishing at 25s 8d in 1900.[15] Throughout this period, the wages of the ordinary labourer were static: he was powerless to extract any increase from the farmer who employed him, and consequently bore the brunt of the swingeing price rise.

The labouring population had little else to live on but their wits for long periods of these two centuries.

15 Stratton, J. M. *Agricultural Records AD 220-1977*.

Common Rights

One of the fundamental and time-honoured rights on which the low-paid populace depended for income in kind rather than cash related to the commons. In Christchurch, these were extensive in the eighteenth century, including a vast stretch of arable land to the immediate west of the town centre, known as Portfield, amounting to about 290 acres. This huge area bordered the River Stour with its rich grazing meadows, and was freely available to the inhabitants of the old borough for their cattle, for the six months between 12 August and 14 February, as was Millhams (14 acres) in the heart of the town, and Ogber, another meadow of some 66 acres at the foot of St Catherine's Hill. The adjoining Coward's Marsh comprised about 69 more acres of river meadow alongside the Avon. It was open to the inhabitants for both cattle and horses, for a small charge, from 21 May, when the Marsh Fair was traditionally held, until 12 August when Portfield was opened. Yet another common, called Town Common, included part of St Catherine's Hill itself and amounted to 100 acres of pine and gorse covered land, available all year at no charge to the inhabitants of the old borough. With this common came extra rights – that of cutting turf for fuel, and sand. Fuel in the form of furze could also be collected on Coward's Marsh: it was specifically reserved for 'the use of the poor of our town of Christchurch who shall fetch it home on their backs', and was used especially for baking bread.

Common rights were thus of vital economic importance. By their existence, the local townspeople were enabled to eke out a living which the wage economy alone seemed incapable of providing them with. In doing so, they harked back to an earlier time, when the manorial system allotted grazing and arable land to each villager in a strip system. This heritage was jealously guarded, and formed part of the presentments at the Court Leet every year. All actions which resulted in the loss or erosion of those rights caused hardship, as is apparent from a reference in 1839 to what must be Portfield:

> On Wednesday last, a meeting was held at the Town Hall to consider the distressed state of the working people and the poor, and the means by which their condition in life might be much benefited. It appeared that several hundred acres of land, immediately adjoining the town, had been given for ever for the benefit of the townspeople and the cottagers, of the advantages of which land the working classes had been in a great measure deprived. The destitution and distress occasioned by the negligence manifested in

properly and justly appropriating the land in question, called aloud for speedy and decisive measures to place the sufferers in employment and comfort, which might be so easily accomplished.[16]

There was no further light shed on the persons responsible for preventing the commoners from exercising their rights of pasturage, but the episode demonstrates the vital importance of such common land. It was privately owned, of course, but the owners were obliged to respect the rights over the land awarded to certain inhabitants.

In 1847 a burgess, John Edward Holloway, built a house in Portfield and soon experienced the violent opposition of the aggrieved commoners first hand. It was mayor-making day, an occasion celebrated by the distribution of hogsheads of beer, and several local men, having freely imbibed, decided to destroy certain fences and more substantial structures which had arisen in Bargates. Having trampled fences down and torn down rails on various offending sites, the crowd, by now numbering about 100 according to a witness, proceeded to Mr Holloway's, noisily shouting that they would have their rights. They succeeded in tearing down his fence too, claiming they did so because it was stealing from the poor, but the leaders were summoned and eventually charged with rioting and sent for trial at the Assizes. Further encroachments were halted for a while, but inevitably the housing needs of the growing town resulted in the enclosure of Portfield in 1878 – but even this took twenty years of debate and fierce resistance before it was accomplished.

CHARITY

Other aids to the poor were in the form of charity, none more ancient than the Hospital of St Mary Magdalen, deeds of which go back to 1317. With the disappearance of the so-called lepers for whom it was founded, the charity income was distributed annually amongst the sick in general. Several other charities arose from bequests specifically to the poor and were distributed usually in goods, such as bread or coal. Some were optimistically linked to the attendance of the poor at church, leading to demeaning scenes where those who did not normally attend church would be there in large numbers on the day that the largesse was distributed. *The Christchurch Times* noted in 1860 how the poor felt entitled as of right to benefit from these handouts,

16 SJ 16 December 1839.

and would become quite threatening if they did not receive it: regarding, for instance, White's Charity, the proceeds of which were used to buy coats for the poor – grey with white buttons and the name of the charity inscribed with surprising frankness for all to see: '...these coats are given away fairly. There is, however, a good deal of discontent among those who do not get the coats; those who are refused often threaten.'[17]

Poor children of the parish, as mentioned previously, could be apprenticed through the Clingan's Charity, which paid the premiums required to the employer. Run by a committee of the local great and good, including the Earl of Malmesbury, Sir G. H. Rose (son of Sir George), Sir George Tapps, the Revd Willis, John Spicer, Esq, etc, the charity especially favoured seafaring careers for their charges, some going to Newfoundland. It did not always work out for the parties involved: the records show that on the odd occasion the apprentices absconded, and were otherwise troublesome. An interesting letter from a frantic tailor of Longfleet, near Poole, appeals to the charity trustees about one Philip Taylor, his apprentice from them who had absconded with a week's supply of provisions, who he described as 'a very bad boy'. He was also a thief, who refused to come in at night, preferring the company either of 'Bad girls', or 'the smugglers'. The poor employer had treated him as one of the family, he bewails. Another letter concerned one James Jeffrey who:

> ... has now come to such a hardened state of wickedness and vice that it is quite impossible to put up with it ... He can't speak to anyone without the most shocking oaths and curses ... in conversation and conduct so filthy and depraved that no modest female can stay where he is ... he is addicting himself to every vice that can disgrace mankind.

On the other hand, an enquiry by the Clingan's charity committee in 1810 found that in the last few years not many of their apprentices were boarded as they should be with their masters, some of them were not properly employed in the trades they were taken on to learn, and in effect both parties were merely going through the motions of an apprenticeship scheme, and 'the benefit intended for the children are lost'.[18]

Through the lean years of the Napoleonic War and later periods of hardship early in the nineteenth century, considerable efforts were made to

17 CT 10 November 1860.
18 Clingan's Trust papers.

relieve the distress of the poor of the town, the levels of destitution being far higher there than in the surrounding rural area. Often severe winters brought food shortages and hardship. The gentry and the MPs led the way: Lord Malmesbury in 1789 gave an ox and 150 gallon loaves and 160 bushels of coal, and such munificence was widely encouraged:

> Since the commencement of this rigorous season, the poor inhabitants of Christchurch have experienced a most kind and munificent benefactor in the person of Gustavus Brander, Esq, who ... has distributed upwards of 20 guineas among his distressed neighbours – may the example of this truly good man excite a becoming spirit of emulation in every opulent reader of this paragraph ...

enthused the *Salisbury Journal* in the winter of 1785. Gustavus Brander was Lord of the manor of Christchurch-Twyneham at the time, one of the eminent figures attracted to Christchurch for its situation and climate, and a renowned antiquarian of his day. It is almost inconceivable for us today to appreciate that such was the hunger and poverty, compounded by the prevalence of smallpox at the time, that soup kitchens were set up in the town. The first known of was in 1800, with the objective of providing the poor with some nourishment: the price of bread was still so high they could not afford it, despite the vestry resolution of five years previously increasing the wages of the workmen to take into account the high price of wheat. The local farmers that year, to their utmost discredit, reneged on a pledge they had made to reduce the price of wheat to the poor, to the 'utmost disappointment and distress of the poor', with the sole exception of William Wing Mitchell.[19]

The better natures of a few individuals who formed themselves into a committee was more to the fore in the winter of 1817, when over 900 people in the town were sold food at half price – pickled pork, peas and potatoes – as well as coal, which assistance was maintained the entire winter. The sheer numbers needing such help is eloquent testimony to the low standard of living endured by the majority of the local population – despite smuggling. Even this substantial figure was easily exceeded in January 1837, when the town was snowbound, and the Lord of the Manor of Christchurch, Sir G W Tapps Gervis, distributed money, coal and clothes to over 2,000 people. Worse weather was to come in the following January, the harshest winter

19 SJ 8 November 1800.

for a quarter of a century, which froze the River Stour solid. The ice was so thick, crowds assembled on it to play cricket – surely a bizarre sight. A committee was once again formed to raise money to distribute coals and provisions. The 'many noble and opulent families' of the area were again called upon to be generous to the poor in 1842, by which time Christchurch, Mudeford and Highcliffe had become fashionable and popular areas for the wealthy incomers who often acquired or created large estates.

Self-help
Not that the poor simply sat around waiting for handouts in times of trouble: they were most enthusiastic about Friendly Societies, of which there were said to be four in the town in 1810[20] with a total of 361 members – a fair number of families were thus protected in times of need or want or work. In that year the Lamb Friendly Society at Winkton, a hamlet just to the north of the town, was inaugurated; thirty years later it had a huge membership and an impressive bank balance of over £500.[21] Such societies and Slate Clubs owed much to the patronage and support of the local landowners, in this case, the public-spirited benefactor Sir George Tapps Gervis of Hinton Admiral. Two years later all the members of the friendly societies paraded through the town together, banners aloft and accompanying band music: ' ... to their credit, almost all of the artisans and labouring population of this extensive parish are members', enthused the *Salisbury and Winchester Journal*,[22] and they were 'liberally patronised by the gentry of the neighbourhood'. It was to membership of the Friendly Societies that the relatively low Poor Rate was attributed in an early guide to the town of 1837.[23]

A savings bank appears to have been inaugurated in the town in 1816, a cause championed in Parliament by the town's powerful MP and Treasurer of the Navy, Sir George Rose, although it is hard to imagine at a time of such acute distress it would have had many customers. Later still, *c.* 1855, a Penny Savings Bank appeared, to which it was noted with approval at the time that several of the fusee chain workers of the town wisely contributed what they could spare.

Considerable support was provided to the farmworkers and allied trades by the formation in 1795 of the Christchurch Agricultural Society, largely

20 Vancouver, op. cit.
21 SJ 10 August 1840.
22 6 June 1842.
23 *A Historical and Descriptive Account of the Town and Borough of Christchurch.*

brought into being by the enthusiastic vicar of Sopley, the Revd James Willis. Its avowed aims were to encourage agriculture and, most importantly, to reward 'faithful servants and industry in poor people'. This last ambition was achieved through the award annually of monetary prizes, or premiums; those who had managed to raise their family without recourse to parish relief were specifically rewarded. The prizes in 1812, for example, included categories for good servants and maintaining large families. An incentive to maintaining the supply of future agricultural labourers and servants was also given, in the form of a prize of three guineas, a substantial sum (several weeks' wages), for the midwife who 'had delivered the greatest number of poor women'. This early society lapsed in 1819.

In 1841 it was revived under the title of the South Avon Agricultural Society, under the auspices of the Earl of Malmesbury, the 'primary objective' once more being the 'encouragement of husbandry servants'. The landowners were especially gratified by the humility of the recipients – an admirable quality in their eyes: on the 1845 prize-giving, the report[24] described the 'joy and gratitude' with which these were received, and ruminated on how the limited means of the farm labourers were insufficient to procure them anything but the basic necessities. 'The sovereign or two thus obtained was a fortune for them, towards providing covering for their parents and their little ones against the bitter cold and rain of winter ... far more efficient than the sum spent on charity,' it remarked, whilst frankly and unapologetically reminding readers that the effect was of even more benefit to the farmers and landowners, since the money so dispensed was offset by greater savings on the poor rates.

And so it was to those dispensers of assistance to the poor of charity: in dishing out in the short term they hoped to lessen their outgoings in the longer term. They would also have been mindful that if they did not help the destitute, they were quite capable of taking matters into their own hands: that was another method resorted to by the poor in times of severe distress, when starvation was staring them in the face. An early example of this took place in 1757, following what was said to be the wettest summer within living memory. Prices rose alarmingly, provoking widespread food riots, which were exacerbated by another poor harvest when the crops were ruined by yet another prolonged deluge. When wheat and other basic commodities doubled in price, famine threatened and the desperation was

24 SJ 29 November 1845.

acute. Fordingbridge flour mill was broken into by an angry crowd of men armed with axes, hooks and clubs, threatening the owner they would break the mill up entirely unless they got wheat bread, not the barley substitute they were reduced to living off. Having prised money out of the terrified owner, the rioters proceeded to Bickton and Ringwood mills with similar demands.

No doubt there were other outbreaks of violence occasioned by desperation. Whilst smuggling afforded the poor of Christchurch the means to cushion the blow, charity may well have been at least in part a response from the authorities to fear, and perhaps there had been minor episodes of protest which partly motivated the local benefactors.

The Workhouse and Parish Relief

What if, despite all these measures, hardship was experienced such as to render it impossible to keep body and soul together? In the very many cases where this occurred, there was only one recourse, which was to the parish, by which was meant the Overseers of the Poor. It was these all-powerful officials who dispensed relief, which could take many forms, either in cash or kind. The parish was also responsible for apprenticing the children of the poor, and records for this survive from 1698.[25] A disturbing number of the apprentices in the succeeding years are listed besides their entry as 'dead': 43 out of a total of 65 in the first two decades of the list. This is an alarming indictment of the failure of the authorities to look after its younger and weaker members, and suggests that the parish washed its hands of them once the premium had been handed over, for it was surely a case of negligence by unscrupulous employers.

Nevertheless, for the most part the parish took its responsibilities seriously, providing a range of assistance where needed: medical care ('1729: Thomas Gum paid for Bleeding and Looking after the poor people for the year … £10'), clothing and shoes, house repairs, funeral expenses. The parish supported the families of absent husbands: 'Thomas Gillingham's family he being ill in Newfoundland 5s'; 'Lean's family he being impressed on board a Man of War 5s' (both 1761). It also paid to enforce maintenance orders against the fathers of illegitimate children, a nice example of which occurs in 1761:

25 DRO: D/RHM 372.

Paid a woman for going to Mr Justice Hinxman to be examined about bastardy and expenses thereon at Hinton 2s. Warrant 2s. Expenses at Crumpler's, the father of the bastard being there in custody 5s 11d. William White for guarding him hither 6d. Lodging and other expenses there 5s. A Licence, £1 17s. Expenses thereon at Ringwood, 3s. To the parson, 5s. Clerk and Sexton, 3s 6d. Expenses at Hinton 4d. Ditto at Holloways as to bill 9s. Ditto at Grays 7s 6d. My horsehire and Footners to Ringwood and Hinton thereon 6s 6d. To the men that guarded the father of the bastard 8s. Horsehire to Ringwood 1s 6d.

In that series of entries in the Overseer's account the whole story of a shotgun wedding forcibly arranged by the parish is encapsulated. It was not uncommon. If necessary the parish would detain, bring before the magistrates and convey to the bridewell at Winchester any man rash enough to desert his family, leaving them chargeable to the parish. However, the greatest cost to the parish was not in the direct support of the poor, but in legal expenses created by the complex and stringent settlement laws.

These in essence were devised to ensure that those who paid the poor rate did so to support the poor of their own parish, not those of another. It was therefore necessary to define what factors made people belong to one parish or another. Being born in the parish was not necessarily sufficient: illegitimate children at first belonged to the parish in which they were born, but since this led to situations where a pregnant woman from another parish would be unceremoniously dumped back over her own parish boundary, it was eventually modified. If settlement was not acquired by birth, the most usual way in which it was acquired was by working in the parish for a year. This gave rise to the practice of hiring workers for one day less than a year, at the great hiring fairs, of which there were two in Christchurch each year. Otherwise, property qualifications gave settlement rights, but this would not be of much use to the ordinary poor. If parish relief was sought, and the applicant did not appear to belong in Christchurch, then it would be necessary for the person to be examined by magistrates to determine to which parish he or she should be deported (or that parish was billed). Some examples of local examinations are illustrated on p 34. One of the effects of settlement laws was to prevent working people moving to another parish to better themselves – they were effectively trapped.

Christchurch appears to have been overwhelmed by applicants for relief, for one reason or another, whether on economic grounds, or through sickness or age, and it is apparent from the decision from those arbiters of

power mysteriously referred to as the vestry, to provide a workhouse in a converted barn for what were described as the 'numerous poor'. The Overseers themselves would decide which applicant for relief could be helped in their own homes (out-relief) or sent to the workhouse. Many factors governed their decision: sometimes these were obvious, such as when a person was a helpless child or aged or otherwise unable to work. On other occasions, their personal knowledge would be brought to bear to sift out the shirkers, or 'idle' ne'er-do-wells.

By 1763 the problem was so acute that it was considered necessary to be stricter with unfortunate parishioners, whose 'idleness and vice' needed to be restrained or prevented, especially by giving the inmates some form of employment. A purpose-built workhouse was constructed alongside the barn in the shadow of the church, where the inmates were put to work on spinning flax, knitting stockings, or doing household tasks or cultivating the ground for food. Later, from 1800, Robert Cox began to employ them in making fusee chains (see Chapter 6). Inmates could also be employed outside the house, usually on farming work for local employers, hired on a daily rate. In addition, the parish used their labour for road repairs.

Beggarwoman c. 1740. (Cookson)

Life within the workhouse was strictly regimented and austere, with coarse clothing provided, basic but sufficient food, and a modicum at least of medical care. They were free to leave, if notice was given to the Master, but doing so would mean that no out-relief would be granted so it was not in practice an option; they left when the reasons for their admittance had been resolved, if they were. That is not to say people did not leave without authority: the pages of the workhouse admission records of the early nineteenth century are filled with entries of 'ran off' against the names. Most inmates had no option but to stay: the children until apprenticed out, the aged until death released them, the sick until cured or dead; but for some it was a temporary shelter. Families which had lost the breadwinner, men temporarily out of work, wives of men in prison, are some examples.

Enclosures

Whilst periodic outbreaks such as the Fordingbridge episode of 1757, sparked off by acute shortages, were serious disturbances and a sign

of severe dissatisfaction amongst the labouring poor, it took many more decades of increasing hardship before mass violence resulted. The so-called 'Swing Riots' of 1830 were largely a response to the increasingly desperate situation of the poorer classes as a result of oppressive legislation which effectively disinherited them from their land and left them barred from redress by draconian measures such as the Combination Laws, preventing workers from acting in unison to force a rise in wages. The situation had been building up in the preceding three decades as a result of the enclosure acts, by which the age-old rights to common land had been extinguished and the cottager, previously independent, was reduced to the status of a hired servant. His economic situation was further aggravated by the introduction of threshing machines, which deprived agricultural workers of their traditional means to find work in the winter. Wages of farm workers and labourers in general had been ground down below the poverty line, as has been shown above, and all measures such as linking rates of pay to the price of bread, the so-called Speenhamland system, had only served to depress wages further since employers knew that low pay would be supplemented from the rates. William Cobbett, riding around the south of England in the 1820s, described the countryside as occupied by living skeletons.[26]

The enclosure movement took away the great heathland to the west of Christchurch, on which Bournemouth arose, and parts of the town itself, such as Burton Common, Rushford Warren and Stanpit, but left the great commons of Portfield, Coward's Marsh and Ogber unaffected. For the populace nationally it had spelt disaster: 'Enclosure had robbed him of the strip that he tilled, of the cow that he kept on the village pasture, of the fuel that he picked up in the woods, and of the turf that he tore from the common.'[27] Even the right to glean was withdrawn. The enclosure movement was fiercely resented, but it took three decades or more for the grievances to explode into organised action. References in the *Salisbury Journal* to isolated retaliations before the close of the eighteenth century, such as befell the valuable wheat rick at Thomas Whitcher's North Bockhampton farm, entirely destroyed by arson in 1785, must represent the proverbial iceberg tip. An eloquent plea was made in a London paper as early as 1773 by a visitor who chanced upon a fatherless family in a country cottage:

26 Cobbett, William *Rural Rides*.
27 Hammond op. cit.

No hog, no cow, no poultry, no wood to be seen in their yard. Some of the blessed effects of enclosing commons and consolidating farms. In this disastrous condition, not having strength for labour for the want of proper and sufficient nourishment, they pine away with hunger, with cold, with nakedness, on the meagre subsistence of a parish allowance ... [28]

One local flare-up was reported at length in the *Hampshire Repository* of 1799. It concerned one James Walkingshaw, charged at the Assizes with 'wilfully and maliciously setting fire to certain enclosures of furze and underwood, the property of William Wing Mitchell, in the parish of Christchurch'. Walkingshaw was one of Mr Mitchell's labourers, and the cause of his resentment was his suspicion that his employer had had his dog killed, which he had been using to poach on the land for rabbits. Walkingshaw had threatened Mitchell about the enclosures, swearing he would tear down the gates around it: 'Damme, Mitchell,' he is alleged to have said, 'I'll make your house too hot to hold you some night or the other', which threat he carried out, at least with regard to the fields. Finding him guilty and sentencing him to the standard seven years' transportation, the Judge thundered: 'You have been found guilty of one of the worst crimes I have ever been obliged to try,' on account of the danger to surrounding property from the extensive fire.

Parallel with the enclosures was the increase of prices over wages: the former rose by 60% between 1760 and 1813, the price of wheat in the same period by 130%.[29] This disparity been recognised as long ago as 1795, when the Hampshire County Magistrates commissioned a report on The General State of the Poor. Its findings concluded that 'the lower orders in Hampshire were in extreme want ... and actual deficiency', but so far the agitation which had been experienced in other counties – characterised as of the 'utmost extremity of violence and criminality' – was absent. It was the calm before the storm. Furthermore, 'the prices of necessaries have increased in a greater proportion than the wages of labour.' So much so, that in Christchurch in 1814 it was necessary for a collection to be made in the church and from the local gentry, which raised sufficient funds to relieve 1,579 people in the parish – a large proportion of the population,

28 SJ 11 January 1773.
29 Hammond op. cit.

of the order of 25%, were therefore in need of emergency aid.[30]

In 1823, almost thirty years after the first County meeting on the subject of distress, the situation remained so grave that the county authorities petitioned Parliament. The meeting which was called to decide on this course of action was attended by no less than 5,000 people, and resolved:

> That the distress of the country arose from various causes, the change of currency, burthen of taxation, poor rates, and tithes, and the corrupt state of the representation.

and called for tax cuts, a reduction of the large and expensive standing army, and for publicly or church-owned land to be made available to relieve the distress.

In November 1830 the grievances of the workers boiled over and they did combine. Large, well-organised groups arose in very many towns and villages almost simultaneously and toured the landowners and farmers with what were modest demands for single payouts, or general increases in wages, but which appeared to the farmers as a frightening and intimidating development. This campaign went hand in hand with the organised smashing of the hated threshing machines, which were appearing in ever greater numbers on the farms: in 1803 James Penleaze had one made for him by the builder, John Pillgrem, at the considerable expense of £51 – a large investment to have reduced to splinters by 'rioters'. The investment was one which could be expected to pay off: it cost 42s to thrash 96 bushels of wheat by hand and just 11s 6d with a machine.[31]

Whole areas of the region were in a state of panic at the sudden uprising from the previously compliant peasantry, and the officials were in a state of high alert. The mobs had attacked Stoneham, where over 700 people had smashed every threshing machine, and at Andover several hundred labourers burst into a meeting of the magistrates and succeeded in forcing an increase of wages – on 27 November it looked like Christchurch was to be next in line.

News of a 'numerous and disorderly mob' collecting near Ringwood reached the town by express in the small hours, whereupon the 'principal inhabitants' – anyone of any consequence – met together at the King's

30 SJ 28 February 1814.
31 Vancouver, op. cit.

Arms, probably by prior agreement should such an eventuality arise. The local magistrates were there already ensconced, and speedily enrolled a large number of special constables, roped in the coastguards and Revenue Officers, who were well-armed and had the added back-up of a Revenue cruiser offshore, armed to the teeth. Night patrols went out to scour the adjacent countryside, but the ringleaders were arrested before getting any closer to the town. A week later, trouble was once more close at hand, with a 'formidable mob', occupying Fordingbridge on the night of 3 December, committing 'great depredations', and then heading for Somerley, near Ringwood. This was again defeated by mounted yeomanry raised by Lord Normanton with, apparently, the loyal and allegedly voluntary assistance of 80 men from his estate.[32] All classes were 'united in one feeling of determined opposition to every symptom of disloyalty and lawless proceeding. Every stranger of suspicious appearance ... who cannot give a satisfactory account to the special constables, is instantly arrested ...'.

And so, local organised protest was effectively suppressed. Despite this apparent triumph of the ruling classes, they were severely jolted. The day after the Somerley defeats, the church in Christchurch was crowded with nearly all the landowners and tenant farmers in the parish. They knew they had to avert any further rebellions, for they might not be able to suppress a more concerted protest. Some concessions had been wrestled from them on behalf of the labouring poor. These were that farmers and other employers would at once attend to the problem of winter unemployment, particularly by obtaining land to be rented by the parish for the use of the poorer classes, and an appeal for other land for rent at low cost would be made, so that 'those Cottagers who have no Gardens, or small ones' may have 'a portion of Land for Cultivation'.[33] The vestry further organised a subscription to provide subsidised fuel 'to those of the poor who are not supplied with Turf, or whose Turf may have been injured by the wetness of the season' (specifically addressing the effects of enclosures on fuel supplies). Even more radically, it was agreed by those present to pay those in the employ of the parish 'an adequate remuneration for their labour, rather than a limited allowance for their subsistence', and for private employers to be advised to pay as well as they could afford, without risking laying men off should those wages be excessive. Numerous signatures were put to these important vestry agreements.

32 SJ 5 December 1830.
33 Vestry Minutes 4 December 1830.

The troubles died down, or were suppressed. Throughout Hampshire, large numbers of participants in the protests were arrested and tried at a Special Assizes at Winchester, the chairman of the jury being none other than Sir George Henry Rose, MP for Christchurch. A Special Commission was set up to implement the Government's terrifying and brutal policy to apply 'maximum severity uncompromised by local considerations and deliver an unambiguous message that protest and machine-breaking ... would be dealt with severely'.[34] The ringleaders – or organisers, to use a less loaded word – were sentenced to hang, but later reprieved and with 47 others transported for life to New South Wales; many others were sent for ever away from their home and families to Van Dieman's Land.

The spirit of the Swing Riots was not forever extinguished: mysterious rick-burning episodes permeated the lengthy catalogue of Christchurch fires over the ensuing few years: Bransgore, Waterditch and Burton farms were some of the targets, that at Waterditch in 1837, started in the small hours, utterly destroying three adjacent farms, having all the hallmarks of arson.

These were turbulent times to be poor in Christchurch, and crime was not confined to these desperate protests driven by hunger. The other – far more longrunning – lawlessness was associated with smuggling, at which door most of the violent crime of the period can be laid, including its fair share of murders. It will come as no surprise to hear of Riding Officers being attacked – one at nearby Milton was bludgeoned to death in 1780 by four smugglers, and the following year a daring gang of them on horseback, faces blackened and disguised in other ways, beat and wounded several officers of the Revenue at East Parley near the town. They carried an array of offensive weapons, including blunderbusses and muskets.

The violence was meted out to informers or those suspected of such. Joseph Manuel of Iford, near Christchurch, was one such victim in 1762, who narrowly escaped with his life after having been dragged from his cottage and abducted with considerable violence and cruelty over to Alderney in the Channel Islands (during the journey being thrown into the sea). Part of his brutal treatment at his destination was being made to shoot himself, but the blunderbuss being deliberately overloaded, he escaped with just the loss of part of his hand. He got away from his assailants, and with his life – just. The single most violent local episode occurred at Mudeford in 1784, when battle royal commenced between the Revenue men in a sloop of war and

34 Kent, David *Popular Radicalism and the Swing Riots in Central Hampshire*.

two cutters, and the smuggling vessels in the harbour which had just landed a huge consignment of over 30 tons of tea and 120,000 gallons of spirits. It was such an enormous run it required fifty wagons and nearly 300 horses to convey it away from the beach. The smugglers on shore and at sea engaged the Revenue cutters in a desperate battle to save their vessels and the booty from capture, during which the captain of the sloop was killed by a shot from the shore. Some of the smugglers were captured and tried, and the man who fired the fatal shot was hanged, his body later being gibbeted at the scene of the crime.

The *Orestes* incident was just one battle in one long war characterised by relentless violence and ruthlessness, and it was not often that an offender was brought to book. Nevertheless, the Christchurch mayor and burgesses did have a most useful tool in dealing with truly troublesome smugglers: they impressed them into the local militia. The trade did not completely disappear until well into the Victorian period.

GAME LAWS

But there were other forces at work to compound the severe difficulties under which the poor were labouring (in both senses of the word):

> … rate aid not being sufficient to bring wages to the maintenance level, poaching, smuggling and ultimately thieving were called in to rehabilitate the labourers' economic position. He was driven to the wages of crime. The history of the agricultural labourer in this generation in written in the code of the Game Laws, the growing brutality of the Criminal Law, and the preoccupation of the rich with the efficacy of punishment.[35]

Offences against the game laws were rife throughout the area in the post-1820 period, but of a different order entirely, being confined to the actions of one or two men at a time, and not committed for profit as part of an organised illicit trade, as smuggling was. Poaching, 'trespass in pursuit of game', arose directly from the enclosure acts, which defrauded the common man of the means to sustain his family from the bountiful harvest nature provided in the countryside around him. That harvest had, by those Acts, been parcelled out to benefit the landowners alone – who, whilst representing less than one in ten thousand of the population, populated

35 Hammond, op. cit.

the woods on their estates with gaily-coloured pheasants 'before the eyes of half-starved labourers breaking stones on the roads at half a crown a week'.[36]

The great number of people charged with poaching was a consequence of the detrimental effects of the various enclosures in and around Christchurch from 1802. By an Act of 1816 any armed offender risked a sentence of seven years' transportation, later modified by being kept in reserve for punishment of the third such offence. In 1828 Winchester Prison housed over sixty people jailed after coming into conflict with gamekeepers; and it has been observed that around this time one in seven of all convictions for crime were for offences against the game laws.

The Hampshire County Magistrates were concerned enough to produce a report on the subject in 1828 which included the comment:

> The evidence taken before the committee shewed that the great increase in the preserves for Game, which had taken place of late years, had tended to the increase of crime in particular districts; a pheasant or a hare was so easily taken, that a labourer only half employed and ill fed cannot resist the temptation ... With respect to the immense number of persons committed for poaching, it would be found that most of them were out of employ at the time of committing that offence.[37]

The authorities were, therefore, well aware that the roots of this crime lay in poverty. The flourishing fusee chainmaking factories established in Christchurch by this time must have considerably reduced the temptation – but not entirely. The report went on to link poaching offences to the subsequent committal of other crimes.

An incident occurred at Somerley, near Ringwood, in the same year illustrates what must have been a typical nighttime scenario in the area. Somerley, it will be remembered, was within two years to be the scene of the nearest incident to Christchurch itself of the Swing Riots of 1830.

> On Tuesday night last a very numerous and desperate gang of poachers invaded the preserves of Somerly, near Ringwood, armed with guns and bludgeons; they were, however, very shortly interrupted by a formidable company of the keepers and their assistants upon the report of the first gun, who, after a most severe contest, succeeded in making a seizure of

36 Hammond, op. cit.
37 SJ 19 January 1829.

three of the most determined of the gang and their guns and bludgeons. The remainder escaped by a precipitate fight, otherwise they would have shared the same fate. The three men were dreadfully maimed in consequence of the obstinate resistance which they made, they were all committed on the following day to Winchester gaol ... and will probably meet the punishment under the New Night Act (a most salutary and efficient one) to which they have exposed themselves, viz. transportation for seven years.

One of the gang (it is said) presented his loaded gun against a keeper, and it is supposed will forfeit his life if he is identified. The keeper, perfectly undaunted by the imminent danger of the moment, rushed at the assassin, and struck the instrument of death at one side, and following up his attack, he and the other assistants eventually succeeded in securing the offenders, who fought with the utmost desperation. Such was the severity of the conflict that a surgeon was sent for in the morning to examine the nature of the wounds, and some of the sufferers were obliged to have the hair from their heads shaved before their wounds could be effectively examined and dressed.

We do hope and trust that these desperate offenders will meet with the full punishment under the new Night Act which they deserve otherwise it is to very little purpose to enact this or any other law for the protection of the person or any kind of property.[38]

In this account, plainly written from the 'establishment' point of view, the 'property' referred to in the last paragraph was the wild animals, both indigenous and introduced, which formed part of the diet of the poor for countless generations beforehand, but had been appropriated by the landowners by virtue of enclosure acts for the mere sport of killing them for fun. The three men were Joseph Bayly, John Bayly and Job Read.

Compare and contrast the almost simultaneous account of an aristocratic shooting party on Lord Malmesbury's Christchurch estates:

Lord Fitz-Harris has been entertaining at Heron Court during the past week, a select party of young noblemen and gentlemen, his Lordship's friends, to whom the extensive preserves on the manor have produced a daily succession of field sports: the rivers and lakes in the neighbourhood also, at this season, abounding with wildfowl have furnished objects numerous, novel and diversified to allure and gratify the sportsman, affording frequent opportunities of displaying extraordinary feats in

38 SJ 2 March 1829.

> gunnery, one of which occurred on Tuesday evening last when a magnificent specimen of that rare bird, the Bean-Goose (Ana fabalis) was shot on the Avon, by Villiers Dent, Esq (one of the gentlemen above alluded to), with a single ball at the distance of 175 yards – Mr Dent wounded its partner with his second barrel; but the lateness of the hour prevented his bagging it, and thus completing his extraordinary achievement.[39]

The same estate was lauded by the newspaper eight years later, ironically in the same issue where 'an organised system of depredation' was reported in Christchurch, the offenders guilty of stealing hay and corn, and butter; one of the two was transported for seven years:

> Our harbour and coast, as well as the river, lakes and ponds in the demesnes appertaining to Heron Court, are still resorted to by immense quantities of wild fowl: swans, geese, the duck tribe, coots, divers etc, hourly fall victims to their pursuers, many of them are of exceedingly rare species; all are doomed to be stuffed; some for the glass-case, and others for the spit.[40]

Many of these locally slaughtered specimens would have been taken to Henry or Edward Hart in Christchurch, specialist taxidermists and members of one of the family chainmaking entrepreneurs. Not all the Journal's readership was so obsequious as the local correspondents appeared to be: as late as 1844 an outraged journalist wrote on the subject:

> ... want and distress being the portion of great numbers of that most useful class of men, the labourers, in consequence of the game-laws and the ruinous custom of landed proprietors in preserving game to such an extent as they do now ... In Winchester gaol alone there are no less than one hundred men confined for breach of the game-laws, and their families are supported in the mean-time at our expense ...

Poachers had other consequences to fear apart from the law, for it was perfectly legal for landowners and their keepers to strew their preserves with terrible traps designed to maim or even kill the hungry interloper:

> I was last week witness to a scene the most shocking I have ever beheld. A gentleman in Suffolk, who had had great trespasses committed upon his estate by poachers, was ... reduced to the necessity of setting thigh-crackers, spring-guns, and man-traps, within a wood where he had

39 SJ 18 January 1830.
40 SJ 29 January 1838.

sustained considerable damage. This hardened banditti, disregarding the notice that was given of what was prepared for their destruction, ventured in the night ... into the wood, when no less than four of them were found in the morning caught in these terrible engines; three had their thighs broke by the crackers and traps, and the fourth was found dead in a body-squeezer. One of the other three was thought by the faculty to be injured mortally ... [41]

The writer of this horrific account was not complaining about the traps, but publicising for its deterrent effect the awful risks which poaching brought; such was the prevailing attitude of the comfortable classes. Death in such a cruel way may well have occurred on the local estates of Lord Malmesbury, Sir George Tapps or other local landowners, and news of it would not have been of sufficient controversy to reach the regional weekly newspapers, nor would the cause of death be recorded in the parish registers. When the setting of spring guns was outlawed in 1827, it only did so in the teeth of fierce opposition from some MPs, the very same gents who would dine on game bought on the markets supplied by poachers.

The offences and convictions did not appear to have diminished as the nineteenth century wore on. The penalty could be stinging, as Francis Shave found to his cost, literally, when he took seven partridges' eggs at Bransgore in 1851. *Each egg* incurred a fine of 2s 6d, or about a day's wage, plus costs of 9s 6d. By some means, he found the money to pay. At the same sitting of the Petty Sessions, a man was fined just 1s for an assault on a woman and an innkeeper was fined the same amount as cost Francis Shave each egg, for being open after hours: a travesty of justice.

The Petty Sessions courts held at Christchurch[42] detail countless examples of poaching between March 1854 and the end of 1858. These include:

March 1854: Men by the name of Stride (well-known Stanpit and Mudeford family) convicted of stealing fish near Sopley Mill.

June: Undoubtedly the same two men – George Stride and John Vivian, gave evidence against two other men at the same place fishing illegally at the same dead hour of midnight only weeks later, just after coming out of prison after serving the six weeks' hard labour received after the last offence. Just as on the last occasion, they were fishing, and set a dog on the keeper, but

41 SJ 28 November 1785.
42 Local History Room, Christchurch Library, since transferred to the DHC.

their companions George and a W (brother?) Butler were sentenced.

July: John Shave was convicted on the evidence of Mr Clapcott's keeper of setting a wire to trap game.

October: James Derham, another well-represented local family name – charged with taking fish in the harbour (dismissed).

January 1855: H Gooby convicted of shooting rabbits on 'Mr Farr's enclosed land'.

October: Soloman Head convicted of using a gun to kill game without a certificate. This man was a colourful local character, constantly in trouble with the magistrates, sometimes for violence but usually for poaching offences. He was regarded as so skilful a poacher that he was eventually recruited by Lord Malmesbury as a keeper: a genuine example of poacher turned gamekeeper, in which capacity he effectively turned the tables on his former comrades in crime, acting as witness against them time and time again.

December 1857: Henry Campbell convicted of laying traps in Bosley Common for pheasant.

January 1858: Theodore Church convicted of using a net to catch rabbits in an enclosed field.

October 1858: Edward and Henry Steele convicted of beating for rabbits on Poor Common at Iford – frequent offenders.

December 1858: George Lawrence convicted of using a wire near Hinton to trap game.

George Ford, Joseph Bailey and Richard Hickson each convicted of rabbiting in Mr Dean's land, with ferrets and a dog.

David Clarke, Charles Troke and Charles Summers digging for rabbits on Dudmore Common, Lord Malmesbury's land.

An example of the sort of incident which could land a man in prison is reproduced below, verbatim, from the court records for 1856:

R v Eli Osment – killing game without certificate
<u>Samuel Carpenter</u> sworn
I am a police constable stationed at Hinton. I served Eli Osment personally with a duplicate of the summons produced on Saturday about 10.30 am.
<u>Herbert Plowman</u> sworn
 In the evening of the 14th Oct between 5 and 6 o'clock I was in one of my fields. I heard the report of a gun – I looked in the direction and saw smoke within 100yds – I ran to the spot and a few yards before I came to the hedge I saw someone run to the other side of the hedge, stoop down

and pick up something. I got over the hedge and saw Eli Osment – I said I've found you out now, Eli, although only 2 or 3 days ago I warned you and told you if I did find you I should make you pay for it. You've shot a bird. He said he had not. I said I am quite sure you have. He still said he had not. I was close to him – I put my hand in his pocket and took out a partridge not quite dead. I know the man – he was a constant labourer of mine and had been for some time.

Costs 11s 6d. Penalty £1. To be paid forthwith or committed to prison for six weeks' hard labour.

There were related offences arising from trespassing in forbidden land enclosed by virtue of the parliamentary awards. From the same period of the Petty Sessions we get the following examples:

November 1854: Benjamin Whatton convicted of taking furze faggots from Iford Poor Common.

December: Levi and Andrew Watton convicted of chopping boughs of trees in a plantation at Moordown, north of Bournemouth. These two are almost certainly the sons of Benjamin Whatton (or Watton), above – a family well known to the police and magistrates for this kind of offence.

March 1855: Henry Preston charged with taking a tree branch from private land near the Barracks (dismissed). He was just a boy.

June 1855: Thomas Cutler convicted of breaking dead branches off trees in Lord Malmesbury's plantation. The evidence against him showed that the keeper watched carefully to see what the man was gathering: 'besom heath' was permitted, but he took branches of withy and alder.

December: Levi Watton – the Whatton family again – convicted of 'malicious damage', again in the Moordown plantation. He had been collecting wood, some of which had live leaves on them.

May 1856: Joshua Watton convicted of malicious trespass on Mr Clapcott's land – taking fern.

December: J Starks convicted of cutting down trees belonging to Sir George Gervis, at Hinton: the fact that the remainder of the trees were found in Starks' fuelhouse plainly show the motivation for the theft, which was simply to keep warm.

June 1857: Henry Phillips convicted of 'having pheasants' eggs in his possession' – taken from Lord Malmesbury's fields.

December: Mary Troke and George Button convicted of taking wood from Winkton plantation: 'The bundle was large enough to heat her oven,

nearly two faggots.' Once again these were taken just for basic needs in a humble home.

July 1858: John Brenton convicted of taking a piece of 'ashen stick' from a private hedge near Purewell in the town.

March 1858: a man called Brixey convicted of cutting furze on private land.

The number of poaching cases continued to rise, increasing during the 1860s by about a third. The Hampshire Chamber of Agriculture was still debating the game laws as late as 1870, a conference on which was held at Fordingbridge and attended by local farmers, including Mr H. Bone of Avon and Mr John Waterfield of Bockhampton. That poaching offences brought no disgrace to those committing them they were well aware of: 'Who are most blameworthy, he who takes a pheasant or he who buys it from the poacher?', being one of the moral questions discussed; '... the guilt of poaching is shared by all classes, but not so the punishment'. The law had become increasingly brought into disrepute, by men being fined for taking rabbits, which were agricultural pests, and fined punitively by the magistrates, who were as a rule landowners. 'To think that rabbits should be protected in the nineteenth century did not augur much in favour of our civilisation,' argued Mr Waterfield, showing rare enlightenment.

OTHER CRIMES, AND PUNISHMENT
Christchurch experienced a variety of other crime in this period, being in this respect no different from inland towns. Robbery in the form of burglary was not uncommon: shops were the usual target, but private homes and public houses did not escape the attention of thieves. Apart from cash and valuables such as silver, merchandise was taken: lace and muslin from a dressmaker (1778), shoes from a shoemaker (1801), clothing from a tailor (1826), and so on. Robbery by mugging was not unknown, and even stagecoaches or carriers' carts were not safe from these thieves. The twice-yearly fairs were attended by a certain amount of crime, usually involving the theft of livestock, pickpocketing and swindling. Twice the fair was the occasion of manslaughter, the consequence of recklessness rather than malice: young men behaving with characteristic zest for speed, trying out the horses for sale by 'riding with great violence through the public streets'.[43] In 1819 this

43 SJ 19 June 1819.

resulted in the death of a young Bransgore woman. 'Uttering false coin', otherwise using forged money, was another trick at such fairs.

Another frequent target for local thieves was livestock, particularly horses, but pigs, sheep and dogs were also taken. By 1825, when the lead from the roof of the Priory Church stables was stripped, robberies in the neighbourhood were described as 'frequent'.[44] For all such misdemeanours the redress could be severe: it varied from a prison sentence with hard labour at Winchester Gaol, to the death sentence by hanging. James King received this penalty in 1792 for the theft of a mare at Christchurch, although he was later reprieved, as was often the case. Around this time there were no less than 200 offences against property punishable by death.[45] In 1819 Stephen Simmonds was convicted of breaking in to a house and stealing £6 – a fair amount in those days – and a coat and other articles; his death sentence was commuted to transportation for life. Death sentences on James Stanley for the theft of a mare in 1827 and Joseph Gattrell in 1833 for stealing a watch appear not to have been commuted.

The most extremely severe punishment commonly handed out was transportation, either for a limited period such as seven years, or for life. It has to be remembered that nobody who was transported got a return ticket, so limited sentences were in effect also life sentences. Those who were deported from Christchurch included Israel Ellinger in 1757 for the theft of dowlas (a cloth) from the merchant Moses Sleat; Elizabeth Trevis in 1818 for the theft of 'a great variety of property' from a draper and William Eggs the same sentence for receiving them. That sentence split husband and wife, for Mary Eggs, charged with her husband with receiving stolen goods, was on conviction jailed for six months. It is an example of the widespread wreckage to family relationships resulting from a sentence which shipped people thousands of miles from home and dumped them on foreign territory, with no return ticket. In this particular case, the workhouse register soon had new admissions entered: those of 'Charlet Eggs', aged three, who became an inmate in April 1818 until the following August, and was again admitted in 1823 with a younger sister, Mary, aged five. Both stayed in the workhouse for four years. Mary's age suggests that her mother was either heavily pregnant when sentenced, or gave birth during the sentence. The fate of William and Mary Eggs' innocent children

44 *Southampton Herald* 31 January 1825.
45 Spence, Margaret *Hampshire and Australia 1783-1791: Crime and Transportation.*

Return of Prisoners 1820. (Local History Room, Christchurch Library)

was an inevitable consequence of the criminal code of the day.

William Swift was transported for burglary (seven years) in 1817; Benjamin Vey was transported for seven years for embezzling money from his employer in 1833, and as late as 1844 William Eyres received the same sentence for the minor offence of stealing some boards from a builder. A return of Christchurch people sent for trial at Winchester in 1820 is reproduced above: Stephen Simmonds the burglar is among them.

Should it be thought that transportation was in any way a soft alternative to a prison sentence, some understanding of the nature of this punishment appeared in the *Launceston Advertiser* and was reprinted by the *Salisbury Journal* in the hope 'it will eradicate any erroneous notions'. Running through an ironic list of 'comforts' to be expected in New South Wales, the article lists flogging, being made to work a treadmill, being forced to join a chain-gang, being subjected to attack and even the chance of being killed by local aborigines, 'perpetual work and no pay ... hard labour, hard living, hard words and hard usage ... Those who wish for places of horror and

terror as receptacles for criminals need not go far afield; we can supply him with such places as would satisfy the most insatiable appetite for torturing and punishment.' This was the prospect facing transportees, on top of the separation, usually permanently, from their home, family and friends, the family frequently being thrown on to the parish, as were little Charlotte and Mary Eggs.

The ultimate punishment short of being publicly hanged was transportation for life:

> A notorious character of the name of George Pope, a native of Bransgore, Christchurch, is in custody in that place charged with the commission of various felonies. He was for a long time the terror of the neighbourhood, but absconded for some months to avoid being apprehended. Through the active exertions of Joseph Short, the constable of Lyndhurst, his retreat became known, and he was apprehended at Botley. Pope was not unknown in Wiltshire, particularly about Devizes and Melksham, and also in Sussex, particularly in Chichester.[46]

Truly a career criminal. Transportation had commenced in 1718 to America and to New South Wales in Australia in 1787. It remained in use until 1852.

A prison sentence at Winchester, the county jail, in the eighteenth century meant being kept in irons or even chained to the floor.[47]

Other punishments included a public whipping, to which George Tuck, a boy of 13, was sentenced in 1818 for the theft of a watch from the kitchen of a house to which he was delivering meat. That punishment, obviously designed for maximum humiliation, was to follow six month's hard labour in the County Bridewell, and had to be inflicted in the marketplace. It seems to be extremely harsh. An alternative punishment was a private whipping, something which Robert Tuck received for stealing a carpet bag full of clothing and jewellery from a stage coach in 1831, once again in addition to a prison sentence.

The rising crime rate was inextricably linked with poverty, but it was not the only factor involved: the many inns and beerhouses in Christchurch were thought by many, with good reason, to be inextricably bound up with crime, a view which was expressed by the coroner at an inquest in 1834 on a Bargates woman, Sarah Perry. With her daughter, a 'common prostitute',

46 SJ 18 July 1836.
47 Spence, op. cit.

and a young man, 'her companion', she had spent an entire day drinking. The newspaper report shied away from revealing the 'disgusting details', but reported that at the inquest 'the fact was made known that the state of morals in that quarter of the town imperiously demands the interference of the proper authorities to abate the abominable nuisances day and night ... the cause of which may be chiefly imputed to the facility with which intoxicating liquors can be procured ...' This 'quarter of town' was home to most of the fusee chainmakers.

The presence of soldiers, especially after the construction of the barracks in or about 1792, brought in their train the predictable amount of trouble, not only in connection with the many taverns, but also from petty theft. John Rickman, a noted inhabitant, later to become the government's chief statistician and responsible for the introduction of the national censuses, wrote from the town in 1800: 'There has been much pilfering here lately, but a detection took place on Saturday, and the military delinquents are to be flogged, drummed out, and sent to the West India regiment.'[48]

The reaction of the moneyed classes to the increasingly alarming situation was to form an Association for the Protection of Property in the early years of the nineteenth century, which offered rewards for the apprehension of such thieves. Undoubtedly its main purpose was to prosecute poachers. A more preventative approach was initiated in 1832, 'in consequence of the numerous depredations lately committed in Christchurch',[49] with the establishment of a nightly watch paid for by public subscription. Inspectors of Lighting and Watching were appointed, and in turn appointed the watchmen. Much insight into the nature and frequency of contemporary crime may be had from following the activities of the four dedicated watchmen appointed. A surviving notebook of 1837 reveals that a Guard Room was located downstairs in the old Court Hall at the entrance to the castle, and the night watchmen were given keys to the Blind House under the Town Hall in the marketplace and the 'Engine House' – presumably, the fire engine. Our fellows were supplied with sturdy greatcoats and capes, lanthorns and staffs and set on guard over the town. At the end of every watch they were to cry the hour and call 'All's well' at each of the Inspectors' homes. In 1838, these champions of justice had encountered the following subversive activities: 'Disorderly conduct of individuals in the streets during

48 Huntingdon Library collection.
49 SJ 20 February 1832.

divine services'; and detained a young man in the Blind House for stone-throwing; that appeared to be it. Their duties were then toughened up, and it was made clear to them that their role as night watchmen must take priority over any other employment (one of them had fallen asleep on duty); they were forbidden to enter the public houses whilst on beat or appear to take bribes by way of Christmas boxes and suchlike. Presumably, they had been turning a blind eye because of such inducements. The following year the watchmen had the satisfaction of reprimanding revellers piling out of a beershop after midnight, sorting out a disturbance created by commercial travellers at the George Inn, and ensuring that the pubs shut on time. During the course of his duties one of the watchmen was assaulted and had to obtain a warrant from the magistrates against the assailant. By the end of the year the County Constabulary Act had given rise to policemen being stationed in the towns, so the intrepid band of night watchmen was disbanded.

Crimes against the person were usually not serious and dealt with by the local magistrates. Several examples appear in the Appendix where they relate to the fusee chain workers. More serious crimes were rare, but did occur. Murders were few and far between and of a domestic nature (apart from those resulting from smuggling affrays), such as the 1795 killing of his wife by a Tuckton man, James Lockyer. More sensational was the murder in 1803 of William Harben, a farmer, at East Parley, a hamlet in the parish. The facts of the case were that his own son, Jonathan, and an accomplice, John Gubby, in a premeditated act bludgeoned the man to death in his own house, the motives being unclear. They were gibbeted on the heath nearby after their execution – a hideous practice whereby the bodies were hung in chains in a cage, until they rotted. It is said that the mother of one of the criminals, having become unhinged by the revolting and heartrending spectacle, came every day to the spot in a maddened attempt to feed the corpse of her son. An interesting murder took place at Hurn in the parish in 1821. A local farmer, William Troke, rode into one of his fields to check the progress of the harvest, taking his son with him to open the gate for his horse. He was less than pleased to find that his labourer, Anthony Harris, had not finished cutting the crop of oats, despite the fact that it was not yet even breakfast time. Words were exchanged and an angry row ensued, which ended abruptly when Harris sliced off Farmer Troke's head with his scythe. At his trial he received the same sentence as another man who had stolen a watch – just twelve months in prison. It is difficult not to deduce that the labourer was driven to this violent solution to the quarrel by the

excessive and imperious demands placed on him by an exacting employer.

Murder is a rare crime, and in the town itself there is one case known of in this period, which was the strangulation of an illegitimate newborn child by its mother in 1843. The tiny body was then thrown into the river, weighted down with a stone. At the trial, which lasted several hours, the mother, Sarah Stickland, was found not guilty, but the jury at the coroner's court returned a verdict specifically naming her as the suspect for the murder.

The more routine crime cases in Christchurch were public order offences, and certain occasions were dreaded each year as being particularly problematic for the authorities. One of these was Shrove Tuesday and the other was Guy Fawkes Day, and both were used as a good excuse by the so-called lower orders to retaliate against the officials who governed their lives:

> The magistrates of this town, with a laudable zeal for the conservation of the public peace, have determined, and in part succeeded, in abolishing some customs ... One of the customs alluded to consisted of an idle and disorderly rabble assembling every Shrove Tuesday, and under the cover of night throwing a quantity of brickbats, potsherds, glass bottles and other offensive and dangerous missiles, which they ridiculously termed Lent-crocks, at the doors of the inhabitants ...[50]

Why this 'rabble' associated Shrove Tuesday with such behaviour is inexplicable; 'shrive' means to repent! Plainly, no repentance was involved, as the following account of the practice surviving despite the best endeavours of the law proves:

> The evening of Shrove Tuesday is spent at Christchurch by the idle and ill-disposed in throwing bricks, stones, etc at the doors of the inhabitants, which annoyance they denominate *shroving*. The appearance of the constables on Tuesday last prevented in a great measure, their mischievous sport, which induced them to *shrove* at the dwellings of those not immediately in the town, and accordingly they lay siege to the house of a gentleman who had retired to rest, but, roused at the attack, he discharged at the assailants a gun loaded with vetches, with no other effect than putting to flight the *shrovites*, and the enjoyment of quiet the remainder of the evening.[51]

Similar unsuccessful efforts were made to suppress the high jinks on

50 SJ 11 November 1818.
51 *Southampton Herald* 14 Feb 1825.

fireworks night. The magistrates who in 1818 had thought they were rid of the shriving nuisance, were also determined to stamp out the 'too common, but illegal, mischievous and unmanly practice ... of throwing squibs and other fireworks through the windows of dwelling houses, and at passengers, particularly females, on the public streets, whereby the lives and property of his Majesty's Subjects have been considerably endangered'.[52] On that occasion, special constables were enrolled, recruited from 'respectable inhabitants' – this was before the establishment of the watchmen.

Despite the good endeavours of the magistrates, the local youths prevailed in returning with the same mayhem year after year. The occasion would appear to be used in an entirely premeditated way, an opportunity to 'get even' with the authorities, even to the length of making effigies 'to represent individuals whose activity deserves praise, but whom from the idle and ill-disposed receive the grossest insults'.[53] These effigies were then publicly burnt by the participants, who made threats against specific individuals, chiefly the magistrates or other law-enforcers. That particular year the unruly celebrations ended in violence, and arrests were made for 'an outrageous assault' by armed men, including father and son William and Noah Lemmon, on specially sworn-in voluntary constables, in the course of their duties of preventing the 'disgraceful and brutal outrages' intended that night. The fireworks anarchy did not die down as the century wore on, being recalled as being particularly rough in 1850, when the mayhem continued for more than a month. The Town Hall was in danger of being burnt down when a tar barrel was rolled underneath the market arches and set alight; only the enrolment of special constables on 10 December, for an entire three months, quelled the violence.[54]

Thereafter, the court appearances were confined to individual offenders, rather than the riots experienced in the turbulent years preceding, but it was not a custom to be stamped out easily. In 1873 over a dozen local youths were hauled up in front of the magistrates, much to their mortification, for exactly the same offences, throwing squibs in the High Street. It would seem that even relatively harmless ways of having fun if you were young and less well-off were practices to be frowned on by their superiors, the magistrates, who had, naturally, plenty of legitimate outlets for their own entertainment: shooting, hunting, and other equally harmless pursuits ...

52 ibid.
53 SJ 28 October 1828.
54 Tucker, W. *Reminiscences of Christchurch and Neighbourhood.*

CHAPTER THREE

THE CHRISTCHURCH FUSEE CHAIN WORKERS AND THE PIT SITE

The censuses in the Appendix record all the names recorded in the parish of Christchurch from 1841 – 1891, with the exception of Bournemouth itself from 1871 on account of its size and entirely different economic structure by that time. The chapter on Cox and Co. (Chapter 6) describes the child labour which that firm may have solely employed; many more children worked on chains than the censuses reveal, as the evidence in that chapter proves.

The youngest person in the census returns is William Pardy in 1871, who was 9; the oldest is Harriet Carter at 73, in the same census. There are several others of nearly this age, but the majority of the chain workers were young, single women living with their parents, the chain earnings serving as a supporting income for the family. As the women married and they changed their names, they become impossible to follow through succeeding censuses, but we can be sure that most of these young women would have gone on working in chainmaking in support of their husbands' incomes after marriage. Indeed, this is the reason that Rose Andrews, when interviewed as the last surviving chain worker, gives for her mother making chains – to pay the rent.

Where the occupation of the main family breadwinner is given in the census, it is obvious that the employment is neither lucrative nor skilled, although it would be unfair on the skills of some of the men to describe such trades as sawyer, miller, shoe mender, bricklayer and so forth as not requiring knowledge and ability. They certainly did involve those attributes, but were low-paid occupations. Most of the families boasted a breadwinner described as an agricultural labourer; a blanket term for a variety of employment but all of it dependent on poor pay and possibly seasonal layoffs. Even as late

as 1871, only 9-12s per week could be expected from local farmers, leading one correspondent to the local paper to accuse those farmers of being responsible for pauperising the ordinary worker, a charge that was probably entirely justified. Rose Andrews, speaking of a career which began in 1891, remembered being able to make 8s 6d a week at the most: a useful addition to a poor family's income.

That chainmaking enabled the wives and daughters of the men in the household to supplement the family earnings sufficiently to keep them above the breadline is demonstrated by the workhouse records. The census returns include only one person describing their occupation as chainmaking, even in the later returns from the period when the industry was in rapid decline. In fact, the emergence of the boom-town of Bournemouth just five miles from Christchurch, which paralleled the gradual eclipse of chainmaking, was well able to soak up any available surplus labour in its myriads of hotels and villas. Servants and chambermaids must have in many instances have been former fusee chain workers, and the emergence of Bournemouth was very much their salvation.

The maps accompanying the census returns reveal the main source of the labour pool to have been in the Pit site: those little streets in and around Bargates and the lower end of Barrack Road, called Spicer Street, West End and Pit itself, or Gravel Pit. The name derives from the fact that the cottages were built on a site used for gravel extraction, although that activity appears to predate our story so much that nothing has come to light about when this was done and for what purpose. It appears to have been a place which local people felt belonged to them in some way: the compensation claims which resulted from the 1825 fire record some of them claiming it as a free common. Whatever the truth of this, it would appear that the cottagers built without formal permission from anyone, that over an untold number of years grew into a huddle of small, cob and thatch cottages, with barns, stables and all sorts of other outhouses, plus beerhouses, a 'blind house' or lock-up for anyone who over-indulged or committed some other misdemeanour, and the stocks, on a cramped site in the apex between the two main roads, Bargates (the main road out of Christchurch, going to Wimborne) and Barrack Road. This last road is today a four-lane thoroughfare cutting through the heart of the town, but in the historic period was a mere lane leading, as its name suggests, to the barracks, built during the Napoleonic wars in 1792, virtually at the same time Robert Harvey Cox started his fusee chainmaking enterprise here.

Pit site plan pre-fire. Note the stocks and Blind House (the lock-up) and pump in the centre.

We know from a drawing made just after the fire (Dorset History Centre D/RHM7717/8) the layout of these cottages, grouped around a well (marked 'pump'), presenting to the world a motley assortment of odd-shaped structures with narrow alleys. The building marked 'Hugmans', called the 'warehouse' is probably the same as that purchased by the Vestry to house 'such poor people of the parish as it shall not be thought proper to be received into the workhouse of the said parish', though why they should not be suitable is left unstated. The fire records reveal there was also a slaughterhouse, blacksmith's shop, and sawpit. A large barn-type structure appears to have been used for chain-making as well as Hart's factory in

Left: barn in the Pit Site with possible chain factory building behind. Right: cottage which escaped the fire but was demolished in 1890. The man is standing in Bargates.
(Red House Museum)

nearby Bargates, but apart from this snippet of information on the back of the original photograph, no other reference has been found for it.

Most of these humble homes of 'artisans, fishermen and farmers' labourers'[1] were utterly destroyed in the space of three hours one hot July morning in 1825, all through the careless action of a housemaid by the name of Mary Seymour. At 11am, she threw hot ashes close to a fuel house belonging to Thomas Troke, a milkman, living in a little cottage abutting the rear of the Horse and Groom public house, on the other side of Bargates from Pit. Conditions could not have been worse or the consequences more serious. The summer heat was intense, there had been no rain for so long that there was almost no water left in the well, and the wind was blowing with some force in the direction of Pit, the most densely populated area in the entire town. Within half an hour of the milkman's cottage going up in a fireball:

> ... one universal blaze was discernible, the effects of which were that 51 dwellings were laid in ashes besides Barns, Stables, Hay ricks, Waggons and various implements of Husbandry and the demolition and loss of considerable in quantities of Household Goods and Furniture as also Cloaths and Wearing Apparel ...[2]

The press account of the fire in the *Salisbury Journal* describes 'a terrible picture of havoc and destruction', which it was feared was going to engulf

1 SJ 23 July 1825.
2 Fire committee 20 July 1825, DRO D/RHM 7717.

the entire town had the wind not fortuitously changed direction. Valiant attempts were made by 'all ranks' of the inhabitants to put out the flames, but the Mill Stream was too far away to be of use. The *Southampton Herald* painted an even more dramatic picture:

> Half the town ... was threatened with destruction, and every preparation was made by the hasty removal of furniture; the disorder of which, the appearance of the fire, cries of children and shrieks of females, excited feelings more easily conceived than described.

Urgent appeals for help were answered straight away by the men of the 2nd Dragoon Guards up at the barracks half a mile or so up Barrack Road, who were 'instantly in attendance' with 'a powerful engine, and were of infinite service in stopping the progress of the fire', which was effected by 3pm. They were in time rewarded with a gift of ten guineas in acknowledgement of their help.

Pit was reduced to ash, its inhabitants homeless and many having lost their livelihoods. In the words once more of the *Southampton Herald*, 'On the poorer classes, with few exceptions has the loss fallen; many witnessed in 20 minutes the total destruction of the fruits of as many years' hard labour.' Many of these poorer townspeople would have been fusee chain workers. The report picks out for praise those citizens of exceptional capabilities and dedication: John Sloman (of Wick House), Thomas Daw (of the brewing family) and George Aldridge jun.

It is a tribute to the abilities of the people of the time, unaided by the means of communication which we take for granted in our age, that that same evening an emergency committee had not only been formed, but had met and allotted accommodation to each and every affected resident who had no relative or friend to come to their aid. It was chaired by the vicar, and attended by the local gentry and nobility, and its first resolution was to open an appeal. It is probable that the services of the town crier were employed, and it is a known fact that special constables were appointed – six of them – and each in turn authorised to find six men each 'to watch the progress of the Flames and each person to receive two shillings for his service'.[3] The constables were: Gustavus Brander, George Frederick Brander and Henry Augustus Brander; John Newman (farmer), Charles Hicks (corn dealer) and William Cusse (grocer), and they went round the town before

3 Fire committee, DRO D/RHM 7717.

nightfall informing the sufferers where they should go for shelter. Some went to the barn of John Spicer at Somerford Grange just outside the town, some to Priory House, home of the Branders, and the rest in the homes of the well-to-do townspeople.

Over the next few days the new committee met to decide how to alleviate the great distress caused by the fire. The ladies of the town got together to make clothing and the special constables were deployed to protect what property was left. John Spicer chaired the committee and energetically set about organising claims for compensation and the rebuilding of the cottages. Careful investigation of each claim was made, revealing fascinating stories about the way Pit had evolved in an entirely haphazard, unauthorised manner:

> I bought my back House of Mr Edward Tory for £20 in my brother John Edwards' name and the front towards the street I built … I took in a piece of ground in front and built on it. Mr Baker and Mr Humby the Waywardens interfered and said I was coming too far but I continued without further interruption. The stable I built about nine years ago. I have been in Christchurch about thirty years – a few years ago it seemed to me like scrambling for the Gravel Pit and everyone anxious to get as much as he could. (Mary Manley)
>
> The house I put up and have had possession of about 18 years. I had no particular lease for building it – a Quit Rent of Lord's Rent was never demanded of me nor did I ever pay any. I built the Stone Shop about five years ago. Scott was going to build a Pig Stye on the same spot and I thought I may as well take the land myself. I considered the land as a Free Common to the town for ever, but that when a tenement was once put up no one had a right to take it down … My present house is about 12 feet wide and 15 feet in length. (James Butler)

Joseph Lemmon acknowledged to the committee that he had no right to build in Pit 'but he did it because others built on it, that he knew it was a free common and presented as such every year at court'. This refers to the Court Leet, where all commons were annually declared as such as part of the proceedings.

Common land issues were held very dear by the people in Christchurch, as mentioned in Chapter Two. There were hundreds of acres of such land, 300 acres alone in Portfield, which extended from just beyond Pit to the river eastwards, and on which all householders in the old borough had rights to depasture their cattle for part of the year. They were economically vital to the welfare of the poorer classes, who were thereby made self-sufficient in many

respects. The idea of having an inalienable right to build on the waste was an old one, by which a cottage once erected in the space of a few hours, with a fire lit, could not be taken down. In this way, several generations had lived in some of the houses: Betty Butler was born in her cottage nearly 79 years earlier and it was her father's before; before that one Walter Coward lived in it, and 'my mother told me it was formerly a Public House and that soldiers were billeted there'. She is recalling a period way back in the early eighteenth century to the 1740s; the name of Coward appears in Bargates in the 1861 census.

Everybody affected by the fire had to put in a claim for lost possessions, which were scrutinised by the committee and only passed if the claim was deemed to be fair – which was not always the case. James Butler's claim, for instance, 'required investigation'. This man, a wheelwright, was particularly contrary, or independently minded: he eventually got into quite a confrontation with the ever-patient committee when he began to rebuild his cottage himself, contrary to their carefully devised scheme. He carried on arguing about his 'ancient freehold' and with commendable cheek actually got the agreement of the committee to buy the site in question off him for £54. Others revealed that the money provided for replacement goods had not been used as intended:

> I told my husband I had the money Saturday night – he is a bad man – and I have been a good wife. I told him the money was to buy a bedstead and furniture and I was to give account to Mr Spicer – he allowed me 6s a week. I paid the rent. [James Mesher's wife]

Her daughter, a Mrs Lockyer of the Horse and Groom pub, put the fire committee more fully in the picture: 'Father and Mother are both alike but Father is worst. Mother told father that she received £4.'

The fire claims tell us a great deal not only about the possessions of the poor people who occupied this devastated site, but their level of education, trades and other details. This information rarely comes to hand. We may be amused by the creative spelling, but the fact that any of them had learned to write at all gives them great credit. It was not necessary to be literate then as it is now, nor was it usually acquired in any other way than through the family; besides, it reveals pronunciation in a way which standard English cannot. Some are pathetically brief:

Alongside the bill put in John Shambler's claimed for losing a cottage and a small fuel house, all goods and wearing apparel.

Other inventories are remarkably detailed: one runs to four pages and

The Christchurch Fusee Chain Workers and the Pit Site

Above, John Shambler's claim. (Dorset History Centre D/RHM 7717/6)
Below, a typical claim from an unidentified claimant. (Dorset History Centre D/RHM 7717/6)

itemises every conceivable object in the house, outhouse and shop.

The item considered by this man to be his most valuable possession is the one at the top of the list (previous page, bottom image), a wheelbarrow valued at 14s. The second item appears to be hog tubs. Other labouring tools follow: a spade, a two-pronged fork and hatchets. Domestic equipment follows next: buckets, water bath, copper kettle, boiler, colander, skimmer, saucepans, lantern, jug, coal boxes and baskets. Furniture, as in many inventories, is scanty – a stool ('stul'), chair ('cher'), three bedsteads with blankets, and a looking glass are all that is mentioned. Personal possessions can be touching in their obvious value to the owner: the testaments, bible and prayerbook, a 'bird' clock and the 'goods in the winder'. The majority of the lost property consists of clothing, and once again tells us a great deal about the owners: shoes and stockings, jackets, trousers and frocks, gowns and flannel coats, shifts and leather caps. This claimant also had a gun.

The next example (facing page) seems to relate to two houses. The upper section is for the previously mentioned Betty Butler, whose most valued possessions are a four-poster bed and two stump bedsteads with blankets, pillows and quilts; her other furniture is a chest of drawers, an oak table and a leaf table. A list of clothing follows which even for a single person barely amounts to much: a flannel shirt, two pairs of yarn stockings, two waistcoats, a shirt, frock and pinafore, and one pair of shoes only, with a few other items. John Burry's possessions seem to include scaffold ropes and poles, a 'new whitewash brush', saws, chisels and wood, indicating an occupation as a decorator or small builder.

James Tarrant's scrap of paper (overleaf) gives his worldly goods as including the usual bed and bedding equipment, tools such as pitchforks and hatchets, and the pathetic statement that he has lost 'all the cloth [clothes] my wife and children had. We have not a shirt or anything to change'.

William Summers' most valuable possession is his coat, closely followed by his trousers. The sad little list of clothes for his family must have taken them many hours to compose. 'Perlace' is a pelice, or cloak. As in previous inventories William Summers had been able to boast some pictures on the walls of his cottage. He is one of the few to list food items lost: bread and butter and tea. His trade would have appeared to be a carpenter: all his tools amount to ten shillings. The list ends with the surprising addition of a clarinet and flutes, as valuable as the coat at the beginning.

Betty Butler and John Burry's claims. (Dorset History Centre D/RHM 7717/6)

James Tarrant's claim. (Dorset History Centre D/RHM 7717/6)

William Summers' claim. (Dorset History Centre D/RHM 7717/6)

John Butler's claim. (Dorset History Centre D/RHM 7717/6)

John Butler's list indicates that he was a fisherman. Scribbled almost illegibly, the contents of the stable are: harness, what appears to be 400 'old paper stuff', a coil of rope, blocks, empty sacks, herring casks, fish baskets, baskets of barley meal, oats, beans, peas, potatoes; plainly he had a horse, as there was a manger, saddle and more harness.

An extremely detailed inventory bears no name: running to four pages, that with the tools is reproduced on the facing page. It relates to the sawpit

Tools claimed. (Dorset History Centre D/RHM 7717/6)

and itemises beech and elm planks, pieces of oak and fir and old gig shafts. The shop contained carpentry tools such as planes, chisels, gauges, wagon axles and wheels, staves and nails for making two large gates and so forth. On a continuation sheet numerous further items are listed, including 'one pile useful stuff', plough handles, cart panels, gig shafts and hundreds of spokes, suggesting that the person was a wheelwright or general carpenter with a substantial business.

Apart from the clarinet and flute already remarked upon, the unexpected appears from time to time: several had clocks, one had a watch (perhaps because of the familiarity with them from chain-making?); that man lost 'all my Bills and Account Books burnt' – you can almost hear the wail of despair about his business being thrown into chaos. Many cottagers thought it important to have a mirror, or looking glass, which is interesting where possessions were few, luxuries did not exist and life revolved around the necessity to earn the daily bread.

The fire committee commenced rebuilding, on a carefully devised plan of brick houses with non-combustible slate roofs, to be built as shells only, owners to complete. A little row called Caleb's Row had been destroyed by the fire, and John Spicer gave some land of his own adjoining to add to the site as compensation. A new road was to be built, and the old one – probably Caleb's Row – stopped up. Once again, the committee needed all its patience when this proposal met with spirited opposition from some: no sooner had the posts and rails gone up at each end of the old road, then James Pike got two men to drive two horses dragging a piece of timber up and down the old road to prevent its closure; he was aided by James Butler and 'several disorderly persons'. The committee resolved to obtain a Magistrates' order to proceed, 'but from the violent opposition experienced by the committee and the threat of an appeal by persons accustomed to use the Road, the committee considered it advisable to abandon the intention ...' A case of discretion being the better part of valour; the Pit cottagers were not about to be told what they could do after so many years of being left alone.

Eventually, Pit was rebuilt and the houses occupied once more, but its character remained forever one of a lively and somewhat lawless collection of poor people, where life was certainly never dull, as the court records included in the census returns show. Throughout the nineteenth and early twentieth centuries, the area developed a reputation for being rough and somewhat squalid: you had to be tough to live there and they were. What were in 1825 brand-new cottages built with the best of intentions to far superior standards than the previous thatched hovels, had within a century become the slums of the town. Indeed, a report in 1886 noted that 'Many old cottages at Bargates have fallen and not been replaced.'[4] A large-scale clearance was put in place in the early 1930s, and in 1954 all remaining buildings on the site, including the Antelope Hotel of *c.* 1860, were

4 Humphries, N. A., op. cit.

The Christchurch Fusee Chain Workers and the Pit Site

Pit Site 1920s: Bargates left, Barrack Road right. Hart's Fusee factory is the long building bottom left. (courtesy Mrs D Aldridge)

demolished to make way for the huge roundabout which covers the site now. Spicer Street, named after the chairman of the fire committee, went the way of Caleb's Row.

A stone tablet made by the stonemason, William Hiscock, commemorating the fire, which had been placed by the committee in the wall of one of the cottages, today leans propped up against a wall in the garden of the town's museum.

Spicer Street (courtesy the Red House Museum) with detail of end cottage with fire memorial plaque top right.

83

CHAPTER FOUR

A BRIEF HISTORY OF TIMEKEEPING

Whilst the main purpose of this book is to study in detail just one of over a hundred processes involved in the making of a watch, the means by which mankind reached this level of expertise and exactitude of requirements in his desire to mark the passage of time forms the background against which it must be seen. Thousands and thousands of years of human development were to pass before our ingenious brains devised the chain for the fusee, a marvel of engineering miniaturised; thousands of years went by before such a device was necessary or possible. Throughout those aeons, the concept of time, how to measure it and why, steadily developed. Each breakthrough came about through increased understanding of the workings of that vastly bigger machine, the immense universe which dictates the processes involved; each advance brought with it consequences which could not always have been anticipated. Thus, the evolving sophistication worldwide in the science, or magic, of the measurement of time, was both shaped by and in turn influenced the development of human society: rituals, religion, trade, power and control, are amongst both cause and effect in the complex evolution of our advancing knowledge of time and its underlying principles.

Today, we take our watches and clocks for granted. So dependent are we on regulating our lives by constant reference to them we could not function without them. Human society as we know it would collapse in their absence. All that we do in our daily life is governed by the clock, from the waking alarm to the evening's television viewing, and all the myriad activities which fill the hours between – catching the train, taking a lunch break, keeping appointments. Over and above the day-to-day routine are plans we make for the longer term, by the year, which depend on the calendar: the annual holiday, school terms, Christmas and birthdays.

But time measurement began when the earliest humans lived in an entirely

different environment, where the cosmic forces which underpin the periodic events which we experience as the passing of time were dramatically apparent. For them the sky on a clear night was a sight of indescribable splendour, undiluted by the competition of manmade sources of light such as dull our awareness of the stars and planets today. The vista of a slowly moving canopy of a myriad points of brilliance set in the inky blackness of the heavens would have been a source of wonder every night throughout these early people's lives, a subject of endless speculation for the restless human mind, studied and interpreted through the ages; astronomy must surely be the earliest science of all. As the majestic celestial display faded at dawn, so rose that other spectacle in the sky, the source of warmth and light and life itself – the sun. Its powerful presence and beneficial effects had a deep impact on human minds and culture, causing the sun to be worshipped by peoples all over the world as a life-giving force. Night and day, then: the moon and stars and the sun, an elemental human experience of time which was the impetus for all subsequent efforts to regulate our human activity in accordance with the perceived workings of the universe.

Deep within us, we are in tune with the motions of these great planetary movements, in that we have an inbuilt circadian rhythm. Unsurprising, in view of the observation that we are said to be ultimately composed of the very stuff of the universe, stardust. As with all the animal and plant kingdom, even the plankton in the sea and the daisies in the lawn, this daily rhythm governs our period of rest and wakefulness, and appears to be linked most closely to the tides, which are mainly governed by the moon.

The sun was our earliest timekeeper, and regarded as such all over the world in every early culture. The simplest division of time was this natural one between dark and light, which together comprise a day. For long periods of time in the prehistory of early man, that would have sufficed, but as human interaction evolved and became more sophisticated, this simple unit began to be subdivided. Division into 24 (hours) did not take place straight away: some early civilisations such as Egypt, Mexico and Persia divided a day into four parts; in the early Roman era the public criers shouted out the time in the streets only at sunrise and sunset, having no need to keep the populace informed of any subdivisions. The division into hours appears to have arisen in that early cradle of civilisation, Babylon, whose astronomer-priests devised the zodiac with its twelve constellations and used this as a basis for dividing the day and the night into twelve parts each. It was from Babylon also that the further subdivision into minutes and seconds

developed, all as a result of the close studies of the heavenly bodies made by the learned priests of this sophisticated civilisation, who then recorded their observations and thereby built up records over thousands of years. Their knowledge later spread throughout the ancient world. It was the Sumerians or southern Babylonians, highly adept mathematicians, who first subdivided the hour, not into minutes as we use today, but into intervals of four minutes, which system was in place by 3000BC.

That other advanced early civilisation, Egypt, also developed a 24-hour day from a study of the stars. It was considered to be a significant event when a star, as well as the sun and moon, rose, and the Egyptian astronomer-priests observed such risings to occur in groups of twelve and divided the night, and by analogy the day, into twelve equal periods to correspond. The concept of hours did not reach Rome until much later: only by the second century BC were the hours marked.

The concept came to Europe later still, for the Saxons divided the day and night into eight 'tides': vestiges of this are to be found in our words 'noontide' and 'eventide'.

In 605AD, the Pope decreed that the Roman day should have seven periods, a means of dividing the day which lasted centuries, as these marked the times of prayers in the religious houses and were indicated by bells or alarms. Some of their names survive today: matins and vespers.

This is a necessarily broad account of how the day became divided into smaller and smaller units; the evolution of an entire year as a measure is a parallel development, once more traceable back to the observations of the stars and planets. We now know, of course, that a year is the time taken for our planet to orbit the sun, but although that appears to be a straightforward definition, it is not that simple, for there is a sidereal and a solar year. Astronomers today use the former, as calculated from the movement of the stars, whereas the day as measured by the apparent movement of the sun is three minutes and 56 seconds longer. Such precision was not available to the ancients. Their experience of the year, from a study of the stars, was a prodigious feat of memory or record-keeping in that it involved counting the days from one juxtaposition of the moon and constellations to its next exactly similar appearance. By 4000BC or even a thousand years earlier the Egyptians had got it nearly right: 365 days, as had the Babylonians, once again. The ancient Egyptians made the calculation from observing the annual inundation of the Nile, carefully measured. The use of this information was to predict the floods and plan the planting of the crops in the flood plain

accordingly. This was the benefit of establishing a measure for time: the ability to plan ahead was thereby achieved; valuable and potentially life-saving knowledge. The Babylonians had refined the accuracy of the length of the year by a study of the stars; by 500BC they recorded it as 365 days, six hours, 15 minutes and four seconds: a quite incredible feat, just under 27 minutes short of the actual figure.

In primitive Britain, evidence that early peoples were engaged in the same fascinated observation of the stars is to be found in the long barrows which proliferated from 6,000 years or so ago, our Neolithic Age. Although they are thought of principally as burial mounds, they may have had the added function for star observation. This is deduced from the fact that many of them are aligned with each other and the lines so formed are in line with the rising or setting of certain bright stars. Such a theory fits in well with the broadly accepted view of the function of the hundreds of megaliths in Britain, of which Stonehenge is the best surviving example, as time measurers, and specifically, a means to determine the date of the solstices, for what were probably religious purposes.

Along with establishing the exact duration of the year, which as a unit of time in general would be obvious to anyone from the seasonal patterns observed in the natural world, mankind sought also to subdivide that neatly into months. Months, of course, are the length of time of the moon's cycle – the very word derives from this gleaming silver disc in the sky – but although a natural phenomena, the lunar cycle does not neatly equate with the solar cycle of the sun. It lasts approximately 29.5 days, so that a year of twelve months is just 354 days. So, dividing the year into months, as twelfths, does not equate with the actual phases of the moon. Nevertheless, months evolved in many early cultures as a way of dividing a full year and means to compensate for the shortfall were devised and will be referred to below. Certainly, using the moon's cycle for timekeeping goes back at least 20,000 years to the Ice Age, from which era bones have been found with scratched markings on them and holes, thought to be a way to show the number of days until the next new moon.

Our modern names for the months come from Rome, which in turn had absorbed the knowledge of other advanced civilisations. In 738BC or thereabouts, King Romulus, the city-state's founder, instituted a calendar of ten months, starting at the vernal equinox on 25 March. The total of the days in this Roman year was 304: 61 remaining were simply not counted! That is because they had no importance, being winter months and

of no value agriculturally, a system derived from more ancient cultures. These months were Martius, Aprilis, Maius, Junius, Quintilis, Sextilus, Septembris, Octobris, Novembris and Decembris. Romulus's successor added two new months, bringing the tally to our familiar twelve (Januarius and Februarius).

Further subdivision into weeks marks a departure from the basis for all former units of time in astronomy, and is the first manmade imposition of order on what was hitherto linked to the natural processes. Once again, it would appear we can probably thank the Babylonians for the innovation, and from them it spread to the Jewish and Roman world by the 1st century AD, aided by the belief in the magic power of the number seven to the Romans. It was the Roman Emperor, Constantine, who brought the concept to Europe in 321AD, which had prior to that somehow struggled on weekless. Here in Britain a national slant was put on the imposition, with the days being named after the pagan gods of Viking origin, such as Thor and Woden.

All this development, which took place over many centuries, led to various attempts to formulate a calendar which would incorporate all the periods of time from the basic unit of one day which had become a feature of the way life was ordered. Most of them ran into enormous problems as a result of conflict between the length of the year as it was actually being created as the world slowly circled the sun, and the efforts of the scientists of their day to devise a system which would keep pace with that orderly but exact progress of our planet in its stately voyage. Not that the astronomers of the time appreciated that their efforts to encode the earth's motion by a calendar was formulating any such thing, because, of course, they believed the earth was flat and that the heavens were actually moving around us!

Part of the problem, even today, is that the circuit of the sun takes up a very unsatisfactory amount of time, not easily divisible by any number system devised in the long evolution of human civilisation. It takes precisely (or not – the figure is undoubtedly only a round-figure quantity) 365.24222 days. There is no way that can be converted to a convenient calendar without some days 'left over'.

The efforts appear to date back to 3000BC, when the Sumerians, the successors to the Babylonians, attempted a neat 12-monthly year each of thirty days. Obviously, it would have been found to be increasingly out of true to the deductions made by astronomic observation, but it was a start. A rival claimant as the first with a calendar is ancient Egypt, unsurprisingly,

A Brief History of Timekeeping

which had some sort of calendar about the same time.

A huge leap forward in the attempt to keep the manmade record in tune with the celestial or solar, can be credited to Julius Caesar, who in 47BC made a brave attempt to sort out the Roman calendar which had by then become about ninety days out of step. The word calendar comes, incidentally, from the Roman word meaning the first day of the month. The previous 354-day lunar calendar was jiggled about by the introduction of months of various lengths and leap years, and 365 days allowed for, in accordance with the understanding of the solar year. The year was also put back to commence on 01 January for a few hundred years, but reverted to 25 March in 532AD, a state of affairs which lasted over a thousand years. This alteration was in honour of the date on which it was believed Christ was conceived. The Julian calendar was adopted in Britain in 664AD. In Rome it was mainly a tool for the priests and never published for the use of the people. The priests frequently altered the calendar to suit their own purposes. It was eventually abandoned when it was felt necessary to make a more accurate calendar, as the Julian version lost one day every 128 years. The reason why this was felt to be so important was that it affected the timing of Easter.

The situation was addressed by Pope Gregory XII in 1582, whose resultant edict launched the modern Gregorian calendar, with further adjustments made by leap years. It was accepted by some countries immediately; others, including Britain, took two centuries or more to be persuaded to adopt what many thought was a popish plot. Only in 1752 did commonsense succeed in Britain. In the interim, dealings between countries obeying two different calendars must have been very confusing.

This brief outline provides the bare bones only of what was a complex process of evolution, of succeeding civilisations learning from previous ones or through trade and the monasteries where most learning was concentrated. It does not delve into the reasons why it was thought necessary to gauge the passage of time in the first place, which were many and various, but centred on the need to plan for crops, control the populace, organise religious occasions, and regulate an increasingly sophisticated level of society. Further information about these aspects of the history of time may be acquired from a multiplicity of excellent and learned studies on the subject, some of which are included in the bibliography for this work. We leave this subject to explore the means by which our predecessors sought to harness the awesome might of the ceaseless motion of the universe and use it to organise our human activities.

Sunlight and shadows

It took no great ingenuity to notice lengthening and shortening of shadows and relate it to the height of the sun in the sky. From this basic observation some of the earliest and simplest measures of the day developed. It would not have been necessary to have used a purpose-built device of even this simplicity: shadows occurring naturally, say from a distinctive tree, could have served the same purpose and been used to arrange a gathering on the following day, for example. But a simple stick held in the hand or placed in the sand would have cast a sharper shadow, and such objects have been found in the great civilisations of Babylon and Egypt as far back as 4000BC. Later, they had notches cut in them to indicate subdivisions of the day. Alternatively, the stick in the ground may have been ringed with flat stones; as the shadow reached a particular stone a prearranged activity could take place. For the first time, groups of people could thus organise their day in advance. Such objects were the precursors of the sundial.

The obelisks in Egypt are merely huge shadow sticks, and were used from about 3500BC. A study of shadows gave the ancient people a knowledge of solstices and equinoxes, and would have proved entirely adequate for the needs of a community which had no reason to require great accuracy in a timekeeping device. A variation was a shadow stick with a graded bar across it, which was pointed at the sun and a reading taken off the horizontal bar. In ancient Greece people used their own shadows, measuring their length and marking the ground it covered into the hours. Unfortunately, the length of shadows vary from day to day according to the season, and so as society became increasingly sophisticated and needing to plan ahead with greater certainty, the sun had to be utilised more reliably. The sundial was the next innovation, and once more probably appeared first in Babylon as a result of the accumulated wisdom from centuries of star-study in that region.

Sundials were certainly well known by the time the first written reference to survive occurs, in the fourteenth century BC in Egypt. There is an eighth-century BC reference in the Bible (Kings 11, XX:11): 'And Isaiah the prophet cried out to the Lord who brought the shadow ten degrees backward by which it had gone down on the dial of Ahaz.' There is no consensus as to what type of sundial this was; it may have been an obelisk mounted on a flight of steps, each step representing a period of time.

Other early forms of sundials are known as hemicyclium, and as the illustration shows, were curved bowls with the hours marked; the curvature enabled greater accuracy to be achieved than by a simple stick-type

Ancient Greek hemicyclium. (Brearley) Ring dial. (Brearley)

sundial. A hemicyclium made in effect a mirror image of the sun's apparent movement across the sky, so that the pointer held above its curved surface reproduced on a small scale the sun's progress across the sky. Although this improved accuracy, the lines were too close to be used for estimating minutes, and this was sometimes overcome by increasing the scale of the 'bowl' to a occupy an entire courtyard, the shadow being tracked across the surface. The standard construction of sundials became a plate with the hours marked upon it and a pointer, called a gnomen, from the Greek for 'one who knows'. This commenced as a vertical stick but later became angled parallel to the Earth's axis, pointed not at the sun but the North Pole. The science and mathematics of sundialling became so complex that in 1612 a work on the subject ran to 800 pages.

The earliest known sundial in Britain is a vertical dial type on a stone cross in a Cumbrian churchyard, Bewcastle Cross, which is Saxon, probably seventh century; the dial itself remains but the projecting horizontal gnomen is long lost. Unlike other Saxon tide dials, this one divided the daylight into twelve.

It was the requirements of the church which resulted in the proliferation of sundials, so that the canonical hours could be determined. These had five divisions and were known as mass dials.

Eventually, sundials evolved into portable forms, as the technicalities behind their design became increasingly advanced, especially useful for travellers and farmers from the eleventh century on. The most common form was the ring dial, an ingenious device which had a hole through it for the light to shine onto an adjustable inner ring. It needed careful orientation to obtain any degree of accuracy.

Pocket sundials. Left to right: late eighteenth-century German-made sundial in wooden case, with compass. On reverse (not illustrated): is a list of towns and latitudes. Brass sundial with compass made in 1742 by Stokes. Sundial in leather case, adjusts for latitude, c. 1760. (Hampshire County Museums Service) (see colour section)

The design of the dial and gnomen was specific to the latitude in which it was to be used, and does in fact only indicate true time. The length of each day is not exactly the same, being variable by up to sixteen minutes because the earth's orbit is elliptical, not circular. Human affairs demand that each day is of the same length, and so are calculated as a mean or average of the actual days. Thus a sundial measured what is termed 'apparent' time, and this only equates exactly with a standardised day four times each year. This made them inaccurate as timepieces, and the fact that they only operated in sunny, daytime conditions limited their use (although there were nocturnal dials). Nor could they be made to operate a bell, for use in churches. They nevertheless were the principal method of timekeeping for thousands of years in every culture on earth, right up to the nineteenth century in Britain. Despite their inaccuracy, they were for long periods of time more reliable than early clocks, which were regularly set against a sundial to be corrected.

Extremely beautiful sundials were made through the ages, often with illuminating or cryptic mottoes inscribed on them about the nature of time. Amongst the most attractive are the stained glass window dials, a superb example of which is illustrated. One of the most curious English sundials is that at Settle in Yorkshire (below), an eighteenth century, but probably earlier, dial using the natural rock outcrop on Castleberg hill. The dial was the hillside itself, on which five large stones indicated the time as the shadow fell on them. Presumably, it was 11.30pm in 1778 when the engraving was made, soon after which the unusual timepiece disappeared.

A Brief History of Timekeeping

Pedestal sundial at Parley Court, near Christchurch. (drawn by Kathleen Chilver Courtesy *The Hampshire Magazine*)

Stained glass sundial at Toller Porcorum. (see colour section)

The sundial at Settle. (The Guildhall Library, Corporation of London)

WATERCLOCKS

Sundials were abandoned in Rome as the official timepiece in the second century in favour of a technology which could be used day and night, indoors as well as outside, without the need for complex mathematical calculations to adjust it for the latitude and time of year, and which depended on an endlessly renewable and cheap supply of power – water.

Waterclocks had been utilised for several thousands of years by this time by all early civilisations throughout the world, apparently independently developed by each of these. The earliest known surviving example is Egyptian, from 1500BC, but they are recorded as having been in use in both India and China as early as 4000BC. The technology is simplicity itself – merely a container with a hole in it through which the water steadily dripped into another, graduated, container. Unlike the sundial, which today has mainly a decorative use as a garden feature, waterclocks remain in use in some parts of the world in this, the 21st century, notably in North Africa. It became more and more elaborate and ingenious with time, as well as accurate, as will be described.

Another name for waterclocks is clepsydra, from the Greek 'thief of water'. They spread from Egypt to Greece and the Rome, where they were in effect public clocks, placed in the marketplace or a public square and taken care of by a civic officer. Servants were sent out from the houses of the Roman nobility to ascertain the time from such clocks; the poorer residents were kept informed by the waterclock officer blowing a horn at the change of guard, in much the same way as the watchmen of old England called out the hour throughout the night. Waterclocks were installed in the Roman senate to limit the time permitted by the lawyers for speaking – but they were sometimes tampered with by those lawyers by the addition of mud to slow the speed of the water's passage out of the upper chamber! Water clocks are recorded as being in use in Britain at the time of the Roman invasion. When Rome fell, water clocks disappeared from the western world.

In 250BC or thereabouts, the Greek scientist and inventor, Archimedes, developed the geared wheel which was applied to the waterclock mechanism, along with later innovations in the form of levers and cams, all of which extended the functions of the clock to incorporate dials, gongs, bells and calendars.

Perhaps the most elaborate water clock of all time was created in Baghdad for the Emperor Charlemagne in 800AD. This city was at the time a centre for culture and learning, and the scientific knowledge inherited from the

Waterclock with gearing. (Brearley)	A more elaborate waterclock with geared wheels. (Brearley)

Babylonian astronomer-priests was added to extensively when observatories were built in the city. The clock made for Charlemagne was in honour of his coronation by the Pope and must have been a truly fabulous application of mathematical and artistic achievements. It featured a dial with twelve small doors. Each door opened at its appropriate hour, and spewed forth one by one a number of small copper balls onto a metal bass drum. Thus the onlooker could see the time from the number of the door which had opened, and someone out of sight of the clock would hear the hour struck by the fall of the balls. At noon, twelve miniature knights on horseback emerged from the contraption and closed all the doors, ready for the sequence to commence all over again at one o'clock.

Water clocks were a departure from methods of telling the time by reference to the stars. Their disadvantages were few – one of them being the propensity to freeze up in colder climes. Another drawback was soon overcome, which was that a vessel full of water will not slowly empty into a lower container at an exactly steady rate: the full container at the outset

exerts more pressure on the water going through the aperture than one nearly empty. This was solved by the use of a double vessel in the lower container, containing a float which rose as the container filled up; the level of water was marked on a scale. The upper container was attached to a reservoir which constantly topped it up to keep the pressure even. By these means, the waterclock became a very accurate device, certainly more accurate than mechanical clocks before the invention of the pendulum.

Whilst waterclocks continued to become increasingly refined in the east, including China, in the west the people of the Dark Ages lost all knowledge or use for them. They began to reappear around the first millennium in the monasteries, where the monks needed to know the correct times for prayers. Whilst a sundial could usually, in suitable weather, provide the required information, on cloudy days and in the night they could not. And so waterclocks made a comeback, and remained in use in some continental countries throughout the Middle Ages until superseded by mechanical clocks.

The development of sophisticated waterclocks during the thousand years in which they were in use was largely responsible for the discovery of the principles which were later applied to early weight-driven clocks; the Chinese invented the escapement about 900 years before it was reinvented in Europe, and knowledge of gears made an important contribution to horology which later watchmakers used to their advantage.

SANDGLASSES

Similar in principle to water-powered timekeepers are those which utilised flowing sand to regulate time. No one knows how far back in time the so-called hourglass goes back to, although it cannot have predated the discovery of glassmaking in ancient Egypt; it has not yet been entirely abandoned, being put to use as the humble eggtimer even today. It does not need the sun; it does not freeze; it does not need replenishing; it is not subject to variable pressure; all that it requires is to be turned over to start measuring the allotted time all over again.

The name is a misnomer, for these devices do not always use sand nor do they measure an hour's duration. They might be filled with powdered rock or even crushed eggshells, or sometimes mercury, and measure anything from a minute to several hours. They may have been in use in Alexandria in ancient Egypt in the 3rd century BC, which seems entirely plausible in view of the plentiful supplies of its single ingredient, and were certainly carried by

A Brief History of Timekeeping

Two eighteenth-century sandglasses. (Hampshire County Museums Service)

wealthy Athenians as portable timepieces, much as we carry a watch on our wrists. They were used in churches quite extensively from the Middle Ages onwards to limit the length of sermons in exactly the same way that the clepsydra were employed in the Roman senate, and enjoyed much popularity in Elizabethan England in a similar role in jousting and in debates.

The most useful application of the hourglass was at sea, where they were designed to run for four hours, the length of a watch. Sandglasses were aboard the ships of Columbus when he made his discoveries. Another use aboard ship was to measure the speed in knots: a 28-second sandglass was started and a rope with a log tied to its end thrown overboard and allowed to play out until the sand had run through. The rope was hauled back and the length measured; the faster the speed the more rope was expended. To assist in hauling such a rope back on board, it was knotted at equal intervals, 47' 3" apart, hence the term 'knots'. The mariner merely counted the knots as they slipped through his hands to establish the rate of knots. Hour and half-hour glasses were still used by the navy as late as 1839. Their usefulness at sea was on account of their being unaffected by the motion of the ship – something which a weight-driven device such as a pendulum clock was useless at counteracting.

A curious application of the principle was used in the British House of Commons to time the division bells throughout the building by means of a two-minute sandglass, calling the members to vote.

The main disadvantage of the sandglass is its tendency to clog, and the difficulties inherent on account of the size required in making a glass to

run for more than two hours. It cannot be used to operate a pointer or be attached to a dial.

Incense sticks

These are the Eastern equivalents of the hourglass and were also used at sea to time the watches in the same way. As with all the inventions of mankind, what started as a simple measure became more intricate and ingenious as time went by, so that in a late refinement the burning stick was placed on threads from which were suspended small metal balls. As the thread was burnt through, the balls dropped down into a receptacle below with a clang, thereby announcing the passing of an hour.

Candle clocks

Both waterclocks, hourglasses and incense sticks fall into the category of 'interval timers'; candle clocks are another. In use in the Roman empire, they were extremely simple and cheap, being merely a candle with the hours marked off, sometimes protected from sudden draughts by a lamp. Their simplicity ensured they remained in use even as late as the eighteenth century in Europe.

The story of King Alfred the Great is often related in the many publications on the history of timekeeping. He is supposed to have invented the idea of the candle clock in the nineth century, but that is apocryphal. To implement his vow to divide his day into three eight-hour periods devoted to religious purposes, government and rest, he had candles made with the divisions of the hours marked on them to keep track of the time and the promise. He improved the design, just as did the Romans, by providing the candles with a lantern, made from horn.

Using a similar principle, the Chinese and Japanese used slow-burning ropes, knotted at regular intervals: this was in essence a wick clock. Both these types of timekeeper are known as wastage devices.

Mechanical clocks

As with so many horological inventions, mechanical clocks appear in the pages of history gradually, leaving no epoch-shattering moment when we can say: 'That was how the very first clock came to be'.

However, by general assent credit for the introduction of mechanical clocks is usually awarded to an unlikely figure, a Pope. Born with the name of Gerbert in or around 920AD, he became a monk and studied in Catalonia,

Spain, where he is known to have made contact with the Eastern body of learning, and become acquainted with Arabic numerals some four hundred years before they came into general use in Europe. He made terrestial and celestial globes to illustrate his lectures at the University of Rheims, and is thought to have been responsible for several important inventions, including the first escapement mechanism at the close of the tenth century. When he became Pope Sylvester II his influence over the religious community would have been second to none. Unfortunately, such was the paranoia about science in this superstitious era, he was at once thought to be in league with the devil and for a time even banished to France.

But Gerbert has rivals as the inventor of the clock, both from earlier times and in other cultures, especially China, and it would be quite plausible that the principles which had been discovered through other applications of clockwork and waterclocks evolved in various places independent of each other. Indeed, another authoritative source[1] believes that the story of Gerbert is anachronistic, since the Arab astronomers of Spain at the time had no knowledge of mechanical escapements, necessary for the principles of clockwork to be applied to timekeeping devices. All that may be said with any confidence is that clocks had appeared by the late thirteenth century in the monasteries of Europe, and it may well be that they were first developed in England.

Monastic life was the impetus behind the development of a clock, with its rigid adherence to ritual and prayer both day and night. At some stage, the calling of the hours by bell ringing and calls was mechanised. A true mechanical clock consists of four ingredients: a power source to make it go; a method by which the power was transmitted to the mechanism; a means to regulate that power so that the mechanism operated at a steady rate (the regulator); and audible or visible marker for the hours.

The earliest record of a mechanical church clock in Britain is of one in Dunstable Priory in 1283, which was also possibly the earliest escapement-controlled clock in Europe.[2] Other early records indicate that soon after there were clocks at other religious centres, such as in Exeter Cathedral (1284) and St Paul's Cathedral in London, where a clock-keeper's allowances for 1286 are recorded, indirectly indicating the presence of a clock. Later accounts suggest it had automata known as jacks which struck the hour, but as with

1 Beeson, C. F. C., *English Church Clocks 1280 – 1850*.
2 Beeson, op. cit.

Westminster Hall clock in 1698. (Beeson)

all early clocks, no dial: it was an entirely audible device. The very word 'clock' is derived from the German word 'glocke', meaning a bell. Another early clock, sometimes cited as dating from 1288 but now thought to have been made in or just before 1365, was in Westminster in a clock-tower opposite Westminster Hall, also in London. This one had chimes, and an inscription from Vigil, reading 'Learn justice from my advice'. Its bells were gambled away by that practised plunderer of our national treasure, Henry VIII, although it must be noted in fairness to his legacy that he otherwise took a keen interest in horology and had a large collection of clocks.

The accolade for being the earliest clock still in existence must by general acclaim go to Salisbury in England. It dates from 1386 and may have been constructed a few years previously. Some of the original machinery has been rebuilt, and like those described above is of a type known as a turret clock, an extravagantly expensive piece of machinery intended to serve (or control) an entire community from its installation in a prominent and powerful religious institution such as was the medieval church. The Salisbury clock has no dial, nor even an hour hand, as its function was essentially a mechanical bellringer, as is to be expected from this period.

Early clocks were a product of the blacksmith's art, fashioned from wrought iron and a natural extension therefore of the craftsman's work of making tools, implements of husbandry, ironmongery and other metal items. Every piece would be painstakingly constructed in the forge, every

Turret clock mechanism in collection of Willis Museum, Basingstoke. (Hampshire County Museums Service) (see colour section)

gear wheel tooth filed down by hand. Clockmaking would later become the province of the locksmith; only in the sixteenth century was clockmaking regarded as a separate art, by which time screws had been introduced: previous to this the parts were connected by wedges and nuts. These clocks neither aimed for nor achieved great accuracy, and when they were fitted with a hand there was only one – the hour hand. It was not until the seventeenth century that the accuracy of clocks had improved to such a degree that they could be fitted with minute hands and by 1660, seconds hands were added with the introduction of the pendulum. When dials were first used, likely to have been in the fourteenth century, they were made to look like the dial of a sundial, being rotated against a fixed gnomen, just as early cars imitated their predecessors, the coach. Indeed, these first clocks were set daily from sundials, and this continued to be the case for hundreds of years. The clockwise direction of the hand also imitated the shadow's progress on a sundial (in the northern hemisphere; if clocks had originated in the southern hemisphere it is probable they would have reversed the direction). Dials were at first fixed on the inside of the clocktower, not until the following century were they designed to be read from outside.

The turret clock rapidly caught on, for it fulfilled an important role in the community, particularly when the addition of dials and hands increased their significance beyond the limited initial role as prayer-alarms. They were often also being fitted in the turret of the market house as well as on

Christchurch the Fusee Chain Gang

the church spire. They were capable of endless elaboration and decoration and became a source for much civic pride, as well as a means by which the populace could be subjected to increased control by the Church or state.

Christchurch Priory records do not go back very far, old ones having been lost. The earliest of the surviving churchwardens' accounts, from 1704, records a payment to John Colgill 'for Looking to ye Clock and Cheems & Ringing ye Bell, £4 0s 0d'; in the same year 'Oyle' and leather were paid for it. This entry demonstrates that the chimes were regarded as a separate piece of machinery to the actual clock mechanism. Chimes indicate that the quarters were struck. Volatile oil soaked into porous leather and left in the mechanism would steadily evaporate and provide 'automatic' lubrication. The early clock was replaced in 1837 by one made in Clerkenwell. Its importance to the community is apparent from the howls of indignation which correspondents were wont to fire off to the press whenever the chimes were silenced or the hands stopped.

The foliot and verge escapement was employed to control the movement of early clocks for almost four centuries, from its first use in the late thirteenth century. The illustration is of this mechanism as used in a famous clock in Paris made by a clockmaker called De Vick in 1379. This particular clock did have an hour hand, and was driven by a huge 500lb weight. The verge is the vertical shaft, the foliot is the horizontal bar fastened across the top of it, with small weights at each end. The crown wheel, driven by the weight, has teeth, which turn against two small pallets on the verge, making it oscillate. The combined effect of these devices is to control the falling weight, slowing it down and regulating its speed. This foliot turns alternately from one side to another, as the verge oscillates, thus producing the classic 'tick-tock' of a clock in operation.

Above: Foliot and verge. (Brearley)
Right: De Vick's clock. (Brearley)

Wimborne Minster astronomical clock.
(see colour section)

Galileo's mechanism reconstructed. (Hampshire County Museum Service) (see colour section)

A beautiful clock over six hundred years old can still be seen at Wimborne Minster, not far from Christchurch, made at almost the same time as De Vick made the clock in Paris. This is a variety of turret clock known as an astronomical clock, or one which showed the movement of the sun, moon and the five known planets. Note that the earth is placed in the centre, with the sun and moon orbiting around it: a reminder of the astonishing fact that the medieval mind, whilst able to think up the ingenious verge and foliot escapement and construct exquisitely beautiful clocks, still laboured under mistaken beliefs about the true nature of the solar system. More than a century was to pass before Copernicus' great discovery revealed the truth to a world deeply resistant to the concept of not being at the centre of God's design. The sun symbol acts as the hour hand. The dial is thought to be original although the case is later, made from a sixteenth or seventeenth century organ case.

As mentioned, De Vick's and other turret clocks were driven by a huge weight, making them cumbersome and entirely unsuitable for uses other than being incorporated in substantial tall buildings, such as the tower of a church, except in exceptional cases. How the clock mechanism came to be refined so that it could have more widespread use is down to the efforts of two brilliant minds, those of Galileo and Christaan Huygens.

As a young man of seventeen, Galileo, in 1581 or thereabouts, was

standing in the cathedral at Pisa when the swinging of a lamp in a draught caught his attention. Caught in little eddies of air or stronger gusts, it rocked mesmerically before the fascinated gaze of the attentive onlooker, who noticed that no matter whether the lamp was swung from the vertical by a forceful or weak blast of air, the arc through which it swung appeared always to take it the same amount of time. A puff of wind caused it to swing slowly; a sudden gust speeded it up; it then went farther but in the same amount of time. Galileo was watching a natural pendulum. He never applied his discovery, although towards the end of his life, when old and blind, he dictated to his son instructions about how the effect could be utilised in a clock as a regulator. The son, Vincenzo, never completed the intended clock; indeed, he died only seven years after his father.

It was left to a Dutch scientist and astronomer, Christaan Huygens (1629-1695), to patent the invention, which he did on Christmas Day 1656, although he did not successfully apply the principle to clocks. The pendulum made timekeeping by a mechanical clock a far more precise art, whether in a clock driven by weights or their smaller spring-driven versions which had become common by the close of the previous century. The driving train of the clock gives impulse to the pendulum, which then controlled the rate of the rotation of the wheels within the clock mechanism. Since the length of the pendulum determines the speed of its swing, the weight or bob at its end could be adjusted to control it and through it the accuracy of the clock. It was an invention which revolutionised the design and importance of clocks, especially when an improved escapement – the anchor escapement – was invented by an Englishman, Dr Robert Hooke, in 1676 (although some attribute it to others at a slightly earlier date). He was another of the considerable number of remarkable men who have contributed so enormously to horology. He was an architect, astronomer, mathematician and inventor; one of his inventions was a fire engine: he would have all too clearly remembered the Great Fire of London in 1666. The new escapement meant that longer pendulums could be employed, greater control over timekeeping achieved, and the longcase or 'grandfather' clock was born. The pendulum increased the accuracy of clocks to such a degree – from about 15 minutes per day at best to about ten seconds – that it became possible to include a minute hand on the dial.

The pendulum continued to be further refined: an associate of the greatest of all English clockmakers, Thomas Tompion, by the name of George Graham, invented the deadbeat escapement in 1715, an improvement on the

Left: anchor escapement. (Brearley)
Above: deadbeat escapement. (Brearley)

anchor escapement which further increased accuracy to within about one second a day, and another horological genius, about whom more below, John Harrison, overcame the problems inherent in the changes in temperature on the metal used (resulting in expansion and contraction) with the gridiron pendulum which he invented in 1726. This kept the effective length of the pendulum constant, no matter what the temperature.

John Harrison, probably above all other horological geniuses with which the science abounds, must go down in history as the single most memorable, determined and inspired of all of them. Born in Yorkshire in 1693, he was trained as and worked as a carpenter and had no formal training in astronomy or clockmaking of any kind, being entirely self-taught. He dedicated his adult life to the attempt to solve what is known as the longitude problem, in which after half a century of effort, he was finally to succeed.

This navigational problem was considerable. Charting a course across the oceans in this age of burgeoning trade and discovery was accomplished largely by reference to the stars, from astrolobes (which showed the position of the stars at different dates and latitudes), maps or globes. Latitude was only one of the two coordinates needed at sea to discover the exact position. Without accurate knowledge of the longitude, many lives, vessels and cargo were lost annually. Finding the longitude position depended on knowing the difference between local time aboard ship, as calculated astronomically, and the time of a known reference point, such as Greenwich Mean Time. The latter required a timekeeping device which could keep GMT accurately at sea. No existing clock could cope with the instability of conditions at sea.

Such was the economic importance of overcoming the problem that several governments offered huge cash prizes for anyone who could solve it. In the reign of Queen Anne, in 1714, the British Government offered £20,000 (at

least £1 million today) to the inventor who could create a timepiece which could be used to determine longitude accurately to within half a degree in a voyage to the West Indies and back.

John Harrison, in his efforts to win the prize, pitted himself against eminent astronomers and establishment prejudice to win the prize from the specially commissioned Board of Longitude, although he had one influential ally at least, in George Graham, clockmaker and inventor of the deadbeat escapement, who to some extent backed his efforts financially. In a classic case of moving goalposts and his own drive for perfection, he struggled on through four versions of his invention, named H1 to H4, in which he was ultimately successful. But it took an Act of Parliament to grant him his just desserts, which were withheld by the hostile Board, which event took place in 1774 only two years before his death, an exhausted man. H4 had proved in its final trial to be accurate at sea to one tenth of a second a day, saving lives, and thereby giving Britain a huge economic advantage over its competitors for trade and power. Unlike the previous timepieces made by Harrison to this end, H4 was a watch and not a clock or larger machine, and has been described as probably the most important timepiece ever made.

A copy of the final version, H4, was taken by Captain Cooke and used to chart the South Sea Islands; before long this marine timekeeper was developed by others, notably John Arnold and Thomas Earnshaw, and the chronometer was born, later to provide vital technological breakthroughs in the development of the watch.

From a position of trailing behind Continental clock and watchmakers, the invention of the anchor escapement and the balance spring (by Dr Hooke once more) put England very much in the vanguard, a position which it maintained until the mid-eighteenth century, thanks to the brilliance and skill of its inventors and craftsmen as outlined above.

WATCHES
To chart the story of the increasing miniaturisation of clocks, eventually into the form of a watch, we will have to backtrack nearly 300 years before the development of the chronometer to which the watch was so indebted. During those three centuries, the horological 'baby' transmogrified from bauble to serious timepiece.

In contrast with the contested and obscure accounts of the origins of the first clock, the first watch is usually claimed to have appeared at a precise date and place, associated with another of those gifted and creative minds

who are behind so many of the great strides forward in the history of timekeeping. In reality, it was bound to have been a product of several small advances of which one person took advantage.

The credit goes to one Peter Henlein of Nuremburg, in around 1500, a 'clever and comparatively young man' it is recorded in 1511, who 'creates works of art that are the admiration of leading mathematicians for, out of a little iron, he constructs clocks with numerous wheels which ... indicate the time and strike, and which can be carried on the bosom or in the purse.' The watch itself does not survive, but what must be a similar one, made of iron as was Henlein's, may be seen today in a German museum. It incorporated a mainspring and had a single hour hand and would have been accurate to within about twenty minutes a day.

Nuremburg was a fine medieval city, and the era was one of transition between the medieval and modern period. Peter Henlein's watch would have utilised his no-doubt finely honed skills as a metalworker, and all the individually made parts put together with pins and rivets. It was driven not by weights but by a mainspring, tightly coiled, a feature which had been known of in clocks in the previous century. He continued to make watches, in characteristic oval shaped cases, known as 'Nuremburg eggs'. They were very heavy, especially having been fashioned from iron, quite large at about six inches (15cm) in diameter, and had to be hung from a belt.

The unwinding of the coiled spring, the motive force for the complex interlocking sets of wheels which make the watch mechanism work, was initially achieved in these early German watches by a device called a stackfreed. As a spring unwinds, the force it exerts steadily decreases; the stackfreed evened out this force.

Stackfreed

Mainspring Barrel and Fusee

Stackfreed. (Brearley)

It is at this point in this little history that the fusee was incorporated in watches, superseding the stackfreed as a superior solution to the regulation of the mainspring, and which is more fully described in Chapter 5. In clocks, the fusee and the spring were used to replace the weights, enabling them to be placed on tables or mantelpieces. In the construction of watches, the incorporation of the fusee enabled this new mode of timekeeping to be well and truly launched. The use of brass as the main metal in place of iron, with its non-rusting property and propensity for being finely worked, the switch from rivets to screws in the mid-sixteenth century and then crystal covers over the dial soon afterwards, and the routine addition of a minute hand over the following century, all served to further the development of the watch.

To set the introduction of the fusee into its context, it appeared in a world which had just become aware that it was a sphere and not flat; America had only recently been discovered; the printed book was yet an expensive novelty and everywhere in arts and science new ideas, inventions and discoveries were illuminating the medieval mind, for this was the age of the Renaissance.

Much had yet to be done before the watch was as accurate as contemporary clocks or the common pocket sundials. In Shakespeare's day at the close of the sixteenth century they were not highly regarded in this respect:

> A German clock,
> Still a-repairing, ever out of frame,
> And never going right, being a watch –

was his view (*Love's Labours Lost*). Beautifully crafted and ornamented, but as a timepiece, next to useless.

However, the development of the coiled balance spring in the seventeenth century, once again by the Dutch scientist Christaan Huygens, and improved methods of escapement, from verge through cylinder then detached lever, together with the introduction of jewels in the movement to vastly improve its running, eventually combined to overcome much of the inherent inaccuracy of the watch.

Watches nevertheless remained extremely expensive items, the number of parts from which it is comprised amounting to an astonishing 138 pieces, most of which were made by specialised craftsmen, so that one single watch might have parts in it contributed by up to forty artisans. The gears alone

Early watch c. 1575, probably made in Nuremberg: spring-driven with stackfreed. The hours are divided into quarters. Note the single hand visible in left image, pointing at 9.15. (Hampshire County Museums Service)

might be made by up to six different people and the entire watch would take weeks to construct from start to finish. The role of the watchmaker was to assemble the various separate pieces, which in itself could take fifteen working days. The craft of watchmaking in England became second to none; watchmaking centres sprang up in Clerkenwell in London, Coventry and Liverpool, employing enormous numbers of highly skilled craftsmen.

However, the watch as we know it today could not have developed under these conditions; they would have simply remained unaffordable to the masses. By the commencement of the nineteenth century, the pace of change accelerated with the advent of the machine age. Britain, as far as craft industries were concerned, was slow to change, whereas the New World and Continental countries, especially Switzerland, were pioneers in embracing and developing new technology. Both that country and America developed automated systems to produce the watches in what must have seemed quite fantastic numbers to their English counterparts. In Switzerland, the country which developed the fusee, and also the going barrel which eclipsed it, the watchmaking industry had by 1840 levelled with that of Britain and then impressively outstripped it. In 1800, and 1850, English watchmakers produced 200,000 watches; in the same period Switzerland's production soared from that amount to two million annually. A century later, it was producing some 45 million watches per year.

Meanwhile, in America by 1892, mass-production techniques whereby

a watch was made under the one roof, had brought the price down to one dollar, the week's wage of the average industrial worker: this was the famous dollar watch of Robert Ingersoll. This watch was one that we would recognise today, worn on the wrist, not carried in pockets or hung from a chain on the chest, a development which the First World War and the considerable military importance of providing the common soldier with a readily available and accurate timepiece did much to promote. American watch production in 1900 was nearing three million, against England's quarter of a million.

The twentieth century saw the end of the English watchmaking industry on a large scale, overwhelmed by cheap imports of these mass-produced watches. Whilst valiant efforts were made to reorganise and become more competitive, it was too late; Coventry is typical of other watchmaking centres in finally accepting defeat in 1930, when watch production ceased.

The story of modern watch and clock technology, through the introduction of quartz movements to the caesium atomic clock and the research being carried on today into the 'ion trap' time standard, which will measure time to the incredible accuracy of one second in ten billion years – or the entire lifespan of the universe as it is currently believed to be – is beyond the scope of this brief history.

CHAPTER FIVE

THE FUSEE AND THE CHAIN

Fusee, fuzee… [a. F. *fusee*, primarily spindleful of tow (: – med. L. *fusata*, f. L. *fusus* spindle); hence used for spindle, and in sense 2 – 4 below…]
1. A spindle-shaped figure: = FUSIL…
2. A conical pulley or wheel, *esp.* the wheel of a watch or clock upon which the chain is wound and by which the power of the mainspring is equalised.
1622 in *Naworth Househ. Bks.* 199 Making a fussie to my Lords cloke. **1658** S CROOKE *Div. Char.* 1. ix. 82 This is the first wheel, yea, the Phusee, the inward spring that moves his watch so swiftly. **1677** HALE *Prim. Orig. Man.* 1. ii. 50 In the Watch…the reason of the motion of the Ballance is by the motion of the next Wheel, and that by the motion of the next, and that by the motion of the Fusee. **1713** *Lond. Gaz.* No. 5155/4 A Gold Watch … going with a Spring, without Fusey, Chain or String. *c.* **1790** IMISON *Sch. Art* 11. 284 From the fusy to the balance the wheels drive the pinions. **1824** R. STUART. *Hist. Steam Engine* 146 Chains acting on a spiral in the manner of a fusee. **1827** FARADAY *Chem. Manip.* iv. 112 The mouth at this time represents the going fuzee of a chronometer. **1884** F. J. BRITTEN *Watch & Clockm.* 108 In modern watches and clocks the fusee is furnished with maintaining power to drive the train while the fusee is being turned backwards during the process of winding.

Fusee with chain in place in nineteenth-century clock mechanism. (Hampshire County Museum Service)

With this definition of fusee the Oxford English Dictionary gives both a derivation of the meaning of the word and almost a potted history of its usage.

The earliest known use of the fusee is in a clock belonging to the Society of Antiquaries. It bears an inscription on the barrel of the mainspring which on translation reads: 'When we had reached 1525, Jacob the Czech made me in Prague – 'tis true.' The clock was a gift from the King of Poland to his wife at the time.

A learned paper on the clock[1] argues that Jacob, usually styled Jacob Zech, was utilising the ideas of another, and that other person was none other than Leonardo da Vinci (1425-1519), whose sketchbooks from around 1485-90 contain several drawings of a fusee. Leonardo was at the court in Milan at the same time as the wife of the Polish King, she being the daughter of the Duke of Milan. Jacob may have known him directly through the University of Prague's contacts with other great centres of learning, such as Florence or Rome, or indirectly, through the Polish queen. The drawing did not, though, relate to clockmaking.

As the writer concludes, 'we shall probably never know' if the fusee principle was inspired by Leonardo or not. In fact, it could date back earlier: one Paulus Alemanus referred to the device in a manuscript of 1477, another horological writer[2] claims, a view supported by other writers who date the invention of the fusee as far back as 1400,[3] a date which precedes the birth of Da Vinci. Whenever it first appeared, its horological use in watches had become widespread by the late seventeenth century.

The fusee was initially controlled by a gut line. This regulated the unwinding to some extent, but being a natural material, was subject to stretching and therefore uneven unwinding. A steel chain was also, size for size, much stronger than gut and so could be made far thinner. This in turn allowed watch plates to be mounted closer together, thus reducing the overall size of the watch. Another advantage of a metal chain was its flexibility in one plane only. The accolade for the substitution of gut by a chain goes by general assent to a man by the name of Gruet, originally from Geneva but living in London at the time, about 1664. Once again, this is not without contention, as earlier examples of these chains exist.[4] Such early

1 Lloyd, H. Alan, *The Origin of the Fusee*; *The Antiquaries Journal*.
2 Slee, Ivan , *The Chain Makers*; *Antique Clocks Magazine*, December 1989 No. 7.
3 Wells N. M. and Lipincott K., *Moments in Time*.
4 Slee, Ivan, op. cit.

The Fusee and the Chain

Fusee chains for watches and clocks, with section of steel strip with links punched out. (Hampshire County Museums Service) (see colour section)

chains had much longer links than later chains.[5] 'What is certain is that the first ones were made in England, and that the best examples still come today from this country,' an early authority boasts.[6]

Before chains were made in Christchurch, they may have been imported from the great watchmaking centres of Switzerland. In 1750, according to a census, there was one chainmaker at Le Locle and two more in Chaux-de-Fonds; in 1756 the two valleys in which these towns are situated produced more than 15,000 watches, and thus must have been able to manufacture, with just these three people and out-workers, the same number of fusee chains – each year.[7] 'Trade between Switzerland and England was considerable in the eighteenth century, and Swiss fusee chains may well have been a significant import during the period before 1790,' concludes one authority.[8] The same writer found that fusee chains were made in the central watchmaking town of England, which was Prescot in Lancashire, in 1795, but notes that by the middle of the nineteenth century, no record of chainmaking is found in or around the town, despite the existence of almost 300 small workshops.

In the middle of the eighteenth century, the celebrated French philosopher

5 Britten, F. J. *Watch and Clockmakers' Dictionary and Guide.*
6 Diderot et D'Alembert *Encyclopedie ou Dictionnaire Raisonne des Sciences, des Arts et des Metiers, par une Societe des Gens de Lettres.*
7 Weiss, Leonard *Watch-Making in England 1760-1820.*
8 Weiss, op. cit.

Diderot's *Chainetier*. (Courtesy The British Library)

and writer, Diderot, produced a massive 28-volume encyclopedia of trade and manufacture, each superbly illustrated by carefully drawn engravings of the processes involved, and accompanying text written by the experts of their day. One of those manufactures was chainmaking, and below this is reproduced in translation the description of the process supplied to Diderot by Soubeyran, a Geneva watchmaker, with additional annotation derived from Weiss, with each stage illustrated. Diderot's opinion was:

> This invention of the chain is attributed to a Mr Gruet from Geneva, living in London.... In conclusion, the person behind this invention, by overcoming the inconvenience of using gut twine, did a great service to clock-making.

CHAINMAKING

The illustration on page 114 is of the interior of a chainmaking workshop, where a variety of chains were made as well as clock chains. There are several workbenches and cupboards for holding the chains.

A craftsman is using a wire cutter to cut the iron or brass wire into suitable lengths to make the links. The other craftsman is working on bending the cut wire lengths to form the chain links.

Figures 11, 12, 13, 14, 15, 16, 17 show chainmaker's tools: from left to right: triangular file for cutting thick iron wire; round pliers for bending the links; wire cutters; tweezers; flat-nosed pliers; cutters; anvil horn.

Figure 19 is part of a workbench with a small anvil, cutters, tongs or pincers, and the vice on which the links are held as they are made.

In the subsequent plate, Monsieur Diderot illustrated specific techniques for making the chains used in watches and clocks. Minute though the product was, he said, a very large number and variety of operations was required to manufacture it, such as: punching holes in thin sheets of steel; filing down the rough edges of the holes; punching holes again; cutting the links; making the hooks; making the rivets; riveting the links; buffing the chain; filing the chain and reshaping the little links; tempering; polishing. These processes are illustrated on the next pages.

Diderot's *Chainetier*. (Courtesy The British Library)

The Fusee and the Chain

Figure 1 displays a single link viewed from above, end-on and in perspective.

Figures 2-5 show the next stage, the completed chain: a series of links joined into a chain viewed from above, end-on, exploded diagram and in perspective. From this it can be seen that two rows of links sandwich a third in the middle, straddling the joins of the outer sets of links. The three sets of links are held together with pins, forming rivets on the outside.

Figure 6 illustrates a clock chain, made of five rather than three sets of links.

Figure 10, punching out the holes: another die block held in the vice and the hammer and hole punch above, for making the double sets of holes in the links. The steel-tipped hammer would be brought down sharply on the punch. Next, one end of the punch would be placed in a hole just made, to gauge the next hole to be stamped out, and so on, one hole at a time. Once the entire sheet was punched, the second row was begun parallel to the first row, and so on until the sheet was completed. The rows of holes had to correspond to the size of the links to be cut. After the steel sheets had been punched once with the rows of holes, they had to be filed smooth to remove the rough edges around the holes. Naturally, this had the effect of partially blocking the holes. The sheet therefore had to be repunched from the other side, using just a gentle tap from the hammer, a punch with a single point having been exactly inserted in the original hole.

Figures 12 and 13 show how the holes for the hooks are cut. The hooks are cut from the same thickness of steel as the links. They are punched out with the punch, A, each time placing one of the points of the punch in the last hole made. The procedure would be done on a die block with the hook shape cut out of it. The punched holes would need to be smoothed and repierced in the same way as were the links.

Figures 7 and 8 illustrate a die block on which the steel sheet will be laid with a punch or cutter above it for stamping out the links. Through it has been cut a hole of the size required for the link to be cut and the punch will be of exactly this size. The steel sheet will be positioned between the two so that each link will have a pair of holes in precisely the required place. The cut links will fall into the hole in the die, which is slightly larger at the base of the die than on the surface to permit the link to fall into it. The links are collected in a small container held under the die block.

Figure 9, cutting out the links: the sheet of metal with the holes punched has now been laid on the die, the side that has been filed smooth face

down, ready for the links to be punched out.

Figure 11 indicates the various tools used to cut the links. FG is a very small anvil (about 2″ long) which is held in a vice. DE is the die block in the groove of the anvil. The groove is designed to ensure that sufficient force can be used to stamp out the links with the punch, AB; ef is the arm of the punch; bg is the cutter firmly fixed to the arm. The punch has been fitted into an aperture in the anvil. L is the shoulder on the punch for holding the cutter head tightly. The link cutting explained in Fig. 7 is performed whilst the steel sheet and punch are set up in this way so that the procedure achieves the precision required. The operator would hold the punch in the hand, lifting it up and down to bring the cutter onto the sheet of steel on the die block beneath.

Figure 14 and 15 (no.1) demonstrates the steel wire used to make the pins. The wire, which is resting in a groove on a block of bone or boxwood held in a vice, is being sharpened to a point, tightly held in pincers which have a screw (EF) to tighten the grip. The fusee chainmaker would hold the pincers in one hand and a file in the other to sharpen the wire.

Figure 15 (no.2), on the right is the hook and on the left the link, being linked. This is done by the fusee chainmaker threading the links and hooks as shown, holding two links on a pin and another between the finger and thumb of the right hand, inserting that one between the two other links and lining up the holes. Once aligned, the pointed tool is removed, the chainworker keeping the set of three links tightly squeezed in the right hand, and then picking up a pin and pushing this through the aligned holes.

Figure 16, a link and a hook are held on the pointed wire in a vice, performing the above operation with the aid of a vice rather than the finger and thumb, to exert more pressure.

Figure 17, a pair of tweezers holds the wire so that a light tap of the hammer may drive the pin through the holes of the three links.

Figures 18 and 19, the link and a hook held with the wire through the holes are held in the jaws of a pair of wire cutters and the end of the wire pinched off. The second diagram shows the spaces around the edges of the holes in the links later to be filled by the pin heads.

Figure 20, these small cavities are being filled with the pin heads: the chainmaker lays the links on the vice and taps the end of the pin, a, gently and repeatedly until it fills the cavity, and does this each side of the link. This procedure comprises the riveting.

Figure 21, the chain is now continued by the fitting of more links.

The Fusee and the Chain

Diderot's *Chainetier*. (Courtesy The British Library)

Figure 22, the little chain being furbished by a file or polishing buff, AB, held in the vice; EF are handles attached to the chain hooks to do this operation, the operator gently pulling on the handles alternately to slide the chain backwards and forwards on the file.

Figure 23, the edges of the chain are next being filed (DN is a cross-section of the file). The chain is hooked onto a wooden cylinder, fixed in a vice, and held taut with the right hand. The file used is an ordinary hand-held fine file, used to smooth the edges of each pin in the chain.

Figure 24, polishing the edges of the chain against a fine round file held firmly in the vice.

Figures 25–27, flaws and irregularities arising from the filing of the pins and the edges of the chain are being removed with a furbishing file held in a vice. The chainmaker places the chain in a notch on the file and lightly files it with the hand-held file (Fig 26). More of the same process is next done, using a file with tapered edges.

Figure 28, the chain is now tempered, which is done by winding it around a blow-pipe and holding it over a candle flame until it is red-hot. It is then dipped in oil, returned to the flame and tempered by the oil being set alight and the process repeated (a highly skilled operation).

Figure 29, the chain is taken out of the oil and polished; AB is a small piece of oiled dogwood. The oil would be mixed with powdered turkey-stone or putty powder.

Figure 30, diagram of the hook at one end of the chain attached to the barrel. AB is part of the circular rim of the barrel; b is the hook.

Figure 31, the hook attached to the fusee: DG is part of the edge of the fusee and a is the little cylinder which the hook is gripping.

The foregoing applied to the larger clock chains; it must be appreciated, particularly with regard to the diagrams showing the chain worker's hand holding links or other components, that the parts for watch chains were infinitesimally smaller.

The number of links in a chain varied, sometimes according to the whim of the chainmaker; in particular, time and money could be saved by making chains with fewer but longer links, but these were of lower quality.[9] One horological source[10] states the standard chain length was six inches, a length which would consist of an astonishing 630 separate pieces, based on a

9 Weiss, op. cit.
10 Wood, E. J. *Curiosities of Clocks and Watches From the Earliest Times.*

The Fusee and the Chain

calculation of 63 links and 42 rivets per inch. The particular skill of the chain design was that the finished chain had also to fit into the grooves on the fusee; a very fine fusee with a correspondingly fine chain would be needed for a watch that was not to be bulky. The grooves were square-cut, as opposed to the rounded grooves required for a gut-driven fusee barrel.

The census returns for the Christchurch fusee chainmakers show how they specialised in the various operations described above, some being wire-makers or wire-drawers, others riveters, hook makers, polishers and finishers. A contemporary account of the skills required was nevertheless scathing:

> The chains are made principally by women, who cut them at a certain, and a small, price per dozen. It requires no great ingenuity to learn the art of making watch-chains; the instruments made use of render the work easy, which at first sight appears difficult.[11]

The dies and presses were made by toolmakers and smiths, also listed in the census returns, as is a mechanic.

The invention of the going barrel, needing neither fusee cone nor chain, caused the eventual abandonment of the fusee: 'It is sometimes said that the English addiction to the fusee contributed to the decline of its watchmaking industry; be that as it may, the principle is still cherished and employed in high-grade clocks, and especially in ship's chronometers.'[12] At the height of the Christchurch chain manufacture, it was already becoming a redundant method of regulating the mainspring, which was adapted to compensate for the fusee being dispensed with altogether.

The Swiss had began to make a mainspring which was far lighter than those used with the fusee, yet just as strong, and by introducing jewels into

Going barrel. (Brearley)

11 *The Book of Trades*.
12 Slee, Ivan, op. cit.

the mechanism the spring needed little power to operate; only the middle part of the mainspring is wound in the going barrel. The pressure remained equal in the spring; no regulation of the unwinding was required; the fusee was no longer necessary. Because of this technological advance, by the 1870s it is recorded that half the tools of English watchmakers were in pawn[13]; by 1894 soup kitchens were set up to relieve the distress in the great watchmaking districts of Coventry. By clinging to the old, craft methods of watchmaking, including the use of the fusee when it had been superseded by cheaper technology, Britain not only lost its world lead in the industry but never recovered from the devastation experienced in the trade. It is an interesting thought that for half the period in which chains were manufactured in Christchurch, better technology existed; the town was producing outmoded technology.

After many decades during which no chains were manufactured, the process was revived and refined in the twentieth century by a Gloucestershire clockmaker, Jim Habgood, who commented:

> The chainmakers of Christchurch were certainly skilled, and those among them who made the very small tooling were highly skilled. I think that most horologists look at a fusee watch chain as a very clever achievement of micro-engineering, perhaps a touch of magic. Almost incredible … the chain is a wonderful achievement and is proof of the dedication and skills of that early breed of workpeople.

Having made all the tooling required, Mr Habgood improved the procedures by making the centre link hole larger than the outer ones, thereby removing the requirement to adjust the rivets, having also the advantage of a cam-operated automatic lathe to produce the rivets: 'I cannot claim to have invented any new techniques, but I had the advantage of having an automatic lathe together with improved machinery for making the tools,'[14] he modestly asserts. As a watchmaker, he had come across many fusee chains, the smallest of which measured just 0.22mm wide by 0.5mm high – or nine thousands of an inch by twenty thousands in imperial measurements. Despite these minute proportions, some of the chains, he advises, would have been even smaller. At the other extreme, the largest clock chain he measured was 2.1mm wide by 2.8mm high, of the five-link construction featured in Fig. 6 above.

13 Brearley, Harry C. *Time Telling Through the Ages.*
14 Personal communication.

Mr Habgood made the chains in his retirement, to fill a gap in the market for the repair of high quality fusee clocks and watches, which were otherwise being mended with simple wire instead of chain.

A Christchurch fusee chainworker was interviewed in her very old age in 1967, and her memories are included in Chapter 6. Her recollections of the way in which the chains were made in practice is an interesting counterpart to the textbook procedures detailed above, but indicate that in the century and a half since Diderot wrote his great work and her own working life in the industry, his *Chainetier* section remains a faithful record of the processes involved in making fusee chains.

Chainmaking skills, although eventually redundant, did not completely die, being frequently adapted to the manufacture of other machines which were coming into their own, fortuitously, at the end of the Victorian era, such as sewing machines and bicycle chains. This is precisely what happened in Christchurch, as Chapter 6 relates, although no part of the process would in this case be done seated at the cottage windows as fusee chainmaking had so for so long been done, and the industry had long passed out of living memory.

GRIMSHAW, BAXTER & J. J. ELLIOTT LTD.

WATCH FUZEE CHAINS

Length					Nos.	8-9	10-11	12-13	14
6½ins.	each	3/-	3/3	3/6	3/6
7½in.	"	3/-	3/3	3/6	3/6
8½in.	"	3/-	3/3	3/6	3/6

Marine Chronometer Fuzee Chains. 2-day, each 13/6 ; 8-day, each 20/-

CLOCK FUZEE CHAINS

Best quality. London made.

Stock sizes	4ft. 3in.	4ft. 6in.	4ft. 9in.	5ft.	5ft. 6in.	6ft.
Each	5/-	5/6	6/-	6/3	6/9	7/6

These chains are specially made for our own dial work.

CHAIN HOOKS

LONDON CHAIN HOOKS, FOR BARRELS, ASSORTED.

Progress watch chain hooks, barrel and fuzee, ready shouldered.
per gr. 5/-

Clock chain hooks, barrel and fuzee.
per doz. 3/6

Watch chain rivet steel
per doz. coils 1/6

Fusee chains were still being made in London in 1928.
(courtesy Jim Habgood)

CHAPTER SIX

THE CHRISTCHURCH CHAIN MANUFACTURERS

> Christchurch is the only place in England which contains manufactories of fusee chains for clocks and watches; all the necessary implements for the work are also made in the factories, giving employment to a large number of hands.[1]

At the time the above statement was made (1877), all three fusee chainmaking concerns in the town were in operation. Only one of these was part of a wider horological business. A quarter of a century later, all three firms had ceased to trade. Cox and Co, Jenkins and Co, and William Hart and Co: here are their stories.

Cox & Co. c. 1790-1885

The man credited with establishing the fusee chain industry in Christchurch was Robert Harvey Cox, the son of a master mariner improbably residing inland at Wimborne Minster in Dorset. His mother was Jenny Cox, nee Harvey, the illiterate daughter (signing her will with her mark)[2] of Robert Holloway Harvey, a yeoman of the hamlet of Muccleshell in Holdenhurst, a stone's throw from Christchurch itself. Jenny (or, as spelled in the parish register, 'Ginny') Harvey, was born in 1731, and married the mariner, Robert Cox. Their marriage is not recorded at Christchurch, Holdenhurst or Wimborne, but their first known child was born in the mother's home village of Holdenhurst and baptised as Robert Harvey Cox on 29 October 1754; two sisters and a brother, William, followed, all born in Wimborne.

Robert Cox appears to have been a wealthy man from a family with

1 Eyre Bros, *The Watering Places of the South of England*.
2 Although a 1765 bond bears her signature, my argument is that it was done for her; the ability to write once learnt is not forgotten.

Baptism of Robert Harvey Cox (last complete entry) in Holdenhurst.
(Hampshire Record Office 9M75/PR1)

connections with the great port of Poole in Dorset, a few miles from Wimborne where the family lived. Apart from being a master mariner he was also the owner of one or more ships, possibly involved in the important and lucrative Newfoundland fish trade. Unfortunately, the source of his undoubtedly substantial income was also the cause of his untimely death at the age of about 35, when he was lost at sea, leaving his young widow with Robert Harvey as the eldest child, aged just ten, and three other small children to raise alone – one of whom may not yet have been born.

Jenny Cox at once had to draw up letters of administration because her husband had died not only unexpectedly but intestate: the bond she entered into in that regard in 1765 was for the enormous sum of £1,400, which she would forfeit if she did not have a complete inventory drawn up as the court required.[3] The inventory unfortunately does not survive, but is likely to have been impressive. The family home was in King Street, opposite the minster, and the family memoirs recall it as a heavily timbered house with an oak dado and flooring, restored by the Dorset Building Preservation Trust in 1990 and believed to be the oldest house in the town of Wimborne.

3 DRO WM/A 1765/14.

The Cox family house in Wimborne Minster. (see colour section)

William Cox, by Frederick Buck, c. 1797. (courtesy Wemyss, Australia) (see colour section)

Jenny Cox ensured that both sons were educated at the long-established Queen Elizabeth's Grammar School in the town. Once their education was complete, one son, William, pursued first a military and then a maritime career as his father had done, although an early connection with clockmaking will be mentioned later. In the maritime capacity he took charge of the convict ships transporting those condemned to transportation and virtual slavery in Australia, mainly for petty crimes. The mortality rate on the ships was high, but he is remembered for ensuring that his human cargo arrived in perfect health. He eventually settled in Australia and became a builder, building jails amongst other projects – sometimes using convict labour as was common, but again is given credit for rewarding their hard work with the prospect of being given their freedom once the task was completed.[4]

Why the young Robert became a clockmaker and the initiator of the fusee chain manufacture locally is unrecorded; but we do know to whom he was apprenticed, which was one John Norman, a clockmaker in Poole. The apprenticeship commenced in September 1769, when he would have been just about 15, and was to last seven years, i.e. until 1776.[5] Once he completed his apprenticeship, it would appear that he set himself up in business straight away in Christchurch, since the only known Robert Cox watch, pictured here, is dated c. 1774 but was possibly made by him within two years of that estimated date as a fully qualified clockmaker and is, most significantly, engraved with not just his name but also with 'Christchurch'.

4 Hickson, Edna *Macquarie's Ten Gentlemen*.
5 Information from Dennis Moore, Prescot Museum.

The Cox watch and chain with its case. (Hampshire County Museums Service)
(see colour section)

However, it must be more than coincidence that in June 1774 the stock-in-trade of a watch and clockmaker who had come to Christchurch from London in 1769 and set up shop in 'Meeting House Lane' (Millhams Street), came up for sale. Charles Coulon sold and repaired timepieces, and advertised a 'large assortment of watch springs, chains, keys, pendulums, glasses, clock lines etc'[6,] and the sale included these and 'a great variety of clocks and watches, a very curious time-piece, a silver repeating watch and a variety of materials for mending watches …'.[7] In the December a further auction of Mr Coulon's (possibly Cologn) watches was held. It seems a likely hypothesis that Robert, his mother or Mr Norman effected a purchase of the stock, which may have included fusee chains brought from London by Mr Coulon and so gave rise to the birth of a local industry.

In turn the newly time-served young clockmaker took on apprentices himself at Christchurch, the first of whom was his own brother, William, in 1779: William was born fourteen years earlier in Wimborne, and may have decided or had it decided for him to tread the same path as his successful elder brother, before changing his mind and joining the Wiltshire Militia. His connection with clockmaking did not end there, however, for he married one Rebecca Upjohn, in Clerkenwell in 1789. She was the daughter of James Upjohn of Red Lion Street in that parish, who was a noted clockmaker working for a far more famous clockmaker by the name of James Cox. James Cox made, amongst other horological pieces, fabulous and complex automata, some of which found their way to the Imperial Palace in Peking.

6 SJ 30 October 1769.
7 SJ May 1774.

Marriage certificate Cox/Woolls. (Hampshire Record Office)

This biographical information is important in that it confirms a family link with the clock and watchmaking centre of Clerkenwell, and it is not beyond the bounds of possibility that James Cox was, in fact, a relative of the Wimborne Coxes of this chapter.

William Cox resided, with his new bride, in Devizes around 1790, where in a private collection a longcase clock survives with that date, inscribed 'Will. Cox'. His knowledge of clock and watchmaking was not wasted: it came in useful on the long journeys by ship to Australia, when it is recorded by his descendents that he sold watches to the passengers. Robert Cox's next mention in Christchurch is at the age of 25 as a witness at a local wedding in 1780[8]; he then reappears in the annals of history at Odiham in Hampshire at his own wedding, which was to Ann Woolls on 03 July 1783. After their marriage they returned to Christchurch and in December of that year are recorded as the occupants of a house on the west side of the High Street.[9] It has not been possible to identify the exact property, but it was on the other

8 White, Allen *The Chain Makers*.
9 SJ December 1783.

1. Christchurch and the surrounding area c. 1895. Scale: 2 miles to an inch (J. Bartholomew's *Pocket Series*). To be referred to, in order to locate places mentioned, especially the extent of the fusee chainmaking.

2. Hart's Great Exhibition 1851 entry and Bronze medal-winner.

3. 'An engaging combination of scenes ...'
(*A Historical and Descriptive Account of the Town and Borough of Christchurch*)

4. Christchurch c. 1920s. Bargates left, Barrack Road right, and the Pit site in between, with the High Street centre.

5. Above: pocket sundials. Left to right: a late eighteenth-century German-made sundial in wooden case, with compass. On the reverse (illustrated left) is a list of towns and latitudes. A brass sundial with compass made in 1742 by Stokes. A sundial in leather case, adjusts for latitude, c. 1760.

6. Right: a stained glass sundial at Toller Porcorum.

7. The turret clock mechanism in collection of Willis Museum, Basingstoke.

8. Wimborne Minster astronomical clock.

9. Galileo's mechanism reconstructed.

10. Fusee chains for watches and clocks, with a section of steel strip with links punched out.

11. Top left: *Chainetier* figure 1 (see page 117) a strip partly punched and some punches. (Hampshire County Museums Service)

12. Top right: *Chainetier* figure 10 (see page 117). The die block held in the vice and the hammer and hole punch above for making the double sets of holes in the links. (Hampshire County Museums Service)

13. Bottom left: *Chainetier* figure 15 (see page 118) the steel wire used to make the pins.

14. Bottom right: *Chainetier* figure 7 and 8 (see page 118) punches for stamping out the links. (Hampshire County Museums Service)

15. William Cox, by Frederick Buck, *c*. 1797.

16. The Cox family house in Wimborne Minster.

17. Top: a Cox watch with case and chatelaine.

18. Above right: the case for the Cox watch, above.

19. Left: a Robert Harvey Cox grandfather clock.

Facing page:

20. Top: a fusee watch made by Robert Harvey Cox.

21. Bottom: Frodsham's Hart chain display.

22. Hart's Fusee Factory.

23. Chain tools.

24. Hart's 'Watch and Clock Fusee Chain Manufactory 1845' showing a close-up of the plaque on the front of the factory.

25. Frodsham's Hart trade card.

Overleaf:

25. 1863 Stocking Knitter's Manual.

THE STOCKING KNITTER'S MANUAL

A COMPANION TO THE WORK TABLE

EDINBURGH
JOHNSTONE, HUNTER & CO.

26. The silk stocking factory.

27. Westminster Workhouse acquatint from Ackerman's Repository, 1809.

1851 ● Hart's ● Cox ● Jenkins Tithe Map 1844

Avon Buildings
Bargates/West End
72
Pit
Pound Lane 3
Millhams St 7
Bridge St 7
High St
Castle St
Church St
Wick Lane/Whitehall 13
The Workhouse 1
Church Lane
Sopers Lane
Scotts Hill Lane
Waterloo Place 5
Rotten Row
Purewell 10

28. Census 1851, see page 217.
29. Census 1861, see page 229.

1861 ● Hart's ● Cox ● Jenkins Tithe Map 1844

Avon Buildings 4
Bargates/West End
59
Pit
Pound Lane 6
Millhams St 3
Bridge St 2
High St 1
Castle St
Wick Lane/Whitehall 13
The Workhouse
Church Lane 6
Sopers Lane 3
Scotts Hill Lane 7
Park Place 3
Waterloo Place 4
Rotten Row
Purewell 15

1871 ● Hart's ● Cox ● Jenkins

Tithe Map 1844

Avon Buildings 5
Bargates/West End 48
Pit
Sopers Lane 2
Pound Lane 3
Millhams St 1
Main St 2
Wick Lane/Whitehall 8
Bridge St 2
Castle St
Church St
Church Lane 1
The Workhouse
Waterloo Place
Rotten Row 5
Scotts Hill Lane 3
Purewell 6
Park Place 3

30. Census 1871, see page 238.
31. Census 1881, see page 243.

1881 ● Hart's ● Cox ● Jenkins

Tithe Map 1844

Avon Buildings
Bargates/West End 26
Pit
Sopers Lane
Pound Lane
Millhams St
Main St
Wick Lane/Whitehall 11
Bridge St 1
Castle St
Church St
Church Lane 1
The Workhouse
Waterloo Place 1
Rotten Row 1
Scotts Hill Lane 1
Purewell 2
Park Place

1891 ● Hart's ● Cox ● Jenkins

Tithe Map 1844

32. Census 1891, see page 246.

33. The house of Robert Harvey Cox, watchmaker, was replaced in 1965 by this store; now no trace remains of the birthplace of his remarkable fusee chainmaking industry.

side of the street to where his home was to be for the remainder of his life. In 1784 the first of nine children were born to him and wife Ann. Robert and Ann were singularly unsuccessful with their offspring, only four being known for certain to have survived into adulthood, and four others dying as babies, two within days or weeks of birth. The four were Charles (1787), Jane (1791), Ann Maria (1794) and Harry (1798). Of the nine, there were two sets of twins. In contrast to this misfortune, mishap or mismanagement, Mrs Ann Cox played a large part in the running of the fusee chain enterprise after the early death of her husband, and appears to have been a shrewd and well-organised businesswoman.

From 1786 the name of Robert Cox appears regularly in the surviving accounts of our familiar John Pillgrem, the builder. Apart from a great deal of unspecified carpentry work, Mr Pillgrem's bills to Mr Cox included work for clock cases. The first such mention was actually 'to a watch, £4 4s 0d': why was the builder billing the clockmaker for this? Whatever the explanation, the cost of a watch at this time is clearly prohibitive. Four guineas was several weeks' wages for a working man; watches were to remain the toys of the wealthy for a long time. Later ledger entries include:

1787: 'To a oake Square Head Clock Case £1 4s 0d';
1788: 'To a lock to clock case and putting on of ditto 10d';
1790: 'To work repairing shop shutters 2s 6d';
 'To building a shop to account £21', to which entry was added the cost of weatherboarding on the top;
 'To work painting the shop 4s 6d', then an amount for tarring it and for four casements;
1791: 'A clock and handle to [indecipherable] 2s 0d';
1794: 'To a square head Oake Clock Case £1 8s 0d';
1800: 'To a good Oake Square Head clock case £1 8s 0d';
 'To work to clock case 1s 6d';
 'Oil, mahogany, glue etc to clock case 1s 6d';
1802: 'To one deal clock case £1 4s 0d'.

These snippets indicate that Robert Cox was fitting the movements he had made, or part of which he had made, into cases made by a local joiner, and that he had, by 1790 at the latest, constructed purpose-built premises for this work to be done, behind his home on the east side of the High Street in on the extreme left of the picture on page 130 (photographed in 1893), where from 1789 on we find the growing family. From 1797 he is rated for the property as the owner, and the house was to remain in the

An aerial photograph, showing the Cox premises in front of the church.

ownership of the Cox family for nearly a century. The workshops are clearly visible stretching behind the house in line with the Congregational Church opposite across the road leading off the High Street, Millhams Street. All but the most easterly workshop was demolished in 1965 by Tesco and a supermarket in a uncompromising 1960s brutalist style built on the site, contrasting architecturally and aesthetically as much as possible with the old Ship Inn next door.

Left: Robert Harvey Cox grandfather clock.(see colour section)
Below: Fusee watch made by Robert Harvey Cox.
(see colour section)

> **Established 1780.** | **FREDK. SHICK,** | Goods packed for Export secure from damp.
> **WATCH, CLOCK, AND MARINE CHRONOMETER FUSEE CHAIN MANUFACTURER,**
> **58, RAHERE STREET, GOSWELL RD., LONDON, E.C.**
> BEST ENGLISH MANUFACTURED WATCH FUSEE CHAINS.
> DO. FOREIGN, SPECIALLY MANUFACTURED.
> **CLOCK AND DIAL FUSEE CHAINS AT VARIED PRICES.**
> Ecraseur and Saw Chains for Surgical Instrument Makers. Extra Small Chains for Pocket Aneroid Barometers. Chains also for Telegraph and other purposes. Chain Hooks. Fusees Cut.
> PRIZE MEDAL, PARIS 1878.
> **PRICE LISTS SENT ON APPLICATION.** P.O. Orders payable 237, GOSWELL ROAD.

Shick advert, Kelly's *Directory of Clock & Watch Trades 1880*.

It was probably here that Robert Harvey Cox made the lovely longcase clock and gold fusee watch illustrated, and also where we first hear of him as a fusee chain manufacturer in 1792: 'Robert Cox, Watchmaker and Manufacturer of Watch-chains'. Taking into account the time lag between events and the publication of them in directories, it is safe to assume that Robert Cox commenced the fusee chainmaking enterprise soon after he acquired the house in 1789.

Robert Harvey Cox was not the sole English manufacturer of fusee chains. The advert above for Frederick Shick in the famous clockmaking Clerkenwell district in London indicates that that firm was established in 1780, presumably in the same specialised fusee chainmaking capacity as they were trading in at the time (1880). An earlier directory includes James Shick as a fusee chain maker in 1840, and, even earlier, a William Shick is listed as a chainmaker in 1813 in Brick Lane, Islington Walk, along with others in Whitechapel and Clerkenwell again.[10] Thus the London manufacture of the chains might predate both Robert Harvey Cox's enterprise and the war with France which must have accelerated its development and eventually given Mr Cox a virtual monopoly this side of the Channel.

It is also known that some watches from London in the mid-seventeenth century used fusee chains, and their use in clocks goes back to the previous century in the clock-making centres of South Germany; the authoritative conclusion being that: 'There must have been many places around Europe where these chains were made before and after Christchurch became a centre' for their manufacture.[11] The craftsmen of the time were so highly skilled, at the forefront of the technology of their day, it is inconceivable

[10] *Directory of Clock and Watchmakers*, Guildhall Library.
[11] David Thompson, British Museum, personal communication.

that they could not also have made the chains they needed themselves.[12] It was the ideal task to give an apprentice, helping them develop their skills in working on such minute and intricate operations; fusee chain manufactories or foreign imports may simply not have been extensively needed.

The only confident assertion that can be made is that however the manufacture arose, Christchurch certainly dominated it – we shall below describe the mechanism by which this was achieved – but the town cannot claim to have sole monopoly of the manufacture. At the decline of the industry there are five Watch Fuzee Chain and Hook Makers in Kelly's *Directory of Watch & Clock Trades* 1880. Three of these were in Christchurch, one in Coventry and another in Birmingham. The latter two places had, of course, long been associated as principal centres of the watchmaking industry in England, so the real mystery is why such a specialised branch set up in a small south-coast town so far away from their outlet. It must have been a combination of the entrepreneurial and technical talents of Robert Harvey Cox, the presence of a large unemployed labour force in an impoverished outpost with little else to keep the economy going apart from the large-scale smuggling trade, neat timing as regards contemporary concerns about the high cost of poor relief, and the family connections with Clerkenwell.

Whatever the factors were in the establishment of this curious manufacture in Christchurch, it quickly became the means of support for a great number of the local people. The first reference to it is found in the *Universal British Gazetteer* in 1798, which remarked on the town's 'large manufactory which employs a number of boys and girls in making watch chains'. Where the work was done is a matter for speculation. Although a 'shop' had been built behind the Cox house (page 129) it is possible that the children worked at home. But, bearing in mind that workbenches would have been needed, this seems unlikely, and so the 'shop' was indeed the manufactury. Perhaps parts of the process were done at home, part in the factory. The next reference appears in The *Hampshire Repository* of 1801:

> The children of the poor inhabitants of Christchurch have been for some years past very usefully employed in the manufacture of watch-spring chains. By the spirited and laudable exertions of Mr Robert Cox, watchmaker, between forty and fifty poor children who would otherwise have been a burthen not only to their families but perhaps to the parish, are

12 Dennis Moore, personal communication

now earning an average of four or five shillings a week each, contributing most essentially to the support of their parents, and acquiring habits of industry, duty and affection.

This extract is remarkable for several reasons: it confirms that the manufacture was well-established by 1801; it conveys some of the dynamism of Robert Harvey Cox's character; and, most revealing of all, that the workers were in the first place, children, and in the second place poor. Furthermore, it implies that these children were in the general community and not in the workhouse – specifically being kept out of the workhouse by such employment. The income they are said to earn is quite astonishingly described as useful in supporting their parents – a neat inversion of the usual scheme of things, and at the levels claimed may have been all too true: silk stocking knitters, who would have been adult women, could earn a mere 4s a week! The real earnings are revealed below as being about a third of the level quoted, suggesting a certain amount of propaganda in the extract, or that these rates were payable once the skills had been learned. The extract from the Milton records below quotes 5 – 10s per week potential earnings after three years, which would have made child labour well paid.

Mr Cox must have quickly used up the available child labour, or found a cheaper or more captive (literally) labour pool, for around the time that this description was penned he had found what would be his main source of child labour in the local parish workhouse.

The name of Mr Cox first appears in the detailed employment charts of Christchurch Workhouse on 29 December 1794, and is reproduced below.[13]

Chart of employment, 29 December 1794.

13 This and subsequent tables from DRO MIC/R/356.

Chart of employment, 24 March 1800.

Whilst no indication is given in the return as to how many inmates were working for him, the note records a payment to him of £1 1s 0d. The other payment was for what had long been the staple occupation of the inmates since the workhouse was opened in 1745: the spinning of flax (see Chapter 7); as £1 9s 3d was paid for a weighty 57lbs of flax, whatever work was done for Mr Cox must have been considerable. Note that in this week, of the 114 inmates, about half were considered capable of any work, a fairly typical figure. The rest appear in the columns as old, infirm, too young, too ill or out at work – it may come as a surprise to learn that the parish made use of the able-bodied workhouse inmates on such parochial responsibilities as road maintenance, i.e. filling up the holes with fresh gravel.

Robert Cox then disappears from the employment charts for six years – it is not possible to say whether he was nonetheless employing workhouse inmates – to reappear abruptly in March 1800, as shown above.

The following week it appears to be action stations: flax production had dropped dramatically to just 13lbs, earning a mere 8s, but Mr Cox paid £2 12s 6d for the labour he used – not separately itemised, but far exceeding payments made for other work done. The situation is regularised in the following week's table, by the simple expedient of utilising the hemp-picking column (this was virtually never done in Christchurch) for the work of chainmaking, from which we can see that just eight people are spinning flax – all other available labour apart from a skeleton bed-making force has been taken up by Mr Cox. Unfortunately, the available labour was severely depleted by an outbreak of smallpox in the House. On the Monday, there were 170 inmates, which is almost the highest figure ever known to be

The Christchurch Fusee Chain Manufacturers

Chart of employment, 1 March 1800.

housed in the building, and the crush would have been both uncomfortable and unhealthy in the presence of such a deadly and infectious disease. It is a matter of some surprise that any work could be done at all.

The chainmaking function was soon well established, with Mr Cox having his own column and plainly taking the lion's share of the labour available. The numbers on flax spinning were down to a mere handful at just five or six persons in April 1805, but chainmaking was competing with a new activity: straw plaiting (entered as 'stroplad' by the virtually illiterate clerk, presumably the Master, John Short). This was a favourite workhouse activity of the era, linked with the manufacture of straw bonnets of which there were several outlets in the town (see Chapter 7). At one stage straw work briefly outstripped the chain work, earning for the Overseers of the Poor £3 17s 0d as opposed to £1 19s 0d to Mr Cox. Mr Cox had about a quarter of the commercially available workforce; we do not have a breakdown of the proportions of children to confirm whether these were likely to have been entirely drawn from this age group, but from the evidence of labour agreements with the other workhouses later used by Mr Cox it is likely that all children of a suitable age in the House would have been expected to undertake the work.

It is interesting to note that whatever the number of inmates, which naturally varied, Robert Cox always employed a static figure. This seems to vary not in relation to the overall number of inmates, but with the demand for chains. For instance, as soon as he became established he quickly built up to a workforce of 40 or 42 throughout 1800, whereas the tally of inmates varied from 122 to 171. The following year, illness (almost

135

Chart of employment, 12 October 1807.

certainly smallpox) reduced the numbers available for work and the figures employed fluctuated between just a dozen and up to 42 just once, before taking off again when the crisis was over to maintain the level at around 40-45 throughout the remainder of 1801. 1802 saw a slight but sustained decline to below the 40 figure where it remained throughout the following year, whatever the level of workhouse population, which varied from 87 to 107. A gradual decline is perceived in 1804 to the mid-30s in numbers, then to around 30 in early 1805 and a more sustained drop to around 25 in the later part of that year.

By the end of that series of tables in 1807, the numbers employed in chain work had declined to barely more than a dozen, whilst the flax-spinning, although having been drastically reduced by the arrival of Mr Cox, maintains its number of workers at around seven throughout. The last entry, for 12 October 1807, appears above. The earnings from making chains had dropped to £1 1s 3d from a high of £3 6s 0d. When the record starts again in 1815, some 70 out of a total population of about 112 were classed as unable to work through age or youth or infirmity; but there is no sign of chainmaking. Mr Cox actually died on 8 April that year, a week after the chart, to the right, was compiled. We shall never know for how long after 1807 he had continued to use the workhouse labour at Christchurch, but it was plainly in a steep decline and on the way out. It is

Chart of employment, 1 April 1815.

a reasonable assumption to say that the use of pauper inmates for this work in Christchurch lasted a mere ten years.

It must be emphasised that none of the earnings would have directly gone to the inmates but would have been used to offset the cost of their maintenance and that of their fellow inmates, the majority, incapable of work. The actual amount they earned can be calculated from the tables, which shows that flax-spinning brought in about 2d per person per day whereas the chain work brought in 3d. Mr Cox seems to have paid a higher rate for the labour he used, which would account for the preferential treatment he appears to have received, but we do not have the number of hours worked to calculate this for certain, or what the hourly rate would have been. The wages of the average local adult labourer might be around 1s a day at the time.

Robert Cox had in 1802 become a member of the Vestry, in which position he would have been able to influence policy decisions about the running of the workhouse.

Wimborne

Parallel with the Christchurch arrangements, Robert Cox was using children at the Wimborne workhouse for roughly the same period. In this case, no record of any formal agreement appears to have been made, and the surviving records[14] list receipts for the use of pauper labour in the workhouse without specifying the details of who it was for or of what nature. So, whilst it is not

14 DRO PE/WM: OV 1/1/7 and 8.

possible to date the commencement of chain work there, Mr Cox's name appearing in September 1803 indicates it had been set up by that time. He received £4 4s 0d on that occasion, and the following month £7 8s 6d. Over the next three months he paid the overseers £24 10s 0d, averaging therefore £8 a month, and in that three-month period (January 1804) the accounts record an expenditure of £12 10s 0d for 'Windows and altn [alteration] to the House for the Watch Chain Manufacture', plus £1 15s 8d for 'Stamps and draw & the Bond for the Watch Chain Business'.

This was a sizeable investment for the authorities to make: installing extra windows to permit sufficient light to enter for the close work involved, plus some sort of legal agreement or bond, details of which have not survived.

In the year commencing Easter 1804 Mr Cox paid for labour to the value of £61 3s 0d; total earnings in that period for all employment was £108 12s 0d, so he got the lion's share of the available workers. The following year this increased to £99 14s 2d, out of a total receipt of £145 8s 0d: an increased share for the chainworking. The year after that, from Easter 1805, the figure was down to £83 11s 0d, or just under £12 per month. The decline continued, just as at Christchurch, and by January 1808 less than £5 a month was being earned by the children, similar to the level of payments made at Christchurch. The last mention of the chain shop was in March 1808 when £2 4s 0d were spent on candles to improve the light, presumably to extend the working hours.

Following these references, the workhouse inmates reverted to the hated practice of oakum-picking. The silence did not last, as the name Cox reappears in the accounts from March 1816: almost as soon as Robert was dead, his widow restarted the chain workshop at Wimborne, paying £18 6s 0d in January for work done 'by the children in the Poor House at the Watch Chain Manufactury' up to the end of 1815 (Robert Cox died in the previous April). The business picked up again to the level of approximately £8 each month, declined to about £6 within two years, then all reference to it abruptly ceases. This gives rise to interesting speculation as to why Mrs Cox did not also revive chainmaking in the workhouse of her home town.

MILTON

Robert Cox's methodology was, it seems, to approach various neighbouring workhouses in turn for further agreements to use the inmates' labour on the fusee chain manufacture. It was whilst the numbers involved at Christchurch

The Christchurch Fusee Chain Manufacturers

Left: remains of the Milton poorhouse fusee workshop. Right: Milton agreement. (Hampshire Record Office 84M70/PO2)

and Wimborne were in steep decline that he approached Milton (now New Milton) in 1806 and negotiated the agreement which is reproduced above. The 18d is probably a weekly figure, roughly equivalent to the 3d paid at Christchurch for a day's work. No hours are given, so once again it is not possible to calculate the hourly rate. The little poorhouse survives in an incongruous modern setting and an even more incongruous use, as garages with accommodation over. An office block has been built in front and named 'Fusee House' in tribute to the association.

BOLDRE

Boldre Workhouse records for October 1808 record another agreement with Mr Cox:

> ... that the Master of the Poor House make out immediately a List of every Person with their Age & Employment residing in the House and produce such list at every Committee – and ordered that betwixt this Time and the next Committee Day the Overseers will endeavour to find out if their [sic] are any Children now supported by the Parish who are fit to work at the Chain Manufactury. Mr Cox of Christchurch proposes to employ the Children of the Parish not less than 12 in number and from 9 years upwards in the Trade of Watch Chain Making and states that he is willing to pay them 1/6 per Week the first year, 2/- the second and 2/6 the third, after which they may earn form [sic] 5 to 10 per Week by piece Work.[15]

This entry confirms that the going rate for children was 1s 6d a week.

15 HRO 84M70/PO2.

Once again, there are no further records surviving which would give more information about the scheme proposed and presumably implemented. However, an account of 'Boldre New Poor House' in 1796[16] records children of as young as four or five employed in spinning or weaving for a mere penny a day, or 6d per week, working in the summer period a punishing ten-hour day. This rate of remuneration makes chain work appear fabulously rewarding.

Fordingbridge

The final workhouse known to be used by Robert Cox is Fordingbridge, the Vestry Minute Book of which has the following entry in July of 1812:

> Memorandum of an Agreement made this day between the Committee appointed for managing the affairs of this Parish on the one part, and Mr Robt Hervey Cox of Christchurch in the County of Hants, on the other. The said Mr Robert Hervey Cox engaged to teach and employ Twenty Children in this house in the art of the watch-chain making, and at the end of the first six months to allow the Parish one shilling per head per week for the following eighteen months.
>
> The committee agrees that the said Mr Robert Harvey Cox do have each child the first six months gratis for their learning, and at the end of two years from the above date he the said Mr Cox (in consequence of his being the first who came forward to employ the children and also have been at some expense in putting up the work benches) is to have the preference as the employer of the children in this house provided he gives a fair price for their labour.
>
> It is also mutually agreed by both parties that the children be allowed half an hour at Breakfast and one hour at dinner in order for the children to have some time for Learning to Read, they are to leave work at Four o'Clock in the afternoon.
>
> Be it also annexed that the nature of the agreement between Mr Cox and the Teacher be such as not to gain a settlement in this parish, and that the person so employed be of a good moral Character.[17]

The statement above affords further insights. In the first place, it demonstrates that some parish clerks or officials were more literate than others – Fordingbridge seems to have been relatively well-placed in that

16 *Hampshire Repository 1799*.
17 HRO 24M82/PV1.

regard, and the agreement has been carefully thought out to benefit all parties, incorporating safeguards and recognising the other needs of the children in their charge. The reference to settlement is a Poor Law provision to ensure that the parish does not end up having to provide relief to a person belonging to another parish, and in this case Fordingbridge overseers are stating that a teacher would not be given a settlement status, entitling him or her to relief. Should that be needed, that person would simply be removed to the originating parish or that responsible for them.

The entire exercise smacks of a competition, Mr Cox being the successful candidate; and it must be noted that it was not unusual or reprehensible to employ workhouse labour: this was positively welcomed. The employment charts at Christchurch record a variety of local employers paying for work done in the House. The memo also reveals that Mr Cox equipped the workroom and used a teacher to impart the skills needed. The hours appear to be very long for a child to work; we are yet years away from the Factory Acts and in a vastly different moral climate, but the overseers display at least a modicum of responsibility for the welfare of their charges.

The use of a succession of workhouses may be because the children concerned lost interest in the work: that would explain why Cox approached Boldre after the output from Christchurch and Wimborne declined, and why he made an agreement with Fordingbridge once all work at the former two places had ceased. It was as if he had to turn to pastures new for some reason, and this may be the likeliest explanation.

It may seem to us today to be exploitation, but the evidence from these slim scraps rather suggests that Robert Cox was deliberately engaging pauper workhouse children to bring benefits to all the parties. The children would be occupied: what else was there for them to do all day, confined as they were, and compulsory education many decades into the future? Furthermore, he not only subsidised the cost of their maintenance, thereby reducing the poor rates, but enabled the children to acquire a skill which they could utilise in adult life, away from the workhouse. It is arguable that by using pauper labour he got the work done cheaply, but from this distance in time it is not possible to say if that was as much as the market would bear. It may well have been; fusee chainmaking remained an occupation for the poorest classes and the lowest pay. Certainly, the contemporary account of it quoted above in the *Hampshire Repository* regarded it as nothing other than praiseworthy and beneficial.

Another charge found in some literature on the subject is that the close

work rendered the children and other workers blind. In the opinion of an optician obtained at the time of writing and an ophthalmologist consulted[18,] this is unfounded. One of the most practical reasons for employing children and young people in the chain manufacture was that their eyes could focus so easily on close work. Once the sight deteriorated for any reason, it would simply have become impossible to do the work and it would have ceased. Eyeglasses were used: there is one at the Red House Museum in the fusee chain tool collection. A search of the censuses showed only four blind people in Christchurch, none of them a chain worker. In the 1881 census a search in the main chainmaking areas of the town reveal a girl of just five, too young to have been a chain worker, a boy of 13 blind in one eye, one blind woman of 50, and four blind people in the workhouse. Two of these were from outside the area (Parley and Beckley), and one was blind from birth, leaving one only as a possible candidate for fusee-chain-induced blindness.

The Fordingbridge workhouse records include a revealing Vestry Agreement a few months after the one above, April 1813, transcribed as written (thereby showing that the previous high literacy standards had somewhat lapsed):

Mem. Respecting the watch chain making.

First As there is but two branches of the watch-chain carried on here, namely wire making and riveting, should not the children be taught both of these branches so as to be enabled, when the finger is pricked by riveting, to be set on wire-making, *without any inconvenience or disadvantage to the Parish*, [my italics] and that no loss of time be deducted except in cases of indisposition.

Secondly – As the children gennerlly speaking are fond of new employment and if they find they can by any manouvre be discharged its very likely they will take an advantage of it. Therefore, after having been six months for nothing, the time allowed for learning the chain bussness, should any child be discharged from the employment and another taken in lieu of the child, except in leaving the house, going out to service, or some other reasonable or just cause?

To the first of these questions Mr Cox says he does not make it a Rule to teach any child both branches and that he does not except [i.e. accept] the time to be deduct for the pricking of the finger except they are disabled for more than one day.

In the second he Mr Cox agrees that after the child has been six months

18 Coultas, Cynthia, The Fusee Chain Industry of Christchurch, Hampshire, 1790-1851.

it his opinion they should not be discharged except in cases aforesaid – namely, on leaving the house, going out to service, or some other reasonable or just cause.[19]

Much is revealed about the person and the process in this agreement. Plainly, the Vestry Committee had called Mr Cox in for a grilling, motivated by a wish to maximise the income to the parish from the children's employment. Secondly, the operations undertaken at this and most likely all the workhouses, were only making the wire and riveting, and the children did one or the other, rather like a modern factory production line. The implication is that the more skilled work was done elsewhere, and workhouse children did the repetitive elements of the manufacture. The safeguard over losing the child before he or she has started to earn for the parish after the unpaid training period is agreed to by Robert Cox, but he comes off relatively well in indicating that he is not so ruthless as to stand over the children with a stopwatch to deduct pay for trivial work stoppages caused by minor injuries. He further accepts that he cannot exploit the system by simply replacing the children after obtaining their work free for the first six months – a wise precaution on behalf of the watchful Overseers. Note that there is a hint of the children finding interest and stimulation from being given a new task: value judgements about exploitation etc need to take this into account.

To conclude the examination of surviving local workhouse records, it was found that there were no other places where the work was recorded as having been done. Ringwood, the nearest town to Christchurch, had an employment table for its workhouse for 1814, showing the inmates harmlessly occupied weaving and spinning, or knitting 'hoes'.

Back in Christchurch, Robert Harvey Cox's chainmaking business continued to thrive even as the numbers working for him in the local workhouse steadily declined. The next major innovation was the arrival of Sunderland-born Thomas Barrow from London to the Millhams Street workshop in 1809. Joining as a die maker, he went on to play a prominent role in the factory until his death in 1854, closely followed by his son, James Oliver Barrow. He is recalled in *The Lodge of Hengist,* which he chaired for two years, as 'a quiet, friendly sort of man' whose role was 'foreman at Cox's watch-chain factory'. The connection with London may be significant, implying as it does that there was trading of watch chains between there and London, and an early hint that Christchurch was in effect a manufacturing

19 HRO 24M82/PV1.

outpost for a small part of the watchmaking industry. Evidently he was a key figure and highly enough thought of by the family to act as signatory to the legal documents which have survived, the first one being the will of Robert Harvey Cox, which he was witness to.

In May 1813 Robert and Ann Harvey Cox's younger surviving daughter, Jane, married Joseph Neave of Guernsey, but remained in Christchurch. Less than two years later her father was dead, aged 60. He 'enjoys' an impressive table-top tomb in the Priory churchyard, just across the road from the parish workhouse where until very few years before the young inmates sat at the workbenches busily cutting links and riveting chains for his manufactury. In his will he left his furniture and stock-in-trade to his wife Ann, plus his property for her life. He also left bequests to his daughter Ann Maria and son Harry of £300 each. The remainder of his estate was to be divided between Ann Maria, Jane Neave and Harry: no mention whatsoever of Charles, a most mysterious and unexplained omission. Charles was his eldest surviving son. The mother of the late Robert Harvey Cox, Jenny, within days had made her own will, as well she might at the grand age of 82, in which she left her elder granddaughter, the as yet unmarried Ann Maria, her Wimborne house (not the one opposite the Minster, which the family were only tenants of) together with its entire contents. To her younger granddaughter, now Mrs Jane Neave, she bequeathed just £25 (which sum in addition she gave to Ann Maria). In making this will she virtually bypassed her surviving son, William, who was by then in need of no inheritance, being very successfully established in Australia. Nevertheless, she did leave him the residue of her estate, whatever that might have been. She also omitted to mention either grandson: Charles, then aged about 24, and Harry, just 15. Once again, Charles appears to have been pushed out of the family circle, yet he did own a third of the High Street house, at least by the date of his mother's will of 1829. Perhaps it was on account of him having this share that his father thought he had benefited sufficiently not to need a bequest. We may never know.

At the end of that somewhat eventful year, the widowed Mrs Ann Cox had entered into an agreement with Thomas Barrow in which he was described as her foreman and superintendent, whereby he 'would faithfully and honestly superintend and carry on the business of Watch Fuzee Chain Making' for her, although it would appear that the business management was very much under her control.[20] Although an 1830 directory gives the

[20] Local History Room, Christchurch Library.

The Christchurch Fusee Chain Manufacturers

Left: Tom Barrow's house in the Pit Site. (Red House Museum) Right: OS 1870. showing Robert Cox's house and workshops.

name of the firm as Cox and Barrow, it is her name which appears in the records of the Milton Workhouse during the early years of her widowhood: 'Allowance to Mrs Cox for taking a girl out of the Workhouse: £1' appears in 1818.[21] This refers to a premium paid by the Overseers to employers taking apprentices from them.

Other entries confirm the close alliance between the workhouse and the chain factory in this period: a resolution was passed in 1817 to employ the children in the House at the Watch Chain factory and a woman was paid 'for attending the children in the chain shop' (the word 'shop' having the meaning of workshop). It is unfortunately not recorded what happened to the watch and clockmaking aspect of her late husband's business, but it presumably ceased with his death.

During the Ann Cox/Thomas Barrow period, the demand for chains was sufficient to permit the establishment of a rival chain factory, that of Henry Jenkins in Bridge Street, which appears in a directory for the first time in 1823 and no doubt began earlier. The three chain factories which eventually evolved seemed to have been interconnected, as will be later shown, and a tantalising scrap relating to the Wimborne Workhouse survives undated:

Mr Jenkins
Your letter conveying an offer to this parish to employ 12 Girls in the Watch Chain making has been laid before a committee and the parish will engage to let you have them on the conditions undermentioned.
 12 Girls from 8 to 10 Years old 9 to 10 years [sic] provided we have got them, agreement for three years certain – on both sides. This parish

21 HRO 56M83/PO3.

to find Shop, Benches & Stools and Mr Jenkins to find all Tools required. The hours for the Children to work from Six o'clock in the Morning until 6 o'Clock in the Evening from Lady Day to Michaelmas and from Mich to Lady Day eight o'clock in the Morning until Dark with an allowance of half an hour at Breakfast & one hour at dinner. This parish not to have anything to do with the superintendence. Mr Jenkins to have the liberty to exchange anyone that may be dull or incapable of learning the said work. This parish to be at the expense of the agreement. This parish to receive from Mr Jenkins 1/6 per week for each child so employed.[22]

Wimborne workhouse officials seem to have been a lot less protective of the welfare of the children than Fordingbridge appears to have been. The weekly going rate is confirmed at 1s 6d, which for the longer summer months works out at little more than a farthing per hour. It may be argued that the training was an investment, but the hours worked for an eight-year-old can only be described as punishing to the point of being seriously detrimental to the well-being of the parish's youngest and most vulnerable charges. Unlike at Christchurch, no allowance is to be made for education. The name Jenkins occurring in connection with Wimborne must either be because that town employed a foreman of that name to organise the work of the Coxes there, or it is just possible that it refers to the same Henry Jenkins who started a watch fusee chain business at Christchurch.

Mrs Cox decided to extend her chainmaking empire further into the rural hinterland of Christchurch, and for that purpose bought a cottage at Chewton which she 'used and occupied in carrying on the watch chain manufactury in conjunction with the business at Christchurch'.[23] As Allen White points out, a more unlikely place for a chain factory would be hard to find,[24] and by 1838 the Cox firm was trying to dispose of it. Chewton is between the present Highcliffe and Milton; curiously, the 1851 census for Milton includes three ladies in their forties who give their occupation as 'fusee watch chain maker', plus the daughter of one of them, as if these four were the last trace of the Chewton/Milton connection. There are certainly no other chain workers in the 'daughter' areas used by the Coxes apart from at Milton. Those three older women were children of the appropriate age when the workhouse at Milton was ruthlessly exploiting their children; it speaks

22 DRO PE/WM:OV8/11.
23 Ann Cox's will, Local History Room, Christchurch Library.
24 White, Allen op. cit.

volumes that they were the only ones in all Milton to still find employment into their adult life in this capacity. The cottage was sold off in 1840.

Ann Maria Cox married Thomas Price Wynne in St Clement Danes, London, in 1825. He was said to be in the East India Company, and from Flint in Cheshire, and, like her brother Harry, a surgeon. That she married in London is circumstantial evidence in support of the London connection of the chainmaking industry. She returned to Christchurch after her marriage.

Her mother Ann's death in 1829 created considerable upheaval and regrouping within the family firm. With her obvious business acumen, Ann wrote a will running to four pages. It reveals that with three properties in the town and other unspecified freehold 'messuages', the chainmaking business had brought them prosperity but also a certain amount of disputes. Her son Charles was by now a Captain on half pay, and she had bought off him for £420 his share in the High Street house she was living in.[25] This she conveyed to her younger son, Harry, described as a surgeon living in Blackfriars, London, and who from henceforth looms large in the complicated affairs of the family firm. The share to him was to be held in trust by him and Edward Walker of Holloway: the two are almost always mentioned as a duo; in trust for daughter Jane Neave. The Chewton cottage went to Harry and Edward Walker on the same basis. The stock-in-trade was to be divided between Ann Maria Wynne, Harry, and Jane through the trust set up for her through Harry and Edward Walker.

The codicil to the will added just before Ann Cox's death has been much remarked on, since in it she acknowledges that she has 'omitted … to give any portion of my stock-in-trade' to him; therefore she compensates by allowing him £200. It is as if Charles was bought out of the business and matters settled so that he remained excluded: but it may have been because he was not in a position to oversee it.

Charles Cox was, in fact, a tour-de-force in his own right. Like his uncle William, he had decided on a military career, joining the 87th Regiment of Foot and took part in various foreign campaigns with honour and recognition for gallantry. Subsequently he became the agent for a landowner in Carrick-on-Shannon, in Ireland, from where he appears to have made regular forays to Christchurch.[26] He certainly had no need of financial assistance from his mother's will. By the 1861 census it is clear that he was blind.

25 Ann Cox's will, op. cit.
26 For this and other Cox family information, I am indebted to Barry Cox.

The apparent jostlings for position of the four remaining Cox offspring appears to be explained from their desire to ensure that Jane Neave's inheritance is protected from her husband's grasp; no such protective arrangements were ever drawn up for Ann Maria Wynne.

After the death of Mrs Ann Cox a major shake-up had the result of placing the firm in the control of her son Charles, despite him not having been left any part of the business by either parent. The joint executors to her will, Harry Cox and Edward Walker, drew up a set of accounts which reveal for the first time the set-up of the chain production. Edward Walker is shown to be a watch tool dealer, not only that, but operating from that centre of the watchmaking universe, Clerkenwell in London. Harry was buying chains from Charles and his two married sisters, Jane and Ann Maria, in large quantities, and can only have been acting as the London agent for the sales – as well as being a surgeon. Indeed, a letter from Harry to his brother Charles in July 1830 mentions the existing practice of 'all parcels passing through my hands ...' and that 'the period is not yet arrived when the customers are to be solicited to send their orders to Christchurch.'[27]

That last statement confirms that Harry and/or Edward Walker were receiving the orders for chains in London, and passing them to Christchurch; business was not at that time conducted directly with the manufactury at Christchurch. A further mystery is that William, the brother apprenticed to Robert Harvey Cox as a watchmaker, as previously mentioned, married Rebecca Upjohn, the daughter of a highly regarded Clerkenwell watchmaker whose address was in the same road as that of Edward Walker – Red Lion Street.

From 2 November 1829 until 31 July 1830, the sum of £650 14s 1d – a very large figure for the time – was paid in 'wages and disbursements' by Mrs Neave. Bearing in mind that the children were paid 1s 6d per week, the numbers of them employed must have been considerable. £27 was paid in 1830 on house rent at Christchurch and Chewton – since the High Street house of the Cox family was owned by them, perhaps another building was being used for the manufactury. £124 12s 0d was paid on 17 August 1830 to 'C Cox' for chains; there are references to a 'town agency' (perhaps the London wholesaler) receiving £3 2s 6d; on 19 August the three Coxes, Harry, Jane and Ann Maria were each paid £41 10s 8d for 'finished and unfinished chains'; and a valuation of tools, materials and stock of chains

27 Local History Room, Christchurch Library.

came to over £102. The account for May 1831 records £35 14s ¾d being paid to the three joint owners as 'profit'.

Another clue lies in payments to a 'Mr Wools' twice in 1829 of £5: this was the maiden name of Ann, wife of Robert Harvey Cox. Again, an intriguing possibility arises: were there Romsey links in the business chain (punning unintended!)?

Accompanying the set of accounts are receipts from both Ann Maria and Jane for 'superintending the Watch Chain Manufactory at XtChurch for a period of two years ending the 31st day of July 1832'. From Harry's letter of 31 July 1830 referred to above, both sisters may have not shared equal delight at the transfer of the business to their elder brother: Harry writes that he 'considers Jane's unusually protracted silence quite unaccountable in the present important state of affairs: it would afford us satisfaction to be informed that she were as well satisfied with the intended arrangements as we have reason to believe Ann is …'.

All these papers seem to be preparations for the sale of the entire business to Charles. This is shown to be the case in a deed of August 1830 whereby 'the Goodwill of the said Trade at the sum of one hundred pounds and the tools and utensils therein at the sum of fifteen pounds sixteen shillings' were so transferred.

The final payment was made in May 1831 in a letter from Harry in which he somewhat sneers at his elder brother. Charles had asked him some favour about the baptism of his child – perhaps to be a godfather. Harry declined on the grounds of being unable to do so, adding 'Wife joins me in very affectionate remembrance to Mrs Cox – yourself, Harriet, Henry and all the juniors of your numerous progeny'. Though it is signed 'your affectionate brother', somehow it gives the distinct impression of being a brush-off.

Charles is now king-pin as far as Cox and Co are concerned. It is a strange fact that his baptism is not recorded in the parish register. Two sources indicate that he was born in 1787: the 1861 census and his death certificate, but the child baptised by his parents in April that year was Anthony Joseph, who died within days. If Charles was another of the Cox twins it is inexplicable that his baptism should not have been recorded. No entry for Charles appears in the preceding or following years, yet plainly he is claimed by Ann to have been her son, and in the 1861 census he indicates he was born in Christchurch, not elsewhere. Neither Holdenhurst nor Wimborne came up with a baptism either.

Charles took on sister Ann Maria Wynne as his employee, in view of

the fact that she was 'acquainted with the trade and competent to assist in carrying it on', paying her through Edward Walker £100pa.[28] This compares with the earnings of a child worker of £3 15s per annum!

One of the first actions taken by Charles was to build a proper workshop behind the family house, with access from the lane alongside, Millhams Street. It is clear from the map (page 145) that the picture shows one half only of the building constructed, which could have accommodated a large workforce. It would also suggest that the chainmaking was done in a workshop rather than a domestic environment in the early stages. The deed was between Captain Charles Cox of His Majesty's 87th Regiment and his three siblings on the one part, indicating that the chain business was still very much a family concern, and Rev Daniel Gunn, the Congregational Church Minister for the church on the other side of Millhams Street, whose burial ground the workshop was to abut. Both Thomas and James Barrow were witnesses to the deed.

The next transaction between the four Cox siblings was drawn up three years later, by which time Ann Maria describes herself as a widow and Charles as of Carrick-upon-Shannon in Ireland. The third party to the agreement was once again Edward Walker of Clerkenwell. It would appear that the partnership between these two, Ann Maria and Charles, had become acrimonious: 'questions and differences have lately arisen … in respect to their respective rights and interests' in the business. To end the disagreement, Charles bought Ann Maria Wynne out and Edward Walker was also released from his duty of trustee. In return Ann Maria undertook not to set up in competition with her brother within fifty miles of Christchurch on pain of a £500 penalty. Once again, the witness was James Barrow.

Charles from thereafter had sole control of the chainmaking business, styled Cox and Co. Not long after, Cook's *Topographical Library* (1834)[29] remarked that 'The only manufactury here is that of Watch Fusee Chains, by which many poor children are rendered nearly, if not totally, blind, that business being extremely prejudicial to the sight, and mostly performed by children.' The first guide to the town had this to say in 1837:

> In the town are two extensive establishments for the manufacture of fuzee chains used in the making of watches, which give employment to some hundreds of persons, chiefly women and children.[30]

28 DRO: D/RHM 1362.
29 Quoted by Herbert Druitt, op. cit.
30 *Historical and Descriptive Account of the Town and Borough of Christchurch.*

Charles was back in Christchurch by the 1841 census, together with son, also Charles, aged 15, and describing himself as 'fusee chain manufacturer'. His rival, Henry Jenkins, is also recorded, his entry being overwritten '300': it is not clear whether the enumerator was providing information on the size of the workforce or making a note about his progress in the survey. The 1837 guide is the first time that labour other than that of children is mentioned. The 1841 census is very limited in information, and not many workers are recorded (see Appendix), although plainly it was an industry on a large scale by then. Charles Cox is listed as the occupier of the premises in the 1844 tithe map, and it was about that time that another of his sons, Mathew Dillon Thomas (known as Dillon), worked in the manufactury.[31]

The following year yet another chain factory, that of William Hart, started up. In the 1851 census following, Charles is absent – possibly in Ireland, where he was a JP (he reappears in 1861) and the house records just one Cox: Henry, son of Charles, born in Ireland in 1831, who gives his occupation as 'accountant, fusee chain manufactury'. He must have been keeping an eye on things in the absence of his father, as he later became a surgeon. He died young, in 1862.[32] He was known as Harry.

Harry became embroiled in a bizarre fracas with one of the local doctors in 1857, an undignified affray which reached the Magistrates Court through cross-summons and was reported with some incredulity and disdain in the local paper:

> The Bench were for some time engaged in hearing a cross-summonses brought by Mr Fitzmaurice, Surgeon, and Mr Harry Cox, Watch Chain Manufacturer, engaged against each other for assault. A private misunderstanding having arisen, a quarrel ensued between these two gentlemen ... On the fifth instant [Dr Fitzmaurice] called at Mr Cox's house for the purpose of giving a satisfactory explanation ... that Mr Cox was angry and made use of the most insulting expressions ... that Mr Cox came to him in a threatening attitude, holding his fist to his face and saying, "I am a better man than you. Take off your coat and I will fight you."... Mr Fitzmaurice [said] that Mr Cox then pushed him, saying, "Leave my house, you ruffian"...

31 Barry Cox: personal communication.
32 Ibid.

A scuffle ensued in which blows were exchanged and cuts inflicted, clothing torn and tempers raised. The account concluded:

> Much recriminative conversation took place between the two gentlemen, which was stopped by the Magistrates dismissing both charges, expressing their sorrow that the matter had been brought before them. Both parties said they were satisfied with having made their statements in public.

Not a great deal is revealed about the fusee chain industry by this undignified episode, except perhaps to supply more circumstantial evidence to suggest the Cox family might not have been composed of the most harmonious individuals, and antagonism was second nature to their affairs.[33]

James Oliver Barrow's will of 1859, in which he describes himself as a watch fusee chain manufacturer and chooses Harry Cox as an executor, confirms that the business was certainly profitable: he owned two houses and had recently built a group of three more in Bargates. If this was the case with the foreman, how much greater a fortune must have been accrued by the Cox family as owners.

Evidence for the scale of production from the three manufacturers around this time is provided by the next directory reference of 1859:

> The manufacture of fusee watch chains was introduced here in the latter part of the last century by Mr Robert Harvey Cox; and it now gives employment to about 500 hands (chiefly females) and almost exclusively supplies the watchmakers of London, Coventry and Birmingham, as well as America.[34]

The 1861 census thus falls far short of the actual numbers employed in chainmaking, recording a mere 172 (in 1851 the figure is 197); the difference is likely to be made up by children, whose occupations are merely listed as 'scholar', or the inclusion of the chainworkers in the other towns.

This census has Charles once again in residence, although old and blind, listed as head of household and his son, Price W. Cox, born in Ireland, the family member taking the title of fusee chain manufacture. The naming of

33 He is identified as the irascible and litigious party to the brawl in view of the unlikelihood of London-based Harry Cox the elder being in the town at the time.
34 *White's Directory of Hampshire*, 1859.

this son is tribute to a close affinity between Charles and his sister, Ann Maria, who married Thomas Price Wynne, and rather puts paid to the suggestions of a lasting family rift. Charles died at home at the end of the following year, aged 74.

The business was now in the hands of Price Wynne Cox, who is found listed under 'Nobility, Gentry and Clergy' in an almanack of 1867. An advert in *The Christchurch Times* in May 1870 indicates that the Cox house, a 'handsome residence', was up for sale or rent because its owner, T. P. W. Cox, is 'changing his residence.' Described as 'completed in first-class style, fitted with every comfort and convenience', the abode seems to have oozed with the affluence which chainmaking had brought the family. T. P. W. Cox certainly appears to be about to shut up shop, as it were, as the 'superior furniture' was also available at valuation. Almost a year later[35] it was readvertised as the buyer had withdrawn through illness; this time, a collection of valuable oil paintings was being disposed of as well.

Around the same time, an article reprinted in the local paper from the children's section of the December 1870 issue of *The Hearth and Home*, a New York publication, described the chainmaking industry from the sharp end:

> The Chain as Slender as a Horse-Hair
> In all English watches, there is a conical raised part called a fusee, around which a chain is wound. In fine watches this chain, made of steel, is about eight inches long and contains upwards of 500 links, riveted together. It is not thicker than a horse-hair, and the separate links can just be distinguished by the naked eye.
>
> Nothing as yet been discovered to take the place of this chain that at all equals it in strength, fineness and flexibility. Most of these steel chains are made by the young girls of Christchurch, in the county of Hampshire, England. They punch the links from thin plates of steel, and younger girls pick up the links and rivet one to the other. Their eyes must be very sharp and their fingers very expert to enable them to do this kind of work. How gladly they must welcome the bright Sunday morning that brings them comfort and rest! …

The 1871 census gives the occupant of the High Street premises as still Thomas P. Cox (the same person as Price W. Cox), employing 130 women

35 11 Mar 1871.

Christchurch the Fusee Chain Gang

and one man. There are only 55 other people giving fusee chain work as their occupation in this census and no figures of those employed are given for the other two manufacturers. Shortly after, probably later that year, the Cox family business was sold and Thomas Price Wynne Cox, known as Price, set out for Australia to join the earlier family exodus begun by his uncle, William, and continued by his older brother, Dillon. Before leaving, his friends laid on a farewell dinner for this 'respected townsman' at the adjacent Ship Inn, to 'prove to him the esteem in which they held him'[36]; one of the guests was Fred Hart, his rival chainmaker, described as a friend. Someone else, also described as a townsman, gave him 'some excellent advice which with his experience of fourteen years in Australia he was well able to do'.

The fate of the last Cox chainmaker was tragic. Having taken the decision to change direction in life so radically, from fine engineering to horse-dealing, which involved a long overland trek across the fledgling continent, he set off by sea in 1873 soon after his arrival on a mission to purchase horses north of Sydney and drive them overland to Port Darwin. The return journey was close to disaster, with Price and his team of six men so close to starvation they had to eat the horses they themselves were riding. Worse was to follow, when Dillon died after fighting with his own nephew, but the disasters did not end there. In 1875, Thomas Price and his wife and family all boarded a ship to travel from Port Darwin to New South Wales. That ship was the ill-fated *Gothenburg* which was wrecked in a storm of Queensland: all 102 passengers and crew aboard perished, at the time Australia's worst maritime disaster. Three little Cox girls and a son, aged between two and six, drowned, along with their parents.[37] *The Christchurch Times* was silent about the terrible fate of one of its former leading citizens.

Back in Christchurch, the new owner was one William Clarke and partners of Coventry[38] (surely, his origin is significant?) who continued the watch chain manufacture either on his own account or through his son, Edward Ernest, usually known as Ernest, a colourful figure of the town at the time more remembered for being the captain of the enthusiastic local bicycle club.

36 CT 19 October 1872.
37 Barry Cox, personal communication.
38 Street, Roger, T. C. *Victorian High Wheelers: The Social Life of the Bicycle: where Dorset meets Hampshire*

Ernest Clarke's shop in the former Cox house, 1881. (Courtesy Mrs D Aldridge)

As soon as the business was acquired, an advert was placed for 'Learners to the Watch chain making. Instruction provided and a small wage while learning. Apply at Cox's Factory, Meeting-House Lane'[39] (the older alternative name for Millhams Street), using the original name of the firm, but in 1876 another advert appeared: 'Clarke's Chain Factory. Wanted. A competent person to teach children to Rivet, and to look after their work generally'. Eighty-six years after the commencement of the business by Robert Harvey Cox, children were still being employed. A diary of G. H. Ferrey of Christchurch, the original lost but the transcript by Herbert Druitt surviving,[40] notes:

> At one time there was a bicycle club here and it decided to have a dinner at the Ship [next door to the former Cox house, now Clarke's]. Clarke [Ferrey's brother-in-law] was a member … they kept the high bicycles and gave up when the modern ones came into vogue. They also kept the Chain Factory after Cox had given it up, in Millhams Street where the Fire Station now is.

Mention of the Coventry connection is made in *The Christchurch Times* in an obituary of 1932:

39 CT 25 Oct 1873.
40 DRO: D/RHM 7795G.

The remaining half of the Cox factory c. 1960; another huge section abutted it – note the telltale ridge by the chimney. (courtesy Red House Museum)

> With the death of Mr Harry Trevis ... there passes one of the last few direct connections with the workers of that old Christchurch industry, the manufacture of fusee chains. A local man, born and educated in Christchurch, he commenced his grounding and apprenticeship to the fusee chain manufacture with Messrs Clarke of Coventry. Upon the advent of the firm in Christchurch, Mr Trevis followed them in order to be on his native heath ...[41]

That there was another centre for fusee chain production at Coventry confirms the previous evidence for Christchurch not having a complete monopoly of the production; furthermore, it has already been shown that the chains from Christchurch were used in Coventry and that in 1880 one Mendel Radges was listed in Kelly's as a watch fusee chain and hook maker there.[42]

Despite his professed occupation in the 1881 census, all Ernest Clarke's considerable energies appear to have been directed to a variety of other engineering projects, as the advert alongside from that year demonstrates. According to the *London Gazette* in 1877, the partnership of 'W. Clarke, W. J. Hyley and F Bayley, as Cox and Co, watch, fuzee and chain manufacturers'; was to be dissolved[43] and it is possible that Ernest continued in his own name for a time. By 1880, Ernest was using the Cox house as his bicycle shop, and probably still chainmaking in the workshop in Millhams Street behind. Instead of the familiar domestic appearance of the house, sewing

41 CT 18 June 1932.
42 Kelly's *Directory of Watch and Clock Trades*
43 Street, op. cit.

machines, horse-clippers, prams and skates jostled for position in the front window with bicycles, tricycles and even quadricycles, a lively sight brought to a sudden and premature end by Ernest Clarke's bankruptcy in 1885. Harry Trevis branched off as the advert indicates, confirming the decline and end of the fusee chain business begun by Robert Harvey Cox a few years short of a century earlier. A footnote to the fate of E. Ernest Clarke is that he appears in 1885 to have somewhat indefatigably had another stab at enterprise, with the appearance on the business scene of 'The Brewers' Grain Company', providing a self-explanatory service to the agriculturalists all around the area. Last traces of the factory appear in 1928:

> RELIC OF FUSEE FACTORY The Town Council last week adopted a recommendation of the Municipal Committee that the old crucible in the Fire Brigade station be offered to Councillor [Herbert] Druitt for his museum. Several members were interested in what the crucible was used for, and Alderman Lane enlightened them that it was used for the manufacture of the old fusee chains which were once made in the old Fire Brigade station. He added that the existence of the crucible was quite interesting to him, as he did not know that there was one there.[44]

The Christchurch Times

Strange to think of an artefact lasting for half a century beyond the demise of the factory; sad to say, its present whereabouts are unknown.

JENKINS & CO. 1813-1914

Although Vancouver's work of 1810 mentions the 'watch-chain manufactury' in the singular, when a local vicar, Revd William Bingley,

44 CT 24 March 1928.

Left: *c.* 1950 lateral view of the fusee factory. (Courtesy Red House Museum) Right: the factory location – marked on the left.

wrote his manuscript history of the town in 1813, he refers to two factories: another chainmaking enterprise had commenced. The name of the proprietor of this second factory first appears in the records in a directory of 1823, as Jenkins and Son, referring to a line of traders all named Henry Jenkins. One Henry Jenkins had inherited in 1792 from his father of the same name, plumber, glazier painter and brazier, a fair amount of property apart from the brazier's shop, and would have had plenty of capital to invest in a chainmaking enterprise. However, by 1830 the directory listing is for Henry Jenkins junior, i.e. the son in the firm's 1823 title. This son was called Henry Treasure Jenkins, who was born in 1801, and from his obituary we may glean that he had run the enterprise from 1819 or shortly afterwards, at the tender age of 18 or 19. After Henry Jenkins senior died in 1831, the papers granting the administration of his estate described him variously as a glazier, painter and ironmonger, not mentioning the chain factory. If he did set up the business, which is likely, he appeared not to have anything to do with it at the time of his death.

Robert Harvey Cox's practice of employing workhouse labour – and there is no evidence that he used anything else – may have resulted in the establishment of a second chain business to employ those who had learned the skills as young pauper inmates of the 'House'.

The factory after the fire. (Red House Museum)

The factory was at 10 Rotten Row, Bridge Street and the map alongside indicates that it was of considerable size. The business continued for almost a century. It was the last of the three workshops (factories is too strong a word) to close, and with its closure in or just prior to 1914 the chainmaking era came to an end.

After its closure, it was used as an antiques shop. The local antiquarian, Herbert Druitt, recorded in his diary in 1918: 'Hope has pulled out the lower part of the chain factory in Purewell and is going to make a furniture shop there.' It presents to the world an unremarkable brick building, long and narrow, as was the Hart factory which was purpose-built, and according to Allen White[45] burnt down in 1951, although it was, in fact, only partly destroyed and was rebuilt.

Henry Jenkins senior had married twice, first to Fanny Treasure, by whom he had at least four surviving children, Henry Treasure, Thomas, Catherine and Elizabeth. As a widower he married Ann (surname unknown). Henry senior died intestate, but worth the enormous sum of £3,000, plus stock worth £800. His widow stayed in the house and tried to carry on running the business, but was soon forced out of both by her stepson, Henry Treasure Jenkins, the chainmaking entrepreneur, who was the heir-at-law. In a case which went to the King's Bench, he instigated a vicious struggle with his stepmother. According to the surviving legal documents, he 'threatened to

45 White, op. cit.

The factory 2009.

take every advantage he possibly can' of her, and prepared to 'immediately proceed to disposses her of the possession and deprive her of any benefit which might arise if she were allowed to continue the business even for a short time'.[46] It emerged that his father had placed some mortgage deeds with his bank to prevent proceedings being taken against the other son, Thomas, who had become insolvent, owed the bank £300, and had absconded. The bankers refused to release the deeds. Eventually, Ann Jenkins agreed to a yearly sum of £52 in exchange for relinquishing all other claims. Chainmaking factories and family rifts seem to go hand in hand.

Henry Treasure Jenkins married Mary Hart in 1829, the daughter of William Hart and the sister of another William who commenced chainmaking in Bargates in 1845. In marked contrast to his ruthless treatment of his stepmother, he was a typical 'Corporation man', being by turn a burgess, twice mayor, and a churchwarden, which is unlike either Robert Harvey Cox or the Harts.

The guide to Christchurch of 1837[47] refers to 'two extensive establishments' employing 'hundreds of persons', so it is unfortunate that the census of 1841 picks out such a small handful. Presumably, the workers were equally divided between them: in the 1851 census Jenkins and Co is said to employ 'about 150 hands', reduced to 100 hands in 1861; no figures are given in the

46 DRO: D/RHM 268.
47 *Historical and Descriptive* ... op. cit.

1871 census but in 1881 the numbers had declined to 35 women and two men. The only census where figures for both Harts and Jenkins is given is in 1861, when it is 100 and 104 respectively. No figures are ever given for Cox's enterprise in the censuses, probably because most of them seem to have been children.

It is apparent from directory listings that clock chains were also made at Jenkins and Co. in the 1855 Post Office directory it is described as 'Watch and Clock Fusee Maker', and again in 1867 in Kelly's as a watch, clock and chronometer fusee and chain manufacturer. The 1881 census gives three names of workers describing themselves as fusee clock chain makers: two of them lived in Rotten Row and another on St Catherine's Hill. It is known that Harts made clock chains also, but not Cox and Co. An unexplained directory entry for 1855 has a Henry Y. Jenkins listed in the High Street in Lymington, just along the coast from Christchurch, as a watch and clock fusee chainmaker, but a search of the High Street in both the 1851 and 1861 census revealed no trace of such a person or enterprise.

Few insights into the running of these factories can be gleaned but at Jenkins and Co. a horrible fatal accident occurred in 1863 which resulted in an inquest (see overleaf). The unfortunate victim, George Heales, also appears in the Census Appendix in connection with a dismissal case of one of the factory workers. As far as the chainmaking aspect of the grisly affair is revealed, we learn there was a forge, a lumber room, and a 'little' factory, implying more than one building.

Henry Treasure Jenkins died in 1869, and the local paper described him as 'nearly 50 years a large employer in the town as a Watch Chain Manufacturer'; this confirms that the factory commenced soon after 1819, when he himself would have been 18. He left the factory to his wife, Mary, who continued the business as shown in the 1871 census and also an 1875 directory. Their daughter, Emily, was the last Jenkins to own and run the Rotten Row chain factory.

Solicitor's records[48] for 1856 refer to the firm as 'Jenkins and Jeans', suggesting an early association with the man who took over the running of the business, if not outright ownership. This was William Jeans, although he does not appear in the census until 1881, presumably after the death of Mrs Mary Jenkins. Around this time the Rotten Row factory was recalled by one Henry Vick, who had lived in the same house in Purewell (adjoining Rotten

48 Local History Room, Christchurch Library: Aldridge collection.

> **PAINFUL AND FATAL ACCIDENT.**
>
> An inquest was held on Saturday afternoon last at the Crispin Inn, by the deputy-coroner, Mr Richard Brown, upon the body of Mr George Heales, foreman to Mr H. T. Jenkins, watch chain manufacturer at Purewell, who lost his life by the accidental discharge of a gun on the day previous. It appeared that the deceased, who was an amateur bird fancier, had noticed a thrush, peculialry marked, flying about the garden of the factory, and he expressed a desire to have it for the purpose of stuffing. On the evening previous to the accident, he purchased some small shot and powder, and borrowed a gun belonging to his master. With these he went to the lumber room of the factory on Friday morning, opened the window, and it is supposed struck the lock of the gun against one of the supports of the bench. He was found shortly after the report was heard, in a pool of blood, quite dead. The room, when inspected by the coroner and jury on Saturday presented a shocking spectacle, several being visibly and much affected. On the bench, about the floor, and amongst the lumber were fragments of bone and flesh. The floor, in the place where the poor man had fallen presented the appearance of a slaughter-house, and on the bench facing the window, lay the whole of his brains. A more sickening sight cannot be imagined.

The Christchurch Times
10 October 1863.

Row) since his marriage in 1877. He described a Purewell entirely at odds with its appearance today, 'more like a park,' he remembered, 'with pleasant-looking old thatched cottages and gravel paths along which carriages and pairs were driven'. The couple called to mind 'the last of the old chain or fusee factories, which was situated in Coun. Hope's premises. This industry was fast dying out, and only old hands were engaged in making the extremely fine chains which were used for the interior of watches.'[49] A directory of 1889 has this to say: 'there is also a small trade done in the manufacture of watch and clock fusee chains and hooks.'

Dying the industry undoubtedly was, and it became necessary for William Jeans to diversify: two years after the census in which he described himself as a fusee chain manufacturer, the advert illustrated appeared, indicating that he had turned his hand to tricycle manufacture, but the next census shows that the chains were still being made even if in a small way. Harts was

49 CT 30 July 1927.

still going at that time, and work must have been hard to come by. It is curious how both Cox and Jenkins evolved into bicycle outlets – perhaps they made cycle chains.

No elegy to the lost art of chainmaking marked its demise by 1914, it just quietly expired. It was helped on its way by an old customer for the chains, Mercer's Chronometers, of St Albans, which has only recently closed down. A history of the firm notes:

> Thomas [Mercer] had always bought his chains from Jenkins, and Mercer's continued to do so until the end of 1914. During the 1914-18 war all the makers had closed down so supplies came from Lancashire and Switzerland. On Frank's return from the war in 1917 he at once took himself down to Christchurch and purchased all Jenkins' tools and stock from Miss Rose, the daughter of Jenkins' last foreman, so that the company could be self-sufficient in one more essential part of a chronometer.[50]

The Christchurch Times 06 January 1883.

A letter to the writer from the author's son, Frank, explained that his father had experienced great difficulty in buying chains at the time, and came down to Christchurch to collect the tools from Jenkins, returning in his de Dion steam car. The tools, he informed me, are now at the Horological Institute and at Prescot Museum (which has a fine watchmaking gallery). He also brought back a Miss Nelly Winters, who had worked at Jenkins' factory, to work in St Albans with him as a secretary and office organiser. His father's account of that period appeared is reproduced below.

> In the current number of your journal I noticed the article entitled "Antiquarians learn about fusee chain making".
> This brings back memories of fairly long ago during a serious time in our country's history. At that period I was a gunner officer stationed at High Wycombe, and was on order to go to another front on the Tuesday (the day being Saturday). On the Sunday morning a messenger came from

50 Mercer, Frank *Mercer's Chronometers*.

H. Jenkins' stamp.

Admiralty Headquarters calling on me to report to the Admiralty in Pall Mall on the Monday morning.

The Admiralty gave me instructions to take over the chronometer industry and demanded an output which was staggering. One link in the manufacturing chain was missing – Jenkins, the chain maker, had ceased to exist and no chains were available. I was soon down at Christchurch where the manufacture of chains had stopped. Mr Jenkins had retired, the shop was deserted, and only a dear old lady – Miss Rose – seemed to exist.

To cut the story short, speaking in my official capacity, I bought the place lock, stock and barrel. I went to see Miss Rose who kindly told me all she knew, and within a few days all the equipment was en route to St Albans. Subsequently this dear old lady gave me her Bible Box, which I greatly treasure to this day …[51]

WILLIAM HART & CO. 1845-1896

The last of the three chainmaking factories was started by William Hart and continued in the family in much the same manner as did the rival factories of Cox and Jenkins, until closure in 1896 on the death of Fred Hart.

Born in 1812, the son of 'Duke' (Marmaduke) Hart, a cordwainer (or shoemaker), William Hart grew up in a town which depended on chainmaking as its principal industry – only industry – and joined in the manufacture when demand was at its peak. His brother, Fred, appears in the 1851 census as a fusee chainmaker. William's first occupation, in which capacity he is listed in the 1841 census, was taxidermy, a skill he shared

51 The *Horological Journal* February 1967.

William Hart's Bargates house.

with Tom Barrow of Cox's. It may have been this connection which led him to follow suit in chainmaking; certainly, his taxidermy sideline seems to have been continued as a parallel activity throughout the period when he was also operating the factory. Another brother, Henry, did likewise, combining his boot and shoemaking business, undoubtedly learned from his father, with being a 'bird preserver' (in an 1859 directory) and by the 1871 census a 'Master taxidermist'. This was just as well as he had gone bankrupt with the shoemaking in 1868. He was also convicted of a serious assault in 1851. William's 1841 address was Rotten Row, where he would have been near the Jenkins factory, his relations by marriage. All in all, he would have understood sufficiently about the trade to realise that there was enough demand to keep yet another factory busy.

In 1844 at the age of just 33, the young William bought a large house in Bargates, possibly much older than its eighteenth-century frontage, with a walled garden and outbuildings such as a brew-house.[52] On the land at the rear of the house he constructed a long and narrow brick-built two-storey factory in the garden, measuring 72 feet in length and 17 feet wide and designed to let in as much light as possible. The picture at the end of this chapter is misleading in that the upper half of the first-floor windows are now covered. Over the front entrance a stone roundel proudly proclaims the function of the new building: note that, like Jenkins, William Hart also made clock fusee chains here. The position of the new factory could not have been more ideal, capitalising on a ready labour market in the crowded

52 *Poole Herald* 22 June 1844.

Left: Frodsham's Hart chain display. Right: Frodsham's Hart trade card. (Courtesy Charles Frodsham & Co. Ltd) (see colour section)

cottages of the poorest people in Christchurch, in the Pit site, just over the garden wall, as it were.

Having bought the Bargates site and built his factory, William settled down in the house on the site with his wife, eventually producing a sizeable family of nine children at least, one of whom was another Fred, who became heir to the business once both parents had died. He insured his house in 1851, which was described as built of mud but encased in brick, to include his collection of stuffed birds. Fred, his brother, was in the interim living in the High Street but also describing himself as a fusee chain manufacturer, so must have been involved in the business from an early stage.

William must have been a man of considerable energy and initiative: apart from setting up and managing two entirely differing enterprises, he found time to take part in community affairs. Not for him the usual progress through the offices of the unreformed corporation, burgess, mayor, alderman – as pursued by Henry Treasure Jenkins, nor did he share that gentleman's enthusiastic support for the affairs of the church. William was more of a radical, and barely had the mortar dried in his brand new factory when he hosted a political meeting in 1847 in support of the Liberal Parliamentary candidate against the entrenched Conservative member. Mr Jenkins was a supporter of the Conservative, establishment candidate. The meeting in Hart's chain factory enthusiastically endorsed the candidacy of their Liberal man, but in the end he was defeated. William Hart, like many of his fellow townsmen, wished to break away from the vested interests of the landed proprietors, of whom the victor, Captain E. A. J. Harris, was one.

It must have been a matter of some pride that the only entry from

Christchurch to that tremendous celebration in 1851, the Great Exhibition, was an exhibition of fusee chains from Hart's factory. The entry, No. 113 in Class 10, Philosophical, Musical, Horological, was made in the name of 'William Hart & Co., Manufacturers: Chronometer and watch fusee chains of different sizes'. It was a fortuitous discovery when the writer located the actual entry in 2004 at an antique clock dealer's collection in London, where the pictures illustrated were taken (pages 4 and 166).

Praising the Harts' entrepreneurial spirit, the newspaper commented: 'The extent to which this branch of manufacture is carried on here, and the beauty of the articles produced are not generally known.'[53] The Great Exhibition was a remarkable event which left a deep impression on the ordinary person, and people's desire to witness the marvels on display from all around the world was addressed by the creation of organising committees to enable this to be achieved. Many people of 'the mechanical and working classes' from Christchurch would have taken advantage of the careful arrangements made on their behalf; it is tempting to imagine them gazing at the display of fusee chains from their own town. Perhaps some of these visitors had actually played a part in making those fine chains.

Ironically, fusee chainmaking was by this time superseded by the going barrel. The Exhibition featured entries from all over the world, and the usefulness of the cheaper, newer method of regulating the mainspring would have been a most conspicuous element of the horological entries. The impact which this made was a factor in the decline of the English craftsmen-watchmakers, in favour of mass-produced timepieces from Switzerland.

To have an entry from the town was creditable enough; how much more rewarding it must have felt to the workforce to hear about the outcome:

> The Commissioners for the Great Exhibition have within the last week forwarded to Messrs Hart and Co., a splendidly bound volume of the jurors' reports, and engraved testimonial signed by the Prince Consort, and a bronze medal, in token of their sense of the services rendered to the national undertaking in exhibiting specimens of the local trade of Christchurch, consisting of watch-chains and fusees.[54]

William Hart died at the relatively young age of 56 in 1868, but despite his economic contribution to the life of his home town he does not merit an

53 *Poole Herald* 13 March 1851.
54 *Poole Herald* 2 September 1852.

Notice.

WANTED an experienced PASSER, also a LOOKER OVER, or two good Rivetters to learn the Passing and Looking Over.
Apply to Mr. Hart, Manufacturer, West End.
N.B. Wanted Rivetters and Wire Workers who can have full employ, or Girls as learners.

Above: chain tools. (Courtesy Charles Frodsham & Co. Ltd) (see colour section)
Left: Hart's ad for staff. (*The Christchurch Times* 3 September 1863)

obituary in the local paper. His widow, Sarah, and daughter Emily, carried on the business, employing, by 1871, 'about 76 females' (census returns), from a high of 104 females and two men in 1861 (there are no figures given in the 1861 census). His son, Fred, was living in the High Street and also described himself as a watch fusee chain manufacturer, so was probably playing a major role in the running of the business with his mother and sister, who were still living in the Bargates house, whilst he was bringing up his own growing brood in the town centre.

Ten years later, Mrs Sarah Hart was living alone in the Bargates house with just one servant, and Fred was still in his High Street house with his wife and five children (one of them, Fred III, born *c.* 1879), but by then employing only 40 women. The term 'women' at this stage may be significant, since previously the term was 'females': an impression is given that this latter term covered both adults and girls. The Education Act must have had a profound impact on industries such as this which had employed cheap child labour. But Fred was in trouble financially: fusee chainmaking just was not paying. In 1882 he was forced to remortgage his house and factory for £500, and then could not repay it. A local solicitor,

CHRISTCHURCH. HANTS.—Within five minutes' walk of the Railway Station, and ten minutes by train from Bournemouth.

STAINER & SONS are favored with instructions from the Executors of the late Mr. Fred Hart to SELL by AUCTION, on the premises, on WEDNESDAY, June 3rd, 1896, at 3 p.m., the valuable FREEHOLD PROPERTY, being No. 10. Bargates, Christchurch, possessing a frontage of 59ft. to the main street, with a depth of about 206ft., comprising the conveniently-arranged brick and slated Residence, containing the following accommodation: a well apportioned drawing room, dining room, four good bedrooms, entrance hall, kitchen, scullery, larder, cellar and domestic offices, &c.; together with the detached two-storied Factories (72ft. long and 17ft. wide), a two-stall Stable, Coach-house, and Outbuildings; a walled-in Lawn, and Garden well-stocked with fruit trees. The Property is admirably adapted for any business requiring space, with a side entrance, and sufficient ground in rear for the extension of present buildings.

Particulars and Conditions of Sale may be had of Messrs. Risdon D. Sharp and Rumsey, solicitors, Christchurch and Bournemouth, and (together with Cards to view) of the Auctioneers, Christchurch and Stourvale.

ON TUESDAY NEXT.

No. 10, BARGATES, CHRISTCHURCH.

STAINER & SONS (having sold the property) are favoured with instructions from the Executors of the late Mr. Fred Hart, to SELL BY AUCTION on the premises, on TUESDAY, 23rd June, 1896, commencing at Two o'clock, the excellent FURNITURE AND EFFECTS of the residence, including in drawing and dining rooms—a Spanish mahogany Suite in hair cloth, set of dining tables, a Spanish mahogany sideboard with cellarette, antique rosewood table, cupboard, &c.
Proof Engravings, Oil Paintings and Water Colours, Books, Bagatelle Board.
The Furnish to Four Bedchambers.
China Ware, Glass and Plated Articles.
The Fittings to Hall, Staircase and Landings, Kitchen requisites, a patent mangle.
Out Door Effects—a 19in. iron roller, two lawn mowers, garden tools, vases and rockeries, garden seat, dog's kennel, 40 pigeons, single barrel gun, fishing rod. Also, a smith's anvil and pair bellows, two dozen watchmaker's vices, wire mill, bench screw, carpenter's tools, pair large shears and block, stove, oil drum with tap, a turning lathe with 30in. bed, tools, and numerous other items.
On view morning of sale after Eight o'clock.
Catalogues may be obtained of the Auctioneers, Christchurch and Stourvale, or sent free by post.

Adverts for Hart's business. (*The Christchurch Times* 19 June 1896 et seq)

Risdon Sharp, bailed him out to the tune of £500.[55] He was 'borrowing from Peter to pay Paul'.

The last census appearance of Fred in 1891 finds him widowed and living in the Bargates house with two of his sons, including the young Fred, and one servant and his brother-in-law. Five years later he too had died an early death, virtually at the same age as his father William before him. It is hard not to put this down to financial pressure from the collapsing market for fusee chains.

The factory was then put up for sale on his death: the two adverts from *The Christchurch Times* provide further information about both house and business. Some idea of the equipment installed at the factory is gleaned from the Out Door Effects, which included a smith's anvil and bellows, watchmakers' vices, a turning lathe, and a wire mill (an object of considerable size). This last indicates that one of the raw materials, the wire, was made on site – we already know that the tools were also made in the factories. The lot was bought by Mr Bemister, coal merchant, for £800.

It might have been the end of the factory, but it was not the end of Harts and chainmaking. Young Fred III took on the mantle. Only a teenager at the time of his father's death, he went off to Reading at some stage, taking with him some tools and materials, and set up business there. A trade card survives in the Red House Museum in Christchurch in which he announces

55 DRO: D/RHM 6016.

the fact of trading in both towns. The firm remained in the name of his father, but no Hart at the Reading address is found before 1911. There were at the time about a dozen watchmakers in Reading who may have bought the chains from him, but no trace of the enterprise has been discovered (yet) in trade directories for that town. In 1926 the following letter appeared in the *Christchurch Times* from Fred Hart:

> I recently had sent me a cutting from your paper referring to my uncle's museum [a famous High Street collection of thousands of stuffed birds etc owned by Edward Hart] and my father's chain factory ... you may be interested to know that I am keeping on the business at Reading, and, with the assistance of one of the girls my father used to employ, still sellng a few chains. When I was at Christchurch last summer I went to the Museum at the Red House [when opened as such by its owner, the antiquarian, Herbert Druitt] ... with the idea of offering a complete set of chains and tools to be placed in same, but found it closed ... I think perhaps a set of my father's chains would be of interest to many people at Christchurch. Fred Hart, 81 Whiteknights Road, Reading.

How perspicacious of Fred. Some tools from Harts have, however, survived, but from a different source: from 'the last of the chain workers', which title Mrs Rose Andrews can almost certainly lay claim to. Her account was recorded by Allen White in 1967 or just before, and the following is taken from the transcript which appeared in his book *The Chain Makers*. Of additional interest is an extra tape which appears for the first time in print. Mrs Andrews speaks of a time when the industry was in its death throes; even when she was a toddler watching her mother at work it was in decline, but because her mother, Charlotte Drover, was also a chain worker we are able through her account to reach back into a time when chainmaking provided employment for many young women.

Rose is recalling events of at least 70 years previously: by 1901, her mother was sewing shirts for a living, and Rose herself was a nursemaid to Alan Druitt, no longer a chainmaker.

Rose Andrews: The Last Chainmaker[56]

He used to go twice a year, in the winter and in the summer, to manufacturing places like Manchester and London and different places to

56 Courtesy of M. A. Tizzard.

The Christchurch Fusee Chain Manufacturers

Left: Banister advert. (Courtesy Rita Shenton) Right: Emily Hart.

order, to get orders, and, well, but I couldn't tell you what. There was a Mr – I told you, I think – Mr?

Have you heard of anywhere else in England where these fusee chains were made?

No. I understand this was the only place.

I understand you did some work for Mr Jeans. [i.e. at the Jenkins factory]

Well, that was only the hooks; I made hooks for him. That's what I did for Mr Hart except I helped Miss Hart get out and card some of the chains ... I never done anything else.

Did you ever go down to the factory in Rotten Row?

No, I never went there, and I didn't even know Mr Rose. But he used to, after Mr Hart died, cut the hooks, and whatever they used them for I don't know ...

Did Mr Hart ever have any watches in the factory? Did he used to put the chains in the watches himself? Was he a watchmaker?

No, I don't think so. He had watches and showed me with the chains; he used to call them English lever watches ... And, of course, they were bigger ... different to the watches today – he used to say there wasn't room in the new watches to work from really ... He was always work, work at home. He would wanted [?] craftsman seeing to the tools, for cutting the links, or doing something, and sending them out, that sort of thing. He was always busy.

I believe you said that after the chains had been made they put lime on them.

They put them in a layer of slack [slaked] lime. I don't know – it was a white powder, you see, and it used to be dried because it was supposed to

171

A display of chain hooks. (Courtesy The Hampshire Museums Service)

keep them from rusting ... *You were saying that your mother made the chains in this room in this cottage in Wick Lane, where we're speaking now.*
Yes.
When did your mother come to this cottage?
It would be 89 years since I was born here and they were here I think ... not the autumn before that – in 18 and 76 I was born – I think in 18 and 74.
Your mother was a Christchurch girl I suppose?
Oh yes. And father's people were all Christchurch people.
Your mother made fusee chains; I suppose went into the factory in her young days?
Yes; there were some things that they could do at home and people had it at home 'cos they could see to their families and that in their work at home. But there were some things that they had to go into the factory for: cutting the links, the presses was there; oh, I did cut some cufflinks, I remember, for a little while; they weren't done with the hammer coming down, they were done with presses on the bench and you went backwards and forwards like this and as you went back it came up and down. And it wasn't hard work. That would be burred, as I was telling you the other day; of course, the sewer was under ... 'cos they'd be bigger in proportion.
The very small links were so small I wonder how you were able to pick them up? Did you have tweezers?
No! You picked them up on the wire. You had them down here where you see a little sort of hole and you picked them up on the wire and then two round – no – two flat and one round –
I see. The one round would be the –
Flat to the other side underneath. And then that would belong to the rivet, to be hammered, you see. The rivets were struck off and that, was hammered

down and had room to be hammered. It was just plucked off, like.
I was telling you that I've made a lot of enquiries and I've advertised and I really think you're the last of the chain makers.
I expect so. You see, there was nobody after me, 'cos, well, when Mr Hart died it was shut up, you see, and it was only if there was anybody at Mr Jeans' – he would be the last one, where Mr Rose worked (he was the manager), and I don't think they would take on any other young ones, 'cos you see there was nothing doing; I mean, it was dying out. I expect I was the youngest …
No. He'd have some at home and some come underneath. At one time there used to be full up, upstairs and down, in my mother's time.
Mr Hart lived in the big house?
Yes.
Have you ever been in there?
Yes. Nice house. Nice big rooms and the kitchen and all. Nice. Plenty of rooms.
I suppose he had a lot of stuffed birds in the house, as his brother was a taxidermist?
Well, I couldn't think so. His mother and father lived there in the early days, then his mother went down to Purewell and lived, just past Hengistbury House, on the other side of the road with … she died there as far as I remember. I can only remember Mr Hart's brother … at the museum.

Extracts from transcript published by Allen White in The Chain Makers: Mr White commented that the parlour in which he conducted the interview had an extension to the windowsill where Rose Andrews' mother sat and made chains a century before. Mrs Andrews donated a small hammer, anvil and link punch to the local museum.

How old was your mother when she started work at Hart's?
Well, I should think she was in her teens. I have never heard any of the old ones say that children did the work. I don't think they could have done it: the work was so fine they couldn't have fingered it.
Well they did you know, but that was before your mother's time … I have spoken to several watchmakers and they say that the work was so fine that you must have used a magnifying glass.
Well! That's another thing you can tell 'em. We did not have a magnifying glass. We had to work with both hands. I've got a little glass like a jeweller's glass, but you couldn't keep that in your eye for long. I've seen them making the wires and making the chains and I've seen them cutting them with the tools, and, I meant to tell you, some of them were cut with presses and some worked with a hammer which was worked with the foot.

The links were cut from steel strips, I suppose?
Yes, and there was a tool that came down, with three points to make the holes for the rivets. The wires were cut with shears in lengths to make the rivets.
How many girls worked at Harts?
There were so many working at home. There were not many at the factory. They had to come to the factory to do the cutting [of] the links and for finishing and burnishing. The wires they could do at home, and riveting they could do at home. I think there were about eight in the factory when I was there. In my mother's time the factory was full of girls upstairs and down.
When you was there the industry was in decline?
Oh, yes.
How much money could you make in a week?
It was from 9 till 1 and from 2 till 5; that would be seven hours. Seven fives are 35 and then there was three hours Saturday morning – that was 38 hours ... People say it was poor pay and that sort of thing, but, poor man, I'm afraid he never made a fortune out of it and I don't suppose his father did before him. The most I ever made was 8s 6d a week. I reckoned to make about 2¼d an hour. I used to do the hooks: I had to file them and polish them. That took two hours a gross – 4½d a gross – about 2¼d an hour in them days. My mother spent many hours at that window, and she used to do 14½ inches of chain for 7½d. Of course, money was a different value in them days. She used to reckon to make half a crown a week. And the people with the wires, about 70 in a bundle, about 2½d or something like that. A shilling was something in those days.
How long did it take your mother to make a chain?
Well, I couldn't really tell you. She used to do it at odd times during the day between her housework.
How many chains did you take to the factory on Saturday?
Oh, four – that was her week's allowance. She got half a crown for those. She used to say it paid the rent.
When you took the chains back to the factory Mr Hart would test them, I suppose?
Oh yes. I used to take Mother's work to the factory on Saturday and Mr Hart would test them. They were pulled round a rod sticking up from the bench, pulled this way and that. They also had to hold up a certain weight. Sometimes they did break and I had to take it home, but not often.
Can you remember anything else?
When the chain was made up it was hardened and tempered. Running down the centre of the room was a long bench called 'the pound': there they were tested.
Do you remember clock chains being made?

The Christchurch Fusee Chain Manufacturers

Hart's Fusee Factory. (see colour section)

Oh yes. They were much longer and the links were about ¼ inch long. I have seen Mr Hart hold up a clock chain about 20 feet long.
How long did you stay at Harts?
After Mr Hart died in 1896, I stayed on and helped his daughter, Miss Sally Hart, wind up the business until 1899. They were a very nice family to work for.

Leonard Weiss[57] remarks that the output implied by the responses of Rose Andrews, who claimed to be able to file and polish 144 hooks in two hours, would have amounted to 150,000 hooks per year. He further concludes that as the watch production in London in 1797 is thought to have been some 144,000, the Christchurch chains could have satisfied the entire production needs of the capital, with some to spare, perhaps to be exported.

It is inexplicable that after Mr White recorded such a fascinating interview with the last chainmaker, he had the following to say in an article in *The Christchurch Times* in 1967:

57 Weiss, op. cit.

Christchurch the Fusee Chain Gang

Old Fusee Factory in Bargates Safe from Demolition for the Time Being
A lease to the present tenants, Dacier Ltd, for a further 21 years is almost bound to be granted by the owners. Mr [Allen] White felt that his book had inspired the wish to preserve the factory, when it was in danger of coming down for road widening schemes. 'The only buildings worth preserving to my mind are those which are architecturally beautiful or those which are of historic interest. The factory is a bit of an eyesore and I feel it is unnecessary to preserve it now that a record has been made and pictures taken.'

Fortunately for posterity, the surviving dog-eared old photo or two is not all that has survived: Harts' Fusee Factory has been restored and is still in commercial use, no longer an eyesore.

Hart's Fusee Factory. Hart's 'Watch and Clock Fusee Chain Manufactory 1845' showing plaque close-up on front. (see colour section)

176

CHAPTER SEVEN

OTHER CHRISTCHURCH OCCUPATIONS

Silk Stockings

> The poorer sort of women in the town and its vicinity are chiefly employed in knitting stockings, by which means they earn on average about 4s a week. Not less than 1,000 people are engaged in this manufactury. It is an observation that young women brought up in this employment rarely make good servants.

Despite this allusion in the *Hampshire Repository* of 1799 virtually nothing has survived to shed any light on the stocking-knitting industry – or the inexplicable adverse effect it had on female domestic staff – which other sources describe as predominantly one of silk. We do not know from where the silk was obtained or which markets the finished product was sent to, but can be certain that almost all the output would have been sold on outside the town, probably in London, because it was only affordable by the wealthy, of whom there was a dire shortage in the immediate locality.

Knitting in general as a process appears to have originated in either Syria or Egypt by the 3rd century AD and by general agreement amongst textile experts, spread to Spain, but other contenders are France or even Scotland. The technique was first applied to wool, and coarse knitted stockings were in use in England by the late medieval period. The earliest silk stockings found were in the tomb of a Scottish Bishop who died some time after 1545, but their popularity amongst the followers of fashion only became assured when Queen Elizabeth was so impressed by a pair presented to her by one of her ladies-in-waiting, that she regally declared that from henceforth she would wear stockings only of knitted silk, and never again should the inferior cloth predecessors adorn the royal legs.

1863 Stocking Knitter's Manual. (Courtesy Hampshire County Museums Service) (see colour section)

Queen Elizabeth was not the first royal person to own silk stockings, for it is recorded that her father, Henry VIII, was presented with a pair from Spain, but the Queen's were English-made, and her approval must have given an enormous incentive to the commencement of the domestic industry. Later developments accelerated the trend: the huge influx of Huguenot refugees after 1685 gave rise to the English silk industry, concentrated on Spitalfields. The only silk manufacturing centres close to Christchurch were at Sherborne in Dorset and Tiverton in Somerset, in the eighteenth century.

Silk is especially suitable for being made into stockings on account of its fineness combined with toughness, elasticity and warmth. It can also be

A girl winding silk. (Tomlinson)

easily dyed, and drapes well, but its cost confined its use to the upper classes, largely as part of the costume of the men, despite the story about the Queen. Hand-knitted silk stockings quickly became a boom cottage industry, employing thousands of women, and the development of the stocking frame at a very early date did not immediately affect the demand, for hand-knitting produced a finer, superior product which was only overtaken by the development of more advanced frames in the eighteenth century. As a cottage occupation it was ideal, especially in a town such as Christchurch, since it could be turned to when other livelihoods were not available, such as in a fishing slump or at slack times in the farming calendar.

For some reason, the town may have been the instigator of the trade, for in 1798 it was asserted that Christchurch 'is thought the first place in England for knit silk stockings'[1] – an assertion repeated by Vancouver in 1810[2] – but when this commenced is impossible to say. Christchurch has been known for centuries for its mercers, or dealers in luxury cloths, of which silk is one, who were concentrated in Castle Street near the marketplace, and it could be that these merchants dealt also in locally made silk stockings from a far earlier date than the eighteenth century for which a little evidence survives. A rival to Christchurch is recorded by Daniel Defoe in his *Travels* of 1724: Stourbridge in Dorset was 'once famous for making the finest, best and highest prized knit stockings in England'. English stockings were considered to be far superior to those produced in France or elsewhere, and their production involved a considerable amount

[1] *Universal British Directory*
[2] op. cit.

of skill, as a variety of stitches and patterns would have been used in the process.

Writing in 1774, Postlethwaite[3] attributes the demand for silk stockings to the ever-changing styles in fashion, originating in London, the 'metropolis, centre of fashion'. The Industrial Revolution created a new wealthy class which was able to afford such luxuries, demand for which appears to have peaked in the late eighteenth century, and by then they were worn by women as well as the men. The men usually wore white stockings; the women either white or black. The prices could be prohibitive, and certainly would have been for the people who made them: between 12s and 14s per pair, as opposed to about 8s for a cotton pair in 1780.[4] Worsted stockings cost a mere 1s 3d per pair in 1811, made of grey or white wool.

The restrictions on the importation of raw silk during the Napoleonic Wars and the development of finer cotton stockings, as well as improvements in the machine-made products, caused the decline and eventual extinction of the hand-knitted variety. Their manufacture in Christchurch had recently ceased, according to Bingley,[5] a few years before 1810, but it had hung on far longer in this town than in many other centres. The fact of an import ban would have been good news to the local smugglers who would only have increased their business, and gives rise to the suspicion that the stockings were made from contraband silk. Silk was certainly a smuggled product, well documented, but it is not known whether the yarn was smuggled as well as woven silk. It is difficult to believe that an industry could depend on such an unreliable supply of raw materials, but the enormous scale, ingenuity and organisation of the smuggling fraternity cannot rule out at least a partial dependence.

The stocking-knitters worked for hosiers, and there were three major employers in Christchurch in the eighteenth century: John Raindle, John Aldridge and Moses Sleat.

John Aldridge is listed in a directory of 1784 as a hosier, and in a 1792 directory as a 'manufacturer of silk and worsted knit hose', and his shop was in the High Street and still survives although there is very little of the original fabric visible. He died in 1803 and the shop was sold together with the stock-in-trade of his business as mercer and clothier. The outbuildings

3 *Dictionary of Trade and Commerce*
4 Farrell, Jeremy *Socks and Stockings*
5 op. cit.

included a dyehouse and a two-storey workshop, and great emphasis was placed on the garden ending at the Mill Stream, 'which is of much importance to the business', it is stated in the sale advertisement.[6] Before it belonged to John Aldridge, it was owned by one Pittman Blanchard; a James Blanchard was described as a hosier in 1814 in his will, so the use of the premises as a hosiery manufactury and shop may predate Mr Aldridge's ownership. The premises were purchased by a linen draper and presumably no further hosiery manufacture was carried on. Today it is Abbey National.

Moses Sleat is described in the 1792 directory as a manufacturer of hose, mercer and draper. The accounts of the builder, John Pillgrem, include work for shop hatches and a handle for a mill, 6s for one dozen stocking legs (1778), 16s paid 'to the warping bars' (1783) and to 'repairing of Shittles [shuttles?] at sundry times, 2s', references to what appear to be weaving processes and to what may have been his stocking-making business. A close relative, Luke Sleat, was a mercer, draper and haberdasher; after his death his stock-in-trade was sold in 1775 and included 130lbs of sewing silk.

The most interesting of the three connected with the manufacture of stockings is John Raindle. He had married into a family of clothiers and weavers (Keay and Kitch) and is listed in the 1784 directory merely as a hosier but in 1792 as a 'Clothier, Mercer, and Manufacturer of Silk and Worsted Knit Hose'. His business premises appear to have been in Rotten Row, part of Bridge Street in Purewell, almost certainly at what is now called Tyneham House, which when sold was described as having been an extensive woollen manufactury. John Raindle was also the owner of an early industrial warehouse still surviving in the town centre, tucked away behind the High Street shops. Mr Raindle, like Robert Harvey Cox, the first chain manufacturer, employed workhouse labour for making stockings, as to a lesser extent did Mr Sleat, in the 1790s. John Raindle died intestate in 1794, after which the business was sold, including detailed stock:

> To Be Sold By Auction by Messrs Hookey and Son on the premises on Tues 17th inst. and following days, The genuine and entire STOCK-IN-TRADE, one common and two velvet Palls, working Utensils, Dye Stuffs, Household furniture and other effects of John Raindle, late of Xch, Draper, Mercer, Haberdasher and Hosier, deceased. The stock consists of superfine, broad, narrow and elastic cloths, fearnoughts, flags, kersey-meres, linseys, serges, kersey and plain baize, beavers, swansdown, toilinets, corduroys,

6 SJ 9 January 1804.

Silk stocking factory.

velverets, velveteens, Scotch camblets, shalloons, white jeans, pocket fustians, worsted and sattin florentines, armozeens, lastings, barragins, durants, duroys, gilt, plated and horn buttons, plain and striped wild boars, cotton and silk handkerchiefs, half-ell, three-quarters and yard-wide modes, persiants (2), farsenets, plain and figured ribbons, crapes, buckrams, children's and women's stays, dimities, plain and figured muslins, yard and ell-wide prints, Irishes, Manchester and Weymouth cottons, brown Hollands, tapes, thread, men's worsted knit and plain , singularly constructed Organ, Pictures, Natural History, Elaboratory, Materia Medica, extensive collection of Plants; Books; Farming Stock; Implements; Growing Crops fancy cotton hose, white worsted, large quantity of scoured yarn, lampty and pinions etc etc.[7]

Is this the silk stocking manufactury pictured above? I think so, and it is seriously threatened with demolition.

Pinions are 'cogged spindles engaging with a wheel' (OED); perhaps tools of the stocking-making process.

With the death of these three merchants, the silk stocking manufacture in the town appears to have come to an end. Unfortunately their wills reveal nothing further about their businesses, and no inventories or accounts survive. It is plain from the meagre information surviving that there was, as might be expected, a parallel knitting industry in woollen or worsted

7 SJ January 1795.

stockings, which survived far longer than that relating to the luxury end of the market, and would have been to serve the local people. Vancouver in 1810[8] refers to this as 'carried on to a very considerable extent'. Working with worsted was probably what was being done in the local workhouse in the nineteenth century, when there was usually a handful of people knitting hose. A sole reference to an employer is to be found in an 1823 directory: Henry Preston, 'knit hose manufacturer'.

The Book of Trades (1804)[9] describes the system which controlled the outworkers:

> The wool-comber ... appoints a day, generally once in a fortnight or three weeks, when he will meet his spinners and knitters, to deliver out his wool and his worsted to be spun and knit. The poor women and girls of the village meet him on the day appointed with their work, return what they have spun or knit, and take other work instead. But the money they obtain ... is rarely more than six-pence of eight-pence a day. The wool-comber afterwards dresses the stockings by stretching them on a wooden board, the shape of the leg and foot, having previously caused them to be scowered [sic] or dyed, as the colour or colours require, and then he packs them up, either in a dozen or half-dozen pairs, for sale ...

Coarse-knit stockings, the manual goes on to say, 'are preferred and worn by the common people in most parts of England, particularly by the men'. The hosier's role was to purchase the finished product from the manufacturer and sell them on; in Christchurch these roles usually appear to have been combined. The reference to dyeing explains the dye-house in the garden of Mr Aldridge's house and workshop and John Raindle's dye-stuffs; the wages mentioned confirm the figure given in 1799 for silk stocking making. i.e. 4s a week, a wage described as 'miserably low, but a vital and often only means of earning a living'.[10] No wonder the introduction of fusee chainmaking in 1790 was so successful. Here is what one of the recipients on parish relief thought about stocking-knitting:

> I was born in Christchurch ... and am fifty years of age and upwards. My settlement is in the parish of Ringwood ... I used to knit a pair of

8 op. cit.
9 op. cit.
10 Hartley, Marie and Ingilby John, op. cit.

> WANTED good STOCKING KNITTERS.—Apply at Mrs. Attewell's, High Street, Christchurch.

Stocking advert. (*The Christchurch Times* 03 September 1864)

stockings each week and secured 1s per pair from the Parish officers – this was the manner in which old persons were relieved at that time in the Parish of Ringwood about fifteen years ago ...[11]

The children in the local workhouse were taught how to knit as part of the 'Industrial Training' element of their education; probably as a method by which a family wage could later be supplemented rather than as a purely domestic skill. Its economic importance to the poorer members of the community were well recognised:

> Knit stockings are considered so much better than woven ones to wear, that it is advisable for all servants, cottagers and labourers invariably to adopt them, as the former will last out three or more of the woven, which are more suitable for the higher classes.
> The children of the poor should always be taught to knit, and each member of the family ought to have a stocking in hand to take up at idle moments, by which means many pairs might be completed in the year.[12]

A last echo of the Christchurch silk industry is to be found in the accounts for the workhouse, which in 1819 paid for some of their children to go by cart to Sherborne 'to be teached in the silk manufactury' there, after which no more is heard about this once-thriving cottage industry and it has vanished from the communal memory as if it had never been. A strange observation about an occupation restricted to the poor, mostly female, some of whom were workhouse inmates, which employed large numbers of people over a century or more – just the same as did the famous fusee chain industry.

Glove-making

Parallel with the knitting of worsted stockings was the manufacture of knitted gloves, which Christchurch shared with its neighbouring town to the north, Ringwood, but the latter town also made leather gloves, which does not appear to be the case in the former – but it is not possible to be categoric about it. In 1764 the town of Christchurch's 'chief manufacturies' were silk

11 Examination of Mary Pelley, spinster, at Lyndhurst, 1842; HRO 25M84 PO82/9.
12 Anon *The Workwoman's Guide*.

Glove advert. (Leicester City Museum & Heritage Services)

stockings – and gloves.[13] That there were several glovers in the area in the eighteenth century is also apparent from the Clingan's apprentice records, commencing 1736, and earlier deeds and wills, from which we know of the following glovers:

Nicholas Gale of Christchurch, will of 1670;
Nicholas Clarke of Christchurch, admon of 1718;
Edward Burt of Christchurch, will of 1720;
Moses Belbin of Christchurch, will of 1721;
Joseph Burden, taking an apprentice in 1738; admon of 1760;
Joseph Price of Rotten Row, Christchurch, will of 1744;
John West of Christchurch took an apprentice in 1775;
George King of Purewell, Christchurch, took an apprentice in 1788;
John Hulbert of Christchurch took apprentices in 1799 and 1806 (bankrupt in 1807: as both a glover and a breeches-maker his work might well have been in leather).
Mr Joseph Henry Taylor is listed in an 1867 directory as farmer and

13 Anon *The Beauties of England*.

glove manufacturer at Winkton; his name comes up frequently enough to imply there was a considerable local business in this village just north of Christchurch.

Leather gloves were a vital commodity in an agricultural region, affording protection to the hands from injury by close contact with undergrowth or farm animals. However, it is once again the knitted variety which has a more documented record, and which was acknowledged as being commercially important in a guidebook of 1799[14,] which described glove-making with the silk stocking trade as a 'principal manufacture'.

It was possibly one of the many workhouse sidelines, for it is recorded in 1774 that one Hannah Hendy paid the Overseers 3s for the poor making gloves. Hordle workhouse, just across the parish boundary to the east, certainly employed its inmates on the work, six or seven of the forty inmates being listed as knitting gloves in a surviving return of 1815[15] The gloves were knitted for a Lymington merchant: 'Received of Mr Good for knitting of 2 Dossen and 3 pear of Gloves at 4d per dozen.'[16] That is to say, 25 pairs of gloves for 9d. In Christchurch parish it appears to have survived as a cottage industry well into the nineteenth century, especially in East Parley village where several people described themselves as glovemakers in the census returns of 1841 and 1851. There were also a few closer to the town at Blackwater.

It is probable that the Christchurch trade, such as it was, spread out from the famous Ringwood glove industry, which produced a specialised product constructed with a distinctive and patented stitch, from wool, worsted and cotton. Their particular merit was in providing several layers of wool for warmth, as a result of the dense pattern. They were enough in demand to employ 500 workers as late as 1878, mainly through out-workers, and survived until the last firm (Messrs Ayles) closed in 1958.

Straw Bonnet-Making

In common with other towns, Christchurch had a number of milliners specialising in making straw bonnets, both for as fashion items and for workwear, and once again the local workhouse was resorted to for part of the process, especially gathering the straw and turning it into straw plait.

14 Baker, T., op. cit.
15 HRO 26M79/PO3.
16 HRO 26M79/PO4.

The vestry decided in 1803 to:

> ... take into consideration a proposition for employing the poor children of the said Parish in a certain Art or Business of Straw Hat and Bonnet making. It is agreed and resolved that a sum not exceeding £100 be forthwith laid out and expended by the said parish for the above mentioned purpose of employing the poor children of the said Parish in the Straw Hat manufacture and it was further resolved ... that a Committee of not more than Ten Gentlemen be appointed to conduct the Manufactury... that none but Females and males incapable of severe labour be employed.[17]

That this was a successful venture is apparent from a resolution taken ten years later to employ female teachers, six being named at various weekly rates of pay, from 2s to 5s.

The wording of these resolutions imply that the eligible candidates for such employment were not necessarily workhouse inmates; they could equally be those on out-relief. Employers attempting to earn a living from the manufacture in their own right must have felt some qualms at being undercut by parish labour.

Principally a female trade, as might be readily appreciated, the delightful *Book of Trades* which noted this adds:

> The history of this trade is involved in the same obscurity as the generality of those trades whose commonness excites no attention from mankind ... their trivial natures are esteemed below the dignity of the historian ...

Two stages were involved in the making of straw hat and bonnets: turning the raw material into plait and then creating the finished article from the straw plait. The craft was practised commercially in Christchurch by the late eighteenth century in the Purewell home rented by Richard Young. When the premises were advertised for sale in 1812, he was described as having 'for many years carried on the business of linen-draper, china and earthen-ware vendor, and straw-plait manufacturer in the above shop'[18]. The straw-bonnet makers turning out the finished article were numerous and constantly changing: in directories of 1823 and 1830 respectively straw hat makers were B & M Cranston and E Young (no sex given), and in Purewell the three

17 Local History Room, Christchurch Library (transcript).
18 SJ 27 July 1812.

Misses Mary Belbin, Elizabeth Butler and Mary Cranston (probably the same lady as the M Cranston of 1823); in 1843 a Mrs North was advertising for a 'steady, active respectable, young PERSON, who well understands her business, both sewing and pressing ... also Indoor APPRENTICE ...'; [19] eight people were listed as milliners in White's 1859 directory, including Mrs Ann North, working from Bow Place in Bridge Street; an 1867 directory lists Mrs Cram of Purewell, Miss Catherine Eaton of Church Lane, Mrs Tamlyn of Purewell (wife of a farmer), and in 1869 Miss Burt of Church Lane, advertised herself as a straw bonnet maker. From these particulars it seems reasonable to conclude that both stages of straw bonnet making were yet another cottage industry in Christchurch parish, almost certainly dependent on the spare-time labours of married women and young girls at low rates of pay. As such, it would have made an important contribution to the income of poor families. The presence of so many in the Purewell district must have some significance – but what? Incidentally, it is Mary Tamlyn who according to the 1881 census was blind, which is of twofold interest in that if she was blind in 1867 when making straw bonnets it demonstrates that the work could be done without sight. The second observation is that she does not appear as a former fusee chain worker, which occupation has frequently been blamed unfairly for loss of sight.

Indeed the *Book of Trades* confirms the facility in which such an enterprise could be pursued in a low-wage economy:

> There are few manufactures in the kingdom in which so little capital is wanted, or the knowledge of the art so soon acquired, as in that of straw-platting. One guinea is sufficient for the purchase of the machine and materials for employing two persons several months.

The best straw was rye (grown in the Christchurch area), and it had to be picked with great care after the crop had been cut but before it was thrashed. A trained person would choose the most suitable straw on site, in the threshing barn itself, making sure that the selected material was free of blemish or insect damage.

The straw was cut at the joints on the stem, and the outer cover stripped from it, which was called 'shocking', after which the stems were bundled up in lengths of between eight or ten inches and equal thicknesses and tied up once enough were collected together to fit easily under the arm – about

19 SJ 29 March 1841.

Straw Plait. (Tomlinson)

twelve inches in circumference. The bundles were then dampened by being briefly dipped in water, with the addition of pearl ash and 'sugar of lead'[20] and the excess shaken off, and stacked on edge closely packed in boxes. These preliminaries were especially suitable for children to perform, and we know that they were used for this work since the workhouse records show that they were, and that children as young as six and 'the sons of cottagers to employ their spare moments'[21] were set on the work.

Placed in the centre of each box of straw bundles was a small earthenware dish filled with pieces of brimstone which would then be set fire to and the boxes tightly closed and left to smoulder for several hours to fumigate and bleach the stalks. It had to be carefully watched in case the contents caught fire. After that one person would select from the treated lengths of straw the required amount for another group of workers – as many as fifty – to do the next operation, which was to split the lengths, using a little wooden machine which could split the straw into as many as eight divisions. Each worker would have had a set quantity of split stalks, called splints, which were then wrapped in a linen cloth round one end and held tucked under an arm so that the free hand could be used to draw out splints as needed, for plaiting.

For the plaiting the workers were trained to use their forefinger to sort and turn the splints, and the second finger and thumb to plait. The plaiting was done on a small pasteboard, kept damp. Once five yards of plait had been worked, it would be wound around a piece of board about 18″ wide, and left to dry into shape for several days. The finished plaits were sold by

20 *Workwoman's Guide*, op. cit.
21 ibid.

	£.	s.	d.
Box for bleaching the straw and bonnets	0	18	0
Mill for rolling and glazing the plat	0	18	0
Bonnet stand for ironing and shaping the bonnet upon	0	11	0
Box-iron with two or three heaters	0	4	6
Tin kettle for dying	0	5	0
Tailor's measure	0	0	6
Earthenware jar for the brimstone	0	0	4
Cloths for ironing	0	0	6
Large iron bason tinned	0	1	6
Straw splitting machines, two at 4½d.	0	0	9
Stone brimstone, bone-dust, needles, &c., about	0	3	0
	£.3	3	0

Straw bonnet costs c. 1839. (*The Workwoman's Guide*)

the four or the twenty, and a good plaiter could make about sixty completed plaits each week.[22] The machines were small, and 'may be bought for two shillings each, and will last for many years': an ideal criterion for a cottage industry.

The next stage in the process was for the straw bonnet maker to sew the plait into a variety of hats. The finished article was put on wooden blocks for 'hot-pressing' and to whiten it by exposure to sulphur. It must have carried some risks to health. Straw bonnet makers could earn 'half-a-guinea' a week, perhaps much more for expert workers.[23] Half a guinea was 10s and 6d, making this wage comparable with that of a male agricultural labourer.

A later source of 1838[24], goes into considerable further detail about both stages of the process. There were, it seems, countless varieties of plait; some of them were made with half straws and some whole; some were made with even shorter lengths, and some with double straws. Black straw could be made by treating the straw with copperas (ferrous sulphate, mined at one time in Boscombe, just west of Christchurch) and verdigris. Different types of hats required different plaiting methods: a Dunstable hat used whole but fine straws and was worn by schoolchildren and servants, for example. Coloured straw could also be used, and several colours mixed together to form a pleasing pattern.

22 *The Book of Trades*, op. cit.
23 ibid.
24 *The Workwoman's Guide*, op. cit.

Other processes were applied to the plait such as rolling through a sort of mill with glass rollers to produce a high gloss. The price of all the equipment sufficient to employ up to a hundred people was costed up by the anonymous author of the Guide, as shown in the table.

The Guide provides exhaustive details about the skills required to turn plait into bonnet, from the sewing, bleaching, stiffening ('The best stiffening is that made of buffalo's hide or vellum, which may be procured in London and Liverpool, cut into shreds, and sold at 8d a pound') – stiffening with vellum was accompanied with the salutary warning about the poisonous nature of oxalic acid used in the process; the alternative 'bone dust' must have been equally hazardous – wiring and cleaning and so on. For something made with patently natural raw materials, the noxious substances involved in the manufacturing process seem both appalling and unexpected. One wonders if workers sickened and died from a 'straw bonnet syndrome'.

FLAX-SPINNING

The existence of another cottage industry in the town in the eighteenth and early nineteenth centuries is implied in the records of the local workhouse, in which it was for many decades the principal employment given to the inmates. Applicants for relief could be assisted either in the 'House' or in their own homes, in which case help was sometimes given in kind, in order for them to be able to help themselves. In 1824 one Harriet Tilley asked the Overseers for a spinning wheel, a request which was granted on condition that 'she returns her old one to this House and teaches no less than six children how to use it'. Once again, the economic contribution which children could make was being utilised, in a quid-pro-quo arrangement, and the raw material being spun was almost certainly flax.[25]

In 1776, a new workhouse Master and Mistress were advertised for, with the specific requirement that they 'understand Spinning Flax'. From at least that time, all the inmates capable of work were kept busy on spinning wheels; until the advent of the alternative fusee chainmaking in 1800, about thirty people were daily engaged in this occupation, producing perhaps 60lbs of yarn in a week at its peak. By 1807 the spinning of worsted was also done in the workhouse, but flax-spinning continued to be done, albeit on a reduced scale, right up to the creation of the Union in 1835. The payments recorded for this work seldom link it to an individual employer; but in 1776 Mr Jeans

25 Newman, Sue, op. cit.

Flax plant. (Tomlinson)

paid 10d for the spinning of just 1lb of flax – the Jeans family are not on record as having been in any way connected with agriculture or the cloth trade, being principally surgeons and innkeepers.

Some indication of the nature of the work done by the inmates can be gleaned from the records of neighbouring Milford parish workhouse, for none survive to provide insights into methods of spinning at Christchurch. An inventory taken at Milford in 1804 helpfully lists the contents of each room: the Work Room contained five 'worsted wheels, 31 flax ditto, two looms and flax wheels, 2 worsted swifts, a long table for Trussels [trestles?], a long form & 8 wooden Stools & an old Chest, a Queeling Turn, Warping bars & scribling horse & Fender'.[26] From the existence of 'warping bars', it would seem that at Milford the flax and worsted yarn was subsequently woven. For a small workhouse a total of thirty-six spinning wheels must have crowded the workroom out; it is likely that Christchurch workhouse was similarly equipped and functioned in the same way. What is meant by 'queeling' may be quilling; if so it is of considerable interest, since this is lace-edging, and lace was one of the things which spun flax from the best quality fibres could used for. It is fascinating to toy with the notion that trimming for lace was made locally. Scribbling is an archaic word meaning to card coarsely, which refers to the combing of the fibres prior to spinning. A 'swift' is (OED) a 'revolving frame for winding yarn from': one of these has survived at Christchurch, and is on display in the museum which occupies the former workhouse.

It is almost certain that weaving was done in the Christchurch workhouse, since there were weaving sheds in the eighteenth century and the inmates not only made their own clothes but the cloth they were cut from. The inmates were certainly kept productively at work on a variety of tasks.

Christchurch is not specifically noted for the growing of flax, a rare mention being quite late, when in 1851 farmer T. H. Tuck successfully

26 HRO 31M67/PO36.

A swift (bottom left) in use at Westminster Workhouse. Acquatint from Ackerman's Repository 1809. (see colour section)

harvested the crop from about 50 acres of his farm at nearby Avon; the report described it as 'a novelty in this neighbourhood', so much so that it attracted crowds of curious onlookers when harvested.[27] The enterprise was short-lived, for his 'newly-erected' flax mills burnt down – which attracted an even greater crowd of onlookers. Vancouver in 1810 referred to flax-growing in Hampshire being attempted in only 'a few instances'.

Growing of flax was, however, done on a large scale in Dorset, particularly as a result of measures taken by the Government because shortages were threatened by foreign wars. Both the American War of Independence and the Napoleonic wars with France cut off imports from those areas, as a result of which after 1781 inducements in the form of a bounty were paid for the dressed fibre from the cultivation of both flax and hemp. Cottagers as well as farmers could grow the crop, which was then sent out for spinning; it is possible that it was by these means that flax was obtained in Christchurch or nearby. All financial incentives for flax and hemp production lapsed in 1836, when it is likely that the cottage industry died out. All the more surprising that Farmer Tuck should have attempted a revival in the 1850s.

Flax is a versatile natural fibre, not only used to make linen, but a variety of other products such as twine and cord, button thread, embroidery floss, carpet thread and matting.

27 SJ 14 August 1851.

> **BOUNTY for GROWING HEMP and FLAX.**
> **SOUTHAMPTON,** (to wit.)
>
> IN purſuance of an Act of Parliament, made and paſſed in the 16th year of the reign of his preſent Majeſty, intituled "An Act to continue and render more effectual an Act paſſed in the 21ſt year of his Majeſty's reign, for the encouragement of the growth of Hemp and Flax in that part of Great Britain called England," and in obedience to an order of the laſt general Quarter Seſſion of the Peace, made under the direction thereof, I do hereby give notice, that for the purpoſes aforeſaid, the following Bounties are by the ſaid Act directed to be paid, viz.
>
> To the grower, or other perſon, who breaks and properly prepares for market any flax or hemp, of the growth of this kingdom, a bounty of 3d. per ſtone of hemp of 14lb. weight, and 4d. for every like ſtone of flax.
>
> For the recovering and receiving which bounty, the following conditions muſt be complied with.
>
> The grower, or perſon claiming, or who ſhall be entitled to the ſaid bounty, ſhall ſign and exhibit his claim to one of the Juſtices of the Peace for the county, riding, or place within which ſuch hemp or flax ſhall have been raiſed, mentioning in ſuch claim of what crop the ſame is, and the farm or ground on which the hemp or flax grew; and which claim muſt be likewiſe atteſted by two of the officers of the ſame pariſh with the claimant or grower, who muſt certify that they believe the truth of the particulars contained in ſuch claim, and which claim, when ſo atteſted, the ſaid Juſtice is required by the ſaid Act to counterſign and tranſmit to the Clerk of the Peace, to be by him laid before the Juſtices at their next general Quarter Seſſion.
>
> By order of the Court,
> R. R. CORBIN, Deputy Clerk of the Peace.
> Wincheſter, May 10, 1791. 1357

The *Salisbury Journal* May 1791.

The cottage spinners appeared to be paid about 10-14s a week, judging from the early nineteenth-century accounts of a Bridport flax miller; this particular entrepreneur, Richard Roberts, was at times yet another employer of child labour, some of them from local workhouses in that part of Dorset, although their role was in a preliminary process by which the flax fibres were split and straightened out – very dusty work. The records of the Christchurch workhouse indicate that the pay in that institution was a mere 2d a day.

For a contemporary account of the work of spinning flax we can once again thank *The Book of Trades*. The flax was probably supplied as 'line', or longer fibres which had been prepared by being combed into fine parallel lines and gathered into bundles. This would have been tied onto a long stick, or distaff, and bound on to it criss-cross fashion with ribbon. From this the spinner would pull out a thread and attach it to a spindle, which by pedal-power wound and twisted the flax thread into yarn, the spinner being aided by dipping her fingers into a small pot of water to smooth the thread. There were many different varieties of spinning wheels: it is not known what sort was employed in local flax production, but the product was spun yarn ready for washing, dyeing and selling on to weavers or knitters for linen articles.

A flax spinner
(Tomlinson)

Vancouver has this to say about the economics of flax-spinning:

> The usual mode of regulating the spinning of flax is by the lay of 800 yards; this is measured on a reel two yards round, and when eight of these lays make a pound the price given for spinning is 8d. When the pound is spun to twelve lays, the price is 15d; when to fifteen, it will cost 1½d per lay; and when twenty lay in the pound, 3d per lay.[28]

Christchurch had numerous linen-drapers, who could have been the ultimate customers for the woven flax. Weaving itself is not noted locally with much frequency in this period, apart from references to a Jacob Daw in 1739 in the Clingan's charity records and the will of Thomas Kitch of Rotten Row, Bridge Street, in 1734 (although there was a plot of land called the Cloth Rack in Bridge Street). Whilst earlier directories include drapers, linen drapers specifically are noted in 1823, when there were four (Samuel Bayly, Edward Phillips, Richard Ridout and Richard Wright), three of whom were still listed in 1830. *The Book of Trades* carries an illustration (1818) of a London linen draper's shop, the accompanying text

28 Vancouver, op. cit.

noting that: 'We believe that there is no trade in England in which more efforts are made to captivate the public, and more especially the ladies, by a display of goods ...'

Mantua-Makers

The plyers of this trade are frequently to be found in the useful records of the Clingan's charity, taking on apprentices from as early as 1759 to as late as 1827, under that archaic title; they were, in effect, ladies' dressmakers and most of the 21 people concerned were female or husband-and-wife teams. They were as essential a part of the country-town economy as their male counterparts, the tailors.

From other references, it is apparent that it was a female occupation even where the apprentice records indicate a couple was involved together. Thomas Hoby (Hobby) and wife, for instance, in 1772: he was a collar-maker, she the mantua-maker; Michael Bore and wife of 1778: he was a ship's master; even our familiar builder, John Pillgrem, claimed joint responsibility with his wife for a mantua-making business.

The Book of Trades takes a very tongue-in-cheek look at this occupation, remarking that the customers of a ladies' dressmaker 'are not easily pleased; they frequently expect more from their dress than it is capable of giving,' and therefore the dressmaker must above all 'be an expert anatomist'. Furthermore, her name must, 'if judiciously chosen,' be 'of French termination' – but none in Christchurch appear to have been. The article remarks that 'mere work-women' in the trade 'do not get any thing adequate to their labour. They are frequently obliged to sit up very late,' – the Dickensian image of consumptive, young women clothed themselves in virtual rags, driven to an early grave by sewing all night in some dim garret some fabulous dress for a wealthy swank, is well known.

Fishing

Having explored a few of the means by which the women and children of the poorer households might contribute to the family's income, it is now necessary to turn to one of the male mainstays – that of the fishing industry which was so important to a town snuggled between two rivers and bounded on the south by the Channel.

Whilst every coastal town has a long maritime and fishing history, Christchurch is exceptional for its salmon fishery on the Avon and Stour,

Uniform of sailors *c.* 1790. (*History of London*, Walter Besant, 1893)

records for which go back to the thirteenth century and probably beyond[29] but a huge variety of other species were caught, including eels and lamprey, white fish and shellfish, especially lobsters. Unlike the other trades discussed in this work, that of fishing is still an active commercial feature of the life of the town.

The salmon fisheries of the Avon and Stour and the harbour were owned by the Lord of the Manor of Christchurch, and this and sea fishing near to shore seem to have provided employment to many men. A report of 1799[30] recommended the use of larger nets offshore and exploitation of fish stocks in deeper water, but the catch was very varied: turbot, soles, whitings, grey mullet and 'great quantities of that delicious fish called the red or surmullet'. Herrings and mackerel were also harvested in great quantity. A curious aspect of the fishing industry is a shoreline 'crop' of 'an excellent little fish called the wreckel, sand eel or launce dug out of the sands and sold for 3d or 4d a quart', but their collection carried risks for the fishermen of being stung by weaver fish, which they eased the pain of by rubbing the afflicted site with sea salt. They superstitiously linked the disappearance of the pain, after about five or six hours, with the return of the tide. Another once-abundant source of food from the sea was oysters, which were dredged up by large numbers of smaller boats and formed an important branch of local trade in the eighteenth century.

29 *Victoria County History.*
30 *Hampshire Repository.*

The salmon catch throughout history varied considerably in the remuneration it afforded, on account of widely fluctuating numbers, poor catches often being the result of the Avon being choked with weeds. A speaker on the subject in 1939 gave figures for 1,600 taken from the main Royalty Fishery (the Avon) in 1814, as opposed to just sixteen in the current year. The *Hampshire Repository* of 1799 reported a particularly productive period in about 1780, so much so that the fortunate person who rented the fishery from the Lord of the Manor, then John Cook the brewer, of Square House in the market place, earned between £700-800 annually from it – a fabulous sum. The price of the fish during that glut was 3d or 4d per pound, but the present scarcity had driven prices to 10d.

From the testimony given to the Tithe Commissioner in 1838, it is revealed that the fish catch was weighed at the local inn in Church Street, the Eight Bells, and consisted of pike, mullet, perch and flounders. In 1836, recalled the informant, Edward Joy, the inn's landlord, 156 salmon were caught and sent up to the London markets, but he had personally known of 1,000 being so caught and marketed in previous years. Sarah Adams, widow of a prominent banker and owner of a colliery boat, gave evidence that fish other than salmon were sold in the local market; her figure, as the receiver for the rents of the fishery, was that the previous year not 156 but 204 salmon were caught: conflicting evidence with Mr Joy or possibly some fish were unfit for the market. In theory, a tithe, or tenth, of all fish caught should have gone to the Priory.

Most fishermen lived in Mudeford or Stanpit in the town, often in small cottages clustered around the harbour; the name Fisherman's Bank survives to this day as a reminder of this link. Their lives were sometimes precarious, and tragedies were a fact of life; it was a time-honoured practice still continued today annually to bless the waters to ensure a good catch and a safe return for the fishermen. Divine intervention was nevertheless on occasions insufficient.

There was a brighter side to owning a fishing boat, which was to get together and race them in the summer months for the edification and entertainment of the wealthy visitors to the increasingly fashionable watering place of Mudeford. The resident gentry encouraged the fun: Sir George Rose himself, ensconced in his ostentatious marine villa, Sandhills (today encircled by static caravans), on the foreshore, and his son William Stewart Rose at neighbouring Gundimore (another flamboyant seaside villa), themselves found the prize money. In 1808 the race nearly claimed

Other Christchurch Occupations

Haven Quay, Mudeford, 1832. (By R. A. Grove, courtesy Hampshire Record Office)

the life of a participant: none other than the infamous smuggler, John Streeter, who with his son was rescued from an upset craft. William Stewart Rose replaced the lost boat at his own expense; tacitly showing approval of the illicit trade in which the fishermen would be engaged in on other occasions.

The mackerel shoals came regularly into the harbour, in their tens of thousands, 'furnishing a cheap and wholesome diet to the lower classes of the community'[31] – the price for these was 6d per dozen.[32] In 1842 no less than 80,000 were caught by just one boat.[33] The spectacle attracted large numbers of excited onlookers on the shore, as well may be imagined:

Fisherman, 1808. (*Occupational Costume in England*, courtesy John Johnson Ltd)

> Very large quantities of mackerel have within the last week been caught in the West Bay between Christchurch and Bournemouth, which has been

31 SJ 15 November 1841.
32 SJ 1 July 1847.
33 SJ 29 October 1842.

the means of affording amusement to hundreds of spectators, as well as a great assistance to the fishermen.[34]

Agriculture

It is beyond the scope of this work to explore every aspect of the farming practices of the parish of Christchurch, on which subject the bibliography suggests further reading; it must suffice to provide a few details culled from contemporary sources.

Apart from the extensive heathland in the parish, the soil which could be used productively largely consists of a gravelly loam. In the eighteenth century there were numerous farms around and in Christchurch, even in the heart of the town (Wick Farm in Wick Lane, Bargates Farm in Bargates) and nearly all of the 300 acres of Portfield was arable. Outlying areas close to the centre had farms: Mudeford Farm, Bure Farm, Hoburne (Hubborne) Farm, Somerford Farm, Purewell Farm, Latch Farm in Fairmile, Stanpit Farm, Grove Farm at Bosley, Iford Farm and so forth. All appeared to be typical mixed farms, producing dairy cattle, sheep and pigs, as well as a variety of crops, especially turnips. Government returns for agriculture in 1801 give figures for crops grown, in acreage, as: 2,054 down to barley; 1,648 to wheat; 605 acres to oats; 166 acres of turnips; 132 acres of potatoes; 126 acres of peas and 20 acres of beans. The parish was also one of the few areas in Hampshire where rye could be grown, which was the best cereal for making straw bonnets with.

The lot of the agricultural labourer was to sow and till these crops and harvest them, long hours – in the summer a twelve-hour day and even more at the harvest – preparing the ground by clearing it then ploughing by horse-power, occasionally oxen teams; harrowing by drag; perhaps raking the soil and removing stones; collecting manure from the farm animals and incorporating that or guano into the soil; sowing by hand, or later by means of a drill; and hand-weeding the growing crop; to be followed by the great occasion of the harvest when all the efforts of the past twelve months culminated, with success or disaster according to a variety of factors, including the weather and disease. Elaborate ricks would be made with thatched roofs of straw or river reed to keep the grain stored over winter in the farm's rick-yard, or clamps built to store root crops. Besides the work on the land, there was the livestock to feed and care for, from the strong carthorses to the hens in the coops in the farmyard. All of the

34 SJ 2 August 1841.

FIGURE 170
AGRICULTURAL LABOURER, LAST HALF OF EIGHTEENTH CENTURY

He wears an old coat with the skirt cut off, ribbed stockings, and old black hat with a bit of string knotted round it. Such men are also depicted minus the coat and showing a shirt open at the neck, with sleeves put into very narrow wrist bands.

Agricultural labourer. (Cookson)

produce would ultimately need to be taken to market. Over and above this, a number of other specialised tasks were required of the versatile 'aglab', from hedge-laying to coppicing.

Many of these husbandry operations were performed with the aid of horses and carts or wagons, which gave work to a whole host of related tradesmen and craftsmen. It was the job of highly skilled wainwrights to make carts or wagons (a cart has two wheels and a wagon four), aided by the wheelwright, the sawyer and the blacksmith. A 'liner' decorated the finished cart, painting it and adding any wording on the frame or hood. Each county or region over the centuries developed characteristic wagon styles, depending on local needs. A Hampshire wagon is illustrated: this was of the bow type, rather than the box construction used elsewhere. The design permitted the wagon to being divided into two for use as two wheel carts or to be taken down very narrow lanes. The importance of horses in the economy was enormous, giving rise to saddlers, harness makers, farriers and vets.

By the nineteenth century, all these farms would have been experiencing acute distress, so much so that some were deserted by their tenants: thirty

A Hampshire Wagon. (Vancouver, 1810, courtesy the Hampshire Record Office)

were abandoned in the neighbouring parish of Sopley alone in 1816[35]; the causes included 'crushing taxation'. In the 14-year period prior to that date, no less than eighteen farms in Christchurch parish were advertised for sale or let, the majority of whose tenants or owners were described as 'quitting'. They included Staple Cross Farm, Hubborne Farm, Stanpit Farm, Harrow Lodge Farm at Bransgore, Dudmore Farm, Hurn Farm, Knapp Farm etc. It could have been worse: a Norwich newspaper advertised 120 sales of stock *in one day*.[36]

Those who sold up often left a useful record in the sale particulars of the sometimes baffling implements of husbandry with which the average farm labourer had to be familiar. Here is an example from Hubborne Farm in 1809:

HUBBORNE LODGE. Two miles from Christchurch, on the Lymington Road TO BE SOLD BY AUCTION by John Cranston on Thursday 2 Feb, THE FARMING STOCK (of a gentleman quitting the premises) consisting of three good cart horses, a beautiful pye-bald pony, a year old, 13 hands high; two exceeding good Norman cows in calf; one half Norman, very forward in ditto; a handsome two-yearling Norman bull, a yearling steer, and a weanling Norman calf; a Chinese sow, and two other sows, two good narrow-wheel waggons, two broad-wheel dung carts, one lade cart, a 2' horse roller, a winnowing machine, a double plough, two single ploughs, a

35 *Victoria County History*, op. cit.
36 *Facts for Labourers*, 1884.

pair of drags, three harrows, a quantity of hurdles, four pairs of trace harness, two pair of thill, plough harness, chaff cutter, seedlip, two wheelbarrows, rakes, forks, prongs, sieves, buckets, various useful articles and about four quarters of hogs peas. Also a handsome CHARIOT, with lamp, barouche, seat etc, complete, a SOCIABLE BODY with canopy and curtains, sword cases, drop boxes etc, a small boat, a horse dray with iron wheels, fatting coop, hen coops etc.[37]

The extract provides information about contemporary husbandry practices: a *lade-cart* was a type of farm cart or wagon which had drop-down, hinged sides. This was useful for carrying larger or wider loads, since the sides could be fixed in position partly open. *Drags* were manure forks – the prongs are at right angles to the handle – but in this context it may refer to a drag harrow, which had similarly curved prongs or tines. *Trace harness* had chains to the horse's collar to connect with the cart or harrow being pulled; *thill* is a shaft of a waggon and a thill harness is another specialised type of harness used on shaft horses. The *chaff-cutter* was a machine into which the hay or straw was fed to be chopped; a *seedlip* was a tray, kidney-shaped and with a raised rim, held against the side by a strap over the shoulder and used for holding grain for sowing. It indicates, therefore, that the crop was still at least partly broadcast at this date. *Norman* cows were good dairy cattle from the Channel Islands; Hubborne Farm appears to have the typical mix of arable and pasture, dairy herd and pig production. The produce may well have been used on the farm, the butter and cheese made in the dairy, for example, requiring yet more rural skills which were certainly to be found in the local Christchurch cottages. *Chinese* pigs were held in high regard in this period, and crossed with the native breed to improve the Hampshire bacon and hams which were already highly regarded.

This particular (unidentified) farmer boasted some interesting transport: a *sociable* body was an open carriage which could seat up to four people, in twos facing each other (hence the name). The driver sat up at the front on a box seat. From the additional canopy and curtains the carriage featured it could have been even more 'sociable'! Apart from this, our farmer possessed another carriage with a *barouche*, or fold-down hood.

A later farm sale is illustrated in an advert overleaf. *Shamble carts* were probably used for the transport of dead animals; a *tormentor* was a wheel-harrow, each tine of which had a small share, or hoe, to break up hard

37 SJ 6 March 1809.

SECOND SALE AT EAST PARLEY, HAMPSHIRE.

Five Miles from Christchurch, five from Wimborne six from Poole, and six from Ringwood.

Valuable team of four bay young fresh cart horses, wagons, puts, thrashing machine, gig, carts, ploughs, iron and wood rollers, drags, harrows, land-pressers, drills, turnip and chaff cutters, cake-crushers, hay-making machines, &c.

FOR SALE BY AUCTION, BY

MR. ROSSITER, on the premises, at Parley Court Farm, on MONDAY, the 5th MARCH, 1849, the remaining part of the valuable

LIVE AND DEAD FARMING STOCK,

Late the property of W. HATCHARD, Esq., deceased : comprising four superior fresh young bay cart-horses, sound, and excellent workers; 17 sets of trace, thill, and plough harness; two wagons, on iron arms; two ditto, with wood ditto; one dung-put, on iron arms; three ditto, on wood ditto; two shamble carts, six ploughs, one pair tormentors, two pairs drags, four pairs harrows, one 2 ft. double-cylinder four-horse iron roller, one two-horse iron roller, two two-horse wooden rollers, one one-horse ditto, one iron cultivator, one iron-framed land-presser, one wooden-framed ditto, one Cooke's drill, with scarifier to ditto; one harrow-truck, on four wheels; two seed-machines, one four-knife chaff-cutter, one oil-cake crusher, two seed-lips, three turnip-cutters (by Gardner), 14 sheep-troughs, two timber-chains, two corn-bins, 4 wagon-lines, four ladders, 14, 16, 34, and 36-round; five large rakes, one Wedlock's hay-making machine, nearly new; one winnowing machine, one Amesbury-heaver complete, wheat, barley, and oat-rudders, with chaff sieves; two barley-chimpers, one willow basket, two barn trucks, bushel and half-bushel barn-scoops, twenty-eight cow-cribs, two-horse-power thrashing-machine (by Cambridge), three wire sieves, one malt-mill; beams, scales, and weights; two saddles and bridles, two wheel-barrows, garden-tools, sundry barrels, carpenter's chest, with tools; carpenter's bench, hen-coops, two dog-houses, boat, stone garden-roller, iron vice, a neat gig, nearly new; about sixty corn-sacks, sundry tools, with a variety of other useful articles, too numerous to particularise.

The above horses are known good workers; the greatest part of the implements are nearly new.

In consequence of the number of lots, the sale will commence precisely at Twelve o'clock: and the Auctioneer respectfully solicits a punctual and liberal attendance.

Refreshments will be provided.

Sturminster, Feb. 19, 1849.

A farm advert in the *Poole Herald*, 1 March 1849.

soil. From this inventory it is evident that Parley Court Farm produced a variety of corn crops and kept cows; the amount of machinery by this date is impressive, and farms would later have been able to add steam machines to their array of equipment which the farm workers would be expected to become competent at using.

The farmers would have got their supplies from a corn-merchant such as Charles Hicks, in the High Street, whose stock-in-trade sold off in 1837 comprised:

... in Malt, about 107 qrs, 46 qrs of white and 49 qrs of black Oats, 30 sacks of Beans, 30 bags of Pollard [bran], quantity of Hops, about 80lbs of Swedish and green round Turnip seed, 280lbs of broad Clover ditto, 78lbs of Mill Hop ditto, 160lbs of Dutch ditto; patent winnowing machine, nearly new malt-mill, weighing machine, two pair of large beams, flour and other scales, cast-iron half-hundreds and other weights, imperial bushel, half-bushel and other measures, scoops etc, cast-iron rack, plough-points, land-sides, stumps, collar-clamp, turn-farrow, spanners and plough-wheels, flour and corn-bins, sack-trucks, 8, 9, and 10-step ladders, lade-cart on iron arms, light ditto, double-bladed waggon on iron arms, pair of trucles, saddle and bridle, two sets of thill harness, set of gig ditto ...[38]

Land-sides were flat sides of a plough; *plough-points* detachable metal points fitted onto the plough-share, or blades of the plough; *trucles* are truckles, otherwise pulleys. *Stumps* were probably another type of plough component.

The agricultural societies did much to encourage and develop local farming standards and methods; from first formation in 1794, the Christchurch Agricultural Society – which lapsed in 1819, possibly in response to the crisis – reformed as the South Avon Agricultural Society in 1841, and was supplemented in 1850 by the Vales of Avon and Stour Farmers' Club. These societies encouraged innovation and acted as a forum for the exchange of ideas. For example, trials with a device called the Hainault scythe for cutting wheat were undertaken by competition at Mudeford Farm in 1814, and tested against experienced labourers cutting comparable areas with the old reap hooks. The new-fangled scythe was found to perform better 'even by stout girls and women ... it is equally useful in cutting beans and vetches ...'[39]. Trials were held in a similar fashion to test broadcasting of crops against using a drill, the latter being shown to be superior, and at one stage in the early years of the nineteenth century the farmers organised a Sheep and Wool Fair in the High Street at the annual October Fair of St Faith, which was already acting as an outlet for the exchange of farm animals and implements, wagons and carts and the hiring of labour, and had done so for centuries. The Agricultural Society attempted to further encourage the husbandry

38 SJ 17 April 1837.
39 SJ 29 August 1814.

Left, the Southdown Sheep. Right, Sheep shearing. (Tomlinson)

of sheep by organising sheep-shearing competitions; their efforts were for a short while successful, but ultimately abandoned. Agricultural distress was so deep by 1823 that 500 signatures were obtained throughout the county to call a public meeting.

Things had improved by the time the Tithe Commissioners examined the agricultural health of the parish's farms in 1838, which were reported to be well cultivated, using a rotation of three crops, or four for the less productive land. According to the report, each acre of the best land produced three quarters of wheat, slightly less on the poorer quality land. The pasture land, however, was considered to be poor, 'the grass short and rancorous', with the exception of the river meadows which were well managed in the traditional manner by regular flooding; of these, those by the Stour were the best. The Stour meadows were capable of producing a ton of hay from each acre; the Avon river meadows only managed 14cwt. Lord Malmesbury introduced a new crop: the fir trees for which the area became so well known when Bournemouth was built amongst the pines. These when cut down were shipped from Christchurch, probably from Mudeford Quay, to their destination.

Towards the end of the period under review, despite the encouragements given to labourers by premiums and prizes for clean cottages, longest service, most children without recourse to parish relief and so forth, letters to the press in 1865 were loudly denouncing the subsistence pay earned from the land, which at a beggarly 9s a week was no better than it had been a century

earlier. A carter or a shepherd received the same, with a cottage, and fuel in the form of peat, in addition.[40]

It would appear to the agricultural workers of the day that nothing at all had been achieved by the previous generation from the Swing Riots. In 1895 a significant number of the male inmates of the workhouse are described as agricultural labourers, the largest occupational group, recipients of indoor relief in old age on account of being 'infirm'; their counterparts in the humble homes of the parish on outdoor relief must have been numerous. There was not enough money coming in in their working lives for their support, let alone to keep them in retirement or when they were physically no longer able to carry on.

BREWING

The barley grown in such substantial quantity on the farms in and around Christchurch was destined mainly to be turned into malt in the malthouses of the town, of which there were several, and this in turn into the beer which was the standard drink by all in the days before water was safe. In Christchurch, as in many other towns, the aletaster was an important official, his function being to control the quality of the beer produced for local consumption.

A surprising aspect of the consumption of beer emerges from the account written by Lord Malmesbury in his own hand of the coming-of-age celebrations for his son in 1828. At a dinner held in his honour at the King's Arms, to which all the leading tradesmen were invited, the sumptuous repast was washed down with 'two Hogsheads of strong beer brewed in 1809 with 18 Bushells of Malt to the Hogshead – nearly one half was sent to be drunk at the Dinner at the Hotel – It was sound and very strong, high-coloured and clear'.[41] That beer was therefore nearly two decades old.

According to several sources, brewing employed a large number of men in the eighteenth and nineteenth centuries. There were two principal breweries, both in the High Street: one commenced by John Cook on premises adjacent to his imposing mansion, Square House, and the other on the other side of the street. There were several other smaller breweries, such as Avon Brewery at Stanpit and the London Brewery, and beerhouses which brewed their own supplies, such as the Eight Bells in Church Street,

40 Williamson, J. *Contents of the Mainland of Hampshire.*
41 Malmesbury Estate Papers, since transferred to Hampshire Record Office.

Christchurch the Fusee Chain Gang

Seen from left to right: Square House, Mansion Brewery, brewery arch, all on the left-hand side of this picture of the High Street.

the brewhouse for which still survives. Even the workhouse brewed its own beer, as the records show from the malt and hops which were purchased.

Over the stone arch at the entrance to the earliest of the larger breweries, next to Square House at the southern end of the High Street, was inscribed: 'Christchurch Brewery, established 1723. Strong and Co.' It would appear that the brewery was commenced by one Jeremiah Cray, brewer,[42] the owner of two public houses in the town, the Dolphin in Church Street and the Horse and Groom in Bargates. It was transferred in 1749 to a gentleman who at the time followed a different calling, that of peruke-maker (the wigs which were worn by both sexes as the height of fashion at that time), by the name of John Cook, recorded as an Overseer of the Poor in 1728 for the tithings of Town and Street. It would appear that he continued the brewery business which he had acquired together with the house and outbuildings and use of a lead pump standing outside (most important to a brewery) which were on the site, until transferring it to his son of the same name in 1760. In doing so, John Cook senior wished to 'recompense and reward

42 White, Allen, *Square House*.

John Cook the younger for his great fidelity, care and industry, and the prudent management, conduct and carrying on his affairs and business'. Clearly, he was in a great way indebted to his son for assistance in running the brewery, but his boundless generosity also extended to the transfer of 'all the plate, beds, bedsteads, bedding, linnen, pewter, brass, iron, wood, glass and all other household goods, furniture and implements of household'. In the brewery itself were included 'all the coppers, mash-tun, Under-Back, Coolers, Pumps, beer-casks, barly, malt, and all other stock-in-trade, utensils, implements and things', indicating an extensive establishment. Not content with this munificence, John Cook senior also pledged to his son all monies due to him, and 'all other personal estate … now in his dwelling-house, brew-house, cellars and malthouse', signing the document with a cross: he was clearly illiterate. The reason for the transfer must have been the state of his health, for he died about eighteen months after the transaction was completed.

John Cook the younger (1731-87) rose to some prominence in the small town, being elected as mayor five times. He was evidently a gifted businessman, buying Mr Cray's two pubs from him in 1766, the start of many such acquisitions. He is described in 1764 as 'an eminent brewer …[held] in great esteem for his generous and worthy disposition'[43] and a burgess. In 1767 he married a young lady, Susanna Reeks, who was truly 'accomplished and beautiful'[44] with a 'genteel fortune' to boot. Perhaps acquiring further wealth as well as having business acumen enabled him to build up his alcohol empire which eventually comprised over twenty public houses. His wealth enabled him to tear down his father's dwelling house in 1779 and build the magnificent classically inspired mansion which took its place and graced the town for nearly two centuries.

It would appear that yet another John Cook, son of the above, inherited the business and retired from it in 1796, when Square House and the Mansion Brewery were auctioned. The latter then contained such working utensils and equipment as 'Register-Stoves, Grates, Smoak-jacks etc, Copper and Underback, in Brewhouse, with Coolers and Frames'[45]. Also sold off were the chain of pubs acquired, which included the Dolphin, the Crispin (Purewell) and the George in the town. Also included was a sloop known

43 SJ SJ October 1765.
44 SJ 17 July 1767.
45 Local History Room, Christchurch Library.

Left: fermenting vessels. (Dodd) Right: a large vat. (Dodd)

as 'Stour', associated, unsurprisingly, with smuggling: its master, Richard Rogers, having been caught by Customs officials in 1784 with 34,000 gallons of spirits and four tons of tea on board. There is no question but that John Cook's business benefited and almost certainly sponsored the extensive smuggling of spirits by the townspeople. The buyer of the brewery business was Samuel Spicer, who paid £4,785 for the house, brewery and stock. The hefty price tag reflects the extent of the concern. His brother, John, later to head the Bargates fire committee in 1825, moved in to the mansion.

On the retirement of John Spicer in 1837, the brewery was bought by John Peerman. The following year its 'excellent hydraulic pump' was pressed into service to quell the blaze at the adjoining premises of Ferrey and Son.[46]

The Mansion Brewery covered nearly an acre of ground and included, in the words of the 1839 sales particulars when Mr Peerman became bankrupt, a counting-house, yards, stables, cart and gig houses, piggery, vat and spirit cellars, cooperage, smithy and a kitchen garden. 'There has been an extensive Trade in Beer carried on there for upwards of half a century', we are advised, with in addition a large spirit and wine trade. The products were shipped from Christchurch Quay, some of it to the many other public houses eastwards as far as Portsmouth owned by the

46 SJ 16 October 1837.

Other Christchurch Occupations

Left, filling the butts with beer. (Dodd) Right, The Aldridge brewery, Christchurch.

late vendor. The new owner was solicitor Henry Rowden.

Inside the brewery was an extensive array of equipment, including a copper, pumps, a mill, a crusher, mash tun, and specialised devices called 'hopbacks, squares and stillions'. A *hopback* was a vessel with a perforated base, used to strain the liquor from the hop mixture; a *stillion* was a type of trough for collecting the overflowing yeast in the brewing process. With every conceivable process of a brewery apparently being catered for, with a market over the entire country, it was obviously a major employer. A mash tun contained the coarsely-ground malt, and was filled with hot water from the copper; the water was allowed to soak the grain and dissolve out the sweetness: a man would attend to the copper by stoking up the fire and one above stirring the mash in the mash tun with a long wooden pole.

The other brewery, called the Christchurch Brewery, belonged to William Wing Mitchell (whose Winkton fields were set alight by a disgruntled employee – see page 49). A deed survives from 1794 concerning a 'new tenement' with a malthouse and millhouse, bounded by Millhams Lane, with a recital of deeds from 1749, from which date this brewery may have commenced. The malthouse was in Millhams Street, behind the High Street frontage, now the site of a row of cottages. After Mr Mitchell's death the business was sold to John Elliott in 1796 and later to the Daw family (Ambrose then Thomas) and Blake (William) before passing to the King

brothers, Joseph and James from a brewery in Poole, in 1832. These last two took the opportunity to acquire the rival Mansion Brewery in 1845 and close the Mitchell brewery down. James King and his family then moved into Square House. The King family hid rather a dark secret, in the insanity of the son of James, named Joseph, who owned the business in the late Victorian period.

By the 1850s (possibly earlier) Kings had been joined by another High Street brewery – that begun by George Olive Aldridge and known as Aldridge and Son, at the north end near the junction with the Pit site, behind Bow House. This had a marvellous brewery tower, with a weathervane on top, and a large range of extensive buildings behind the brewer's house. It was known in the 1880s as the Christchurch Steam Brewery, and remained the last of the working breweries in the High Street; the brewery tower was sadly demolished in 1954. The picture (page 211) shows it in action, with six men in various activities or inactivity: one sweeping the extremely muddy roadway, another hanging on to a carriage, a man about to break open a barrel, and another (identified on the reverse as a Bemister) imbibing the product with one hand and carrying a stone jar with further refreshing supplies in the other. The man in more superior attire on the right is Eli Croucher, who must have had some (rather unsuccessful) supervisory responsibilities.

Little is known about the extent of any of these substantial and obviously successful businesses, or the nature of the workforce, but many of the workmen must have come home to a wife making chains, knitting stockings or plaiting straw.

It now remains to conclude this social survey with an analysis of all known workers of the principal occupation under study: that of fusee chainmaking.

APPENDIX

The inclusion of the censuses from 1841 to 1891 follows the work of the late Allen White in his ground-breaking case study of the fusee chain industry in *The Chain Makers*, but has been completely revised from source to amend errors made in the earlier study, to include the 1871, 1881 and 1891 censuses not available to Mr White, and to cover the entire parish for the first time. Although the town of Bournemouth was originally within the Christchurch parish boundaries, its phenomenal growth and entirely different economy made its inclusion in the later census searches both impractical and futile.

The census returns are of considerable value in identifying the number of fusee chain workers in the town and district during the period, their age and sex, and the locations in which most of them are to be found.

On the first point, it must be borne in mind that the numbers of chain workers found are far less than the actual figures employed in the industry at the time. The reasons for this include the fact that many children appear as 'scholars' who would have assisted in supplementing the family income by working on chains at home. It was also not apparently compulsory for part-time occupations to be declared. Furthermore, as we have discovered, the factory operated by Robert Harvey Cox employed people in surrounding towns and villages. A further problem is that the first census, for 1841, lists very few chain workers indeed, at a time when it can safely be assumed their numbers exceeded those given for the next census ten years later. The limitations of this particular census in recording occupations is well recognised, and it is still included as far as it goes because of the details of names which can be shown to carry on to subsequent censuses.

In passing, it should be noted that whilst an attempt has been made to identify chain workers appearing in earlier censuses by the use of asterisks, in an industry dominated by female labour many of the girls and young women would have married and thereby changed their names, so the continuity of the record is lost.

The maps accompanying each census cover the town itself, excluding Stanpit and Mudeford on the east, and Iford on the west. The base map throughout for the sake of consistency and ease of comparison is the Tithe Map, but, obviously, as the town grew streets and roads sprang up that are not recorded. Nevertheless, the maps demonstrate that the principal centre for the chainmaking industry was the Pit site and neighbouring Bargates area, where the Hart's factory was located. It

seems reasonable to conclude that this factory was the largest concern of the three, although the last to be established. Other points of interest are that the workers appear to have lived in subsidiary clusters: one around Wick Lane, the other around Bridge Street to Purewell. It again seems a reasonable conclusion to make that the Pit site workers were employed by Hart's, the Wick Lane workers by Cox in the High Street, and the Bridge Street to Purewell group by Jenkins. If this was the case, the extreme localisation of the labour force to each factory is quite remarkable.

The steady decline of the industry is apparent from the dwindling returns, most dramatically in the last census: it will be of great interest to search the 1901 census when it is published to pick out the remaining few individuals claiming a living from the last remnant of the industry, but it is likely their numbers will be very low indeed. (As proved to be the case when this was later researched.)

All the centres for fusee chain workers are in the parts of the town where small cottages were concentrated; almost nobody in the commercial heart of the town, the High Street and Castle Street, depended on the chain industry for a living – unless they were a manufacturer.

Family relationships revealed in the census extracts are indicated by brackets, and show how it was often the case that whole families earned their meagre living from chainmaking.

Before departing from the subject of the census returns, it seems appropriate to record here that they owe their origin to a Christchurch man, John Rickman.

John Rickman, born in Newburn in 1771, came to live in Christchurch where his father, a retired clergyman who had officiated at nearby Sopley, was living, at Church Hatch. He moved in an exalted circle of literary notables, including Robert Southey (who for a time lived periodically at nearby Burton), Coleridge and Charles Lamb. Thousands of letters which passed between himself and these poets are preserved in the Huntingdon Library. He ultimately became a Parliamentary Private Secretary and government statistician. His principle interest was the study of the population of Great Britain, on which he wrote (probably in Christchurch) a paper in 1796 entitled 'Thoughts on the Utility and facility of a general Enumeration of the People of the British Empire', which reached the attention of the borough's influential MP, Sir George Rose, who was as a result responsible for John Rickman's government appointments. The first Population Inquiry, instigated by Parliament as a result of John Rickman's initiative, was conducted in 1801, and he supervised each ten-yearly national census through to 1831. Another result of his prodigious labours and talents was a complete catalogue of all parish registers in the kingdom, the papers for which he deposited in the British Museum, for which achievement all those interested in genealogy owe him a great debt of gratitude. He died just before the 1841 census was taken, recording for the first time detailed information on individuals.

APPENDIX: CENSUSES

N.B. asterisks denote the number of previous appearances

Census 1841

Bargates
Mary Bursey 50, chain maker
Thomas Barrow 60, fusee chain maker

Gravel Pitts
James Barrow 40, fusee chain maker

High Street
Charles Cox 50, fusee chain manufacturer
Charles Cox 15, apprentice, born Ireland
(presumably in same trade as above)

Whitehall
Mary Fifield 45, fusee chain [indecipherable]
(Husband, Aaron, fisherman)
Receiving parish relief in 1872, infirm
Salisbury Journal 1828: Aaron Fifield
jailed for riot on Bonfire Night, one of
a gang armed and gullty of 'an outra
-geous assault on a special constable'

Union Poor House
William Jellings 60, pauper watch chain worker
In the workhouse in 1834, aged 54

Bridge Street
Henry Jenkins 40, watch fusee chain manufacturer
*(scrawled over entry: '300'. Number
of employees or just a statistical note
unclear. With wife, Mary, two daughters
and a servant)*

Rotten Row
Jane Croucher 19, watch chain factory *(mother
a laundress, brother a labourer
and sister a servant)*

Stony Lane, Burton
Eliza Barnes 20, chain factory *(mother a servant, no male head of household) See 1851 for workhouse, court case and eventual lunacy*

Caroline Barnes 15, chain factory *(probably sister of above, family breadwinners)*

Kitty Tuck 20, chain factory

Stanpit
Mary Booker 35, watch chain maker
Susanna Booker 15, watch chain maker

Burton
Amelia Vardy 15, chain factory *(mother a nurse; no male head of household)*

Ann Vardy 15, chain factory *(probably twin sister of above. She was in the workhouse as a child in 1833-4, aged 10, with her mother and two other sisters)*

Elizabeth Fry 15, chain factory

Iford
Sarah West 20, chain factory
Ann Budden 20, chain factory

Pokesdown
Eliza Summers 20, chain factory

TOTAL ENTRIES: EMPLOYEES 20; MANUFACTURERS 2

Appendix

1851 ● Hart's ● Cox ● Jenkins Tithe Map 1844

CENSUS 1851

Analysis of the sources of the workforce. These and following charts created by Elliot Newman.

Barrack Road
Mrs Elizabeth Toms 35 fusee chain maker (*husband aglab*)
Mrs A. Young wife, 22 fusee chain maker
John Bown lodger, unm. 27, fusee chain tool maker
 (*first appearance, starting decades of
 employment in the industry. Petty
 Sessions 1851: John Bown charged
 with assaulting Proctor Gray in the
 barrack yard; fined 2s 6d and
 13s 6d costs*)

Bargates
Miss Marianne Burry 17, watch chain manufacture marker and cutter
Miss M. Vey) dtr, 17, watch chain maker
Miss E. Vey) dtr, 15, watch chain maker) (*father a
 plumber*)
 *In 1857 is on parish relief, with her
 child [illegitimate], on account of being
 ill; in 1872 appears as 'Kitty', again on
 out-relief, infirm*
Mrs Elizabeth Martin wife, 33, fusee chain maker
 (*husband aglab*)
Miss S. Masterman dtr, 14, fusee chain maker
Miss E. Preston dtr, 17, fusee chain maker
Miss S. Edwards dtr, 19, watch chain manufacture

217

Christchurch the Fusee Chain Gang

Salisbury Journal 1852: On Thursday last an inquest was held before Mr Pain, coroner, and a respectable jury, on the body of the infant child of Sarah Edwards, aged ten hours, who died suddenly. Ann Frampton, the nurse, stated that she was present at the birth; the child was fully grown but of a very dark colour; it cried about five minutes after it was born, but was not known to cry or open its eyes afterwards, though it frequently moaned. Dr Fitzmaurice, surgeon, was then examined. He said he attended Sarah Edwards at her confinement, the child appeared strong and healthy, it cried loudly, he did not notice anything peculiar about its colour. The Coroner requested a post-mortem… Mr Fitzmaurice deposed he had examined the body and found the organs in a healthy condition, but the brain was gorged with black blood, unlike a child which had died from natural causes. Mr Palmer was then examined. He had made a post-mortem examination of the body and was of the opinion the child died from suffocation, from debility and want of power to expand the lungs. As these gentlemen differed in opinion, the Coroner requested a third to be called in. Mr J K Welch, surgeon, therefore examined the child and was of the opinion the child was of feeble powers of life, and that the circulation was improperly performed, and from inability to expand the chest the child died from suffocation. The jury therefore returned a verdict of "Died by the Visitation of God".

PETTY SESSIONS 1857: R v GEORGE BUTLER – MALICIOUS DAMAGE
Sarah Edwards sworn
"On Sunday morning 10 May I was in bed about I think 5 o'clock – I heard something strike against the window. We got up. George Butler threw a brick at the window. I was looking out of the window. We both got out of bed together – he ran away. The brick came through the glass. We moved from the window or should have been struck – it was at the back of the house. He was alone – a pan was flung first it woke us – it did not come through the window – he ran away – it was an upstairs room – he was dressed with light trousers and a striped shirt. I know him well."

PETTY SESSIONS 1857: R v MARY EDWARDS – ASSAULT ON MARY BUTLER
Mary Butler sworn: "On 25th June as I was going home I met Sarah Edwards. She got hold of me and said now I've got you and I'll kill you. I'll beat your two eyes into one. I didn't apply for a summons before because I thought I'd put up with it – she beat me about the head very much with her fists – I didn't return the blows – I held her fast – it was just past 11. This was in the street a few steps from Sarah Starks' door."
Cross-examined: "No one has asked me to take out a summons – I was afraid of my life. At one time I was friendly with Edwards – she has been abusing me these two months. I can't be friendly with a person who threatens my life. My son John don't keep company with such a creature as this – I went in after my son to her house. I haven't been to her house since 25th June – I have several times before. I have never threatened to injure her. There are some windows broken but I didn't break them or threaten to do so. I never threw a plate at her. *I did cut her lips a long time ago in my house [my italics]* – I had no words with her that day. She was coming from home, I was going home. I had been for some candles and she broke them. I said what be you got about Sarah – ? – she struck me in the head. Sarah Starks looked out of her window. It was a Thursday night 25th June, the day after Midsummers Day. I had no ale that night. I had some tea – I had no ale that night."
Sarah Starks sworn: "I live at Bargates. I was at home the night of 25 June. I was abed. I woke and got up and opened the window – I saw Sarah Edwards and Mrs Butler and heard S Edwards say that she would beat her two eyes into one. I saw no blow struck. The next day Mrs Butler had marks of blows on her forehead. She had not such marks on the day before."
Cross-examined: "I did not hear Mrs Butler say anything more. They were about the middle of the path – S Edwards lives near Mrs Butler. There have been squabbles. I never heard Mrs Butler threaten her."
Case dismissed.

Miss Eliza Read visitor, watch chain maker – riveter
Mrs S. Shave wife, 28, fusee chain maker
Witness in an assault case in 1853: "I occupy a house at Bargates. There is a pump enclosed

Appendix

with railings next the house. I have a right to the pump. On 18 July Mrs Saunders' daughter came for water. I went to the pump to fill my tea kettle. I told her she should not have any water (with a fine sense of neighbourliness!). About half an hour afterwards I went to my sister's. I passed Mrs Saunders' house. I heard her use my name. I went in and stated that it was no discourtesy to her that I wouldn't let her have the water. She wouldn't hear what I had to say. She flew at me and kicked me twice in my left side. No one was present. I told her that she should abide by the consequences and she kicked me a third time. I left her and she came and challenged me in the field." The offender, Elizabeth Saunders, was fined the somewhat paltry figure of 1s, although that would have been a day's wages, plus 3s 6d costs.

Miss Ann Barnes	visitor, 32, fusee chain manufacture
	On parish relief by or before 1872, infirm
Miss E Barnes	visitor, 21, fusee chain manufacture

PETTY SESSIONS 1854: R V ELIZA BARNES

<u>Mary Lane</u> sworn: "On Saturday afternoon 1st October I was in the nursery (of the workhouse) when Eliza Barnes struck me with her hand several times and swore at me. She then took up a child's chair and struck me several times on my back. I did not strike her."

<u>Sarah Gould</u> (workhouse mistress): "On the 1st October as I was passing in the passage I saw Eliza Barnes striking Mary Lane with her hand. I told her to leave off but she would not – she continued striking and swearing."

Penalty: 21 days hard labour.

Mrs M. A. Starks)	wife, 70, fusee chain maker (*husband pauper aglab*)
Miss S. Starks)	dtr, 35, fusee chain maker (*see court case quoted above for Sarah Edwards*)
Miss E. Starks)	gdtr, 15, fusee chain maker
Miss M. A. Martin)	dtr, 27, fusee chain maker
Mrs Ellen Best)	dtr, wid. 39, fusee chain maker
Miss M. A. Long	niece, 19, fusee chain maker
Miss M. A. Troke	lodger, 19, fusee chain maker
Mrs Elizabeth Trevis	head, wid. fusee chain maker
Miss A. Starks	dtr, 10, fusee chain maker (*father a miller*)
Mrs S. Mew	wife, 21, fusee chain maker – polisher (*husband a sawyer*)
Mrs Catherine Masterman)	head, wid. 53, fusee chain maker – wire maker
Miss E. Masterman)	dtr, 24, fusee chain maker – link cutter
Miss Aga Tilley)	lodger, 19, fusee chain maker
Mrs Harriet Carter)	head, wid. 52, fusee chain maker
	In the workhouse in 1834 with six children, probably after losing her husband and family breadwinner
Miss E. Carter)	dtr, 22, fusee chain maker
Miss Carter)	dtr, 17, fusee chain maker (*both the above two of the six children of Harriet*)
Miss A. Shambler	dtr, 19, watch chain maker (*father a pauper*)
	Assaulted in this year by one Joseph Cull, who was fined 1s
Miss Sarah Lemmon	lodger, 21, watch chain maker – wire drawer

PETTY SESSIONS 1855 BASTARDY CASE

<u>Sarah Lemmon</u> sworn: "I lodged at Mrs Lemmon's at the same time as Maria Thompson

(bringing the case) – a separate room from Maria Thompson. No one could pass through the passage to Thompson without our knowing – as we opened the door. In Oct last year Js Tilley (the accused, reputed father of the child) was in the habit of visiting her – he frequently came Thursdays Fridays and Saturdays. I never saw any other man come. He generally came not very late in the evening. We could not see who it was when the door was shut."

Cross-examined: "I get my livelihood by factory work. I live at Purewell for about 6 weeks. I lived with Mrs Lemmon 16 months not leaving at any time. Maria Thompson left and went into Pound Lane – she left us on Saturday and returned on the next Friday. Thompson took in needlework. I only saw Tilley visit her. I did not see the soldier or the Packman. I was at the factory in the daytime. I left because they took in more men lodgers – William Reed lodged there and still does – a single man."

"Js Tilley continued to visit Thompson for some months. I have let him in at the front door. I since passed him as he was coming out of her room between 9 and 10 o'clock – it was just after the fair."

Mrs S. Loder	wife, 36, fusee chain polisher
William Hart	head, 39, mar. watch fusee chain manufacturer, born Christchurch, plus nine children and wife
Miss R. Cribb	dtr, 24 fusee chain maker
Miss Jane King	head, 38, fusee chain maker
Miss Ann Brewer	visitor, 19, fusee chain maker
Miss L. Shambler	niece, 24, fusee chain maker
Mrs Sarah Starks	wife, 32, fusee chain worker
Miss Louisa Stote	dtr, 20, fusee chain worker *In the workhouse for three days in 1834 with her family*
Miss Ann Harbin	dtr, 17, fusee chain worker
Mrs Fanny Sturgess)	head, widow, fusee chain worker
Miss Betsy Sturgess)	dtr, 23, fusee chain worker *Receiving parish relief in 1857 on account of illness. Henry, probably her brother, also*
Miss Sarah Toms)	dtr, 19, fusee chain worker
Miss Eliza Toms)	dtr, 17, fusee chain worker
Miss Fanny Toms)	dtr, 13, fusee chain worker
Miss Susan Toms)	dtr, 11, fusee chain worker
Mary Boyt)	wife, 43, fusee chain worker
Miss Fanny Boyt)	dtr, 18, fusee chain worker
Miss Matilda Payne	dtr, 14, fusee chain worker
Miss Eliza Hiscock)	dtr, 19, fusee chain worker
Miss Ellen Hiscock)	dtr, 17, fusee chain worker
Miss Ann Tizard	dtr, 18, fusee chain worker
Miss Sarah Martin)	dtr, 16, fusee chain worker

PETTY SESSIONS 1850: SARAH ANN MARTIN V GEORGE BARNES FOR BASTARDY:
Sarah Ann Martin sworn: "I live at Bargates. On the 11th of April last was delivered of a child. I am a single woman. George Barnes now is the father of that child... I was living at Mr Lemmon's the farmer. The connection continued about a fortnight in August. It was while Mrs Lemmon was away from home … The connection generally took place in the stable in the afternoon. " Sarah's father confronted George, who owned up to being the father. The court ordered him to pay for the maintenance. *Young men seemed so heartless, and no doubt some were, but if they were apprentices they were forbidden to marry before reaching 21.*

Miss Ellen Martin)	dtr, 14, fusee chain worker (*sister of the above*)

Appendix

James Barrow)* head, mar. 55, fusee chain worker*
PETTY SESSIONS 1861: R v GEORGE MACALPINE AND JONATHAN HUNT
James Hornigold sworn: "… Sergeant of Police. On 7 January I served a duplicate of the summons produced on George MacAlpine personally; he was then a prisoner in the Guard Room, Christchurch Barracks."
Henrietta Payne: "On the night of 3 July I was in the road at Bargates. I saw Hunt strike Mr Barrow and one who was with him kicked him. The other man was a soldier. He struck with his fist Mr Barrow full and the other one kicked him on the ground. Mr Barrow's daughter came out and they ran away. No word passed. The blow was in the neck or the head."
James Oliver Barrow sworn: "… the effect of the ill-treatment. I was knocked down in the road. I was struck as I was going into my own gate by soldiers. I can't swear to the men – there were two of them in uniform. They struck me on the head. I got up and got into my own premises. Nothing whatever passed before I was struck between 9 and 10 at night."
Defence: Hunt drunk. Penalty £2 10s.

Thomas Barrow) son, 23, unm. apprentice fusee
 chain worker. *In the workhouse*
 by 1872
PETTY SESSIONS 1860: R v THOMAS BARROW: ASSAULT
Catherine Elizabeth Francier sworn: "On the 20th June about a quarter to 9 in the evening I was talking to a neighbour in Whitehall Lane. Thomas Barrow passed by me and struck me and then swore. I had said nothing to him – he passed on. He struck me on the left side of the head with his open hand. I think he had a little drink … the bonnet slipped to one side … "
George Scott sworn: "On Wednesday evening about a quarter to 9 I was standing at my door. Thomas Barrow was passing by. He crossed the road and struck Mrs Francier a heavy blow on the side of the head. I was standing at my door and heard it about ten yards off. He nearly knocked the bonnet off her head. He said, 'Take that you B--', then he went on."
Defence: "Only touching her bonnet in a joke."
Discharged on payment of costs.
(Petty Sessions 1861: Frank Napoleon Francier charged with deserting his wife and child [the former Catherine Bore] whom he was also to be charged with having married bigamously. He received three months' hard labour.)

Miss Jane Barrow) dtr, 18, operator in chain factory
PETTY SESSIONS 1857
Jane Barrow sworn: "I live at Bargates. On the evening of Saturday 28 March I was passing – I saw Dowling standing close by McGuire's window – I heard the smash of the window. He was standing opposite – he was standing still when I heard the crash. I knew who it was when I passed him. I did not see him do anything – he was nearer the window than I was – he was the other side of the road – I saw no one else there – there was no one else near. This was just after 11. After the window was smashed he walked with me. *I said it's a great shame breaking an old woman's window* [my italics]. He made no reply. He said nothing at all about it."

Miss Ann Barrow	dtr, 14, operator in chain factory
Mrs Mary Ann Fennell	wife, 34, fusee chain worker
Miss Jane Stockley	dtr, 28, fusee chain worker

Gravel Pitt

Mrs E. Best	wife, 32, fusee chain maker
Mrs M. Pickford	wife, fusee chain maker (*husband labourer*)
Miss Eliza Elliott	lodger, fusee chain maker
Mrs M. Troke	wife, 48, fusee chain maker
Miss S. Troke	dtr, 16, fusee chain maker

Christchurch the Fusee Chain Gang

Miss Maria Perry	lodger, 18, fusee chain maker
Miss Ann Barnes	head, 46, fusee chain maker
	On parish relief by 1859, infirm
Miss Sarah Pope	head, 50, fusee chain maker
Miss [?] Caine	dtr, 19, fusee chain maker
Mrs E. Lockyer)	wife, 55, fusee chain maker
Miss S. Lockyer)	dtr, 17, fusee chain maker (*father boot and shoe*
mender).	*On out-relief by 1857, through illness*
Mrs Betsy Drover	dtr, 50, fusee chain maker
	On parish relief by 1859, listed as Elizabeth, infirm. Described as 'irremoveable', meaning that she had gained a settlement in this parish, which was not where she originated; she could not be sent back to that parish

Pound Lane
Miss Charlotte Walden	lodger, 16, fusee chain worker
Miss Francis Best	lodger, 17, fusee chain worker
	As 'Fanny Best', in the workhouse by 1872
Mrs Margarett Preston	wife, 37, fusee chain worker

High Street
Henry Cox	visitor, 20, accountant, fusee chain manufactury *(born Ireland) same house as RH Cox but occupiers now Richard Steel, schoolmaster*

Millhams Lane
Mrs Mary Barnes	wife, 20, fusee chain worker
	In the workhouse by 1872
Miss Mary Lawrence)	dtr, 30, fusee watch chain cutter
Miss Emily Lawrence)	gdtr, 11, fusee watch chain riveter
Miss Anne [?] Barnes	19, fusee chain cutter
Miss Sarah Barnes	17, fusee chain cutter
Thomas Barrow**	head, mar. 68, retired fusee chain maker *(born Sunderland)*
Miss Sarah Tilly	niece, 17, fusee chain operator

Wick Lane
Miss Jane Louden)	dtr, 20, fusee chain maker
Miss A. M. Louden)	dtr, 15, fusee chain maker
Mrs C. Randle	wife, 28, fusee chain riveter (*husband aglab*)
Miss Elizabeth Barnes	visitor, 27, fusee link cutter
Mrs H. Taylor	wife, 46, fusee chain maker
Miss S. Clark	dtr, 13, fusee chain maker
Mrs A. Miller)	wife, 50, fusee chain maker
Miss S. Miller)	dtr, 23, fusee chain maker
Miss S. Miller)	dtr, 15, watch chain maker

Appendix

Whitehall
Mrs A. Hyde wife, 42, fusee chain maker
Mrs A. Vey) wife, 61, fusee chain maker
 (*husband bricklayer*)
Miss E. Vey) dtr, 22, fusee chain maker
Miss M. Sellwood dtr, 15, fusee chain maker

Church Street
Miss S. Laing) dtr, 22, fusee chain maker
Miss H. Laing) dtr, 19, fusee chain maker
 (*mother lodging house keeper*)

Mill Lane (Church Lane)
Mrs M. Moyle) wife, 53, fusee chain examiner
Miss Elizabeth Fry) sister-in-law, 45, fusee chain finisher
Miss Charlotte Rogers visitor, 54, fusee chain link cutter

Workhouse
Miss Mary Holloway inmate, 59, pauper watch chain
 marker and cutter

Bridge Street
Mrs Sarah Abbott) wife, 47, fusee chain worker
Miss Jessie Abbott) dtr, 24, fusee chain worker
Miss Ann Troke) dtr, 20, fusee chain worker
Miss Selicia Troke) dtr, 18, fusee chain worker
Miss Eliza Troke) dtr, 14, fusee chain worker
Henry Treasure Jenkins, head, 50, watch fusee chain manufacturer
 employing about 150 hands
Mrs Charlotte Billett) wife, 45, fusee chain worker
Miss Alice Billett) dtr, 13, fusee chain worker

Rotten Row
Mrs Ann Burry) wife, 28, fusee chain maker
John Jones) head, 32, labourer in chain factory
Miss Charlotte Hiscock) visitor, 20, fusee chain maker
Mrs Maria Bailey) wife, 50, fusee chain maker
 (*husband bricklayer's labourer*)
Miss Marina West) dtr-in-law, 19, fusee chain maker

Purewell Street
George Heales) head, mar. 36, fusee chain maker

PETTY SESSIONS 1857: R v EDWARD BARROW – ASSAULT

George Heales sworn: "I am engaged in Mr Jenkins' [chain] factory. The defendant was also employed there. On the 1st May about 10 o'clock at night I went to Mr Button's for a pitcher of water. As I returned Barrow was standing in the road – he said, 'Mr Heales,' – I said, 'Well, Ned?' – he said, 'Ain't you a bloody fine man.' He said, 'Will you be [i.e. 'bugger'], you've got the bread out of my mouth.' I said, 'Ned, I can't have this language here and I'm not going to stop to hear it.' I left him to walk indoors – just as I got to the door he seized me by the collar – he held me till Pitt came out of the slaughter house. I drew his hand away. The next day I could not swallow. He came threatening and said he'd lay wait and have his revenge on me – Mr Hicks came – I went indoors – he must have held me over 10 minutes."

Elizabeth Heales sworn: "I am daughter of George Heales. On the evening of the 1st May I saw Barrow have hold of my father close by his own door. I heard him say he'd have his revenge. I

can't tell how long – Mr Pitt came and assisted my father. Mr Pitt removed his hand. He took my father by the collar of his coat. The coat is not torn. I did not hear what was said before."
Defence
"Wished to speak to him – he was going on – I caught him by the coat. He hollered out – they came out. I had no intention to injure the man. "
Convicted. Penalty 2s 6d. Costs 9s 6d. To be paid on 18th inst or committed 21 days.
Plainly, Edward Barrow considered himself to have lost his job at the chain factory through Mr Heales, the foreman.

Ge. Heales)	son, fusee chain maker
Miss Mary Ann Heales)	dtr, 15, fusee chain maker
Miss Eliza Heales)	dtr, 13, fusee chain maker
	(see above, as 'Elizabeth')
Ge. Laidlaw	head, mar. 30, fusee chain maker
Miss Love Ward	dtr, 18, fusee chain maker

PETTY SESSIONS 1853: R v KETURAH JEFFREY (A FREQUENT VISITOR TO THE COURT) FOR ASSAULT:
<u>Love Ward</u>, sworn: "On Monday 5 December Ionida and I went into the Halfway House and asked for some apples about half past seven in the evening. The landlady asked us to go into the parlour. We had a pint of ale. A party of girls came into the parlour, Mrs Jeffrey with them, to see the Mummers. B [?] asked me who this woman was. I told her a married woman. The woman said, 'What the b-y hell is it to us whether she was married or not?' She swore she would kill me. I had never been in her company before. After the Mummers had done they left. We left. The two girls followed us. As we were going on Jeffrey struck me on the side of my face and pulled the crown of my bonnet out, took my apron away and kept it. Threw me over in the road, tore the tail of my dress from my body… a young man named Duffett came out of the Halfway House, picked up my things for me …"
Cross-examined: " *She* (Keturah) *had a baby on her left arm all the time.*" [My italics]
<u>John Ash</u> sworn: "I was in the parlour practising Mumming. I saw Love Ward in the parlour. She said, 'That whore, I'll give her two black eyes. If I'm a married woman what's that to her?' I saw no blow."
Two other witnesses stated that there was no quarrelling but the court found against their old adversary and fined her 2s 6d with costs – a heavy penalty.

Mrs Sarah Brewer	wife, 35, fusee chain maker
Miss Matilda Seymour	dtr, 19, fusee chain maker
Miss Mary Scutt	dtr, 18, fusee chain maker
	(*mother, the head, widow, charwoman*)
Frederick Hart	son (*of Marmaduke, cordwainer*),
	30, unm. fusee chain maker
William Jennings	lodger, wdr, 68, pauper, formerly
	fusee chain worker

Burton Road
Abraham Stonestreet	head, mar. 27, fusee chain smith
Mrs Maria Clark	wife, 56, fusee chain maker
	(*husband pauper invalid*)
Miss Charlotte Barrow	dtr, 18, fusee chain maker

Unspecified:
William Brent	lodger, unm. 14, watch chain maker

Stanpit
Edward Barrow	20, unm. watch chain maker

Appendix

	Convicted of assault –
	see George Heales, above
Miss Selina Fry	dtr, 16, fusee chain maker
Miss Ann Cook	dtr, 25, fusee chain maker
Miss Ellen Cook	dtr, 19, fusee chain maker
Mrs Jane Cosser)	wife, 54, fusee chain maker
	(*husband aglab*)
Miss Eliza Cosser)	dtr, 25, fusee chain maker
Miss Ellen Cosser)	dtr, 20, fusee chain maker
Mrs Mary Booker)	wife, 50, fusee chain maker
	(*husband aglab*)
	On out-relief by 1872: infirm
Miss Susanna Booker)	dtr, 29, fusee chain maker
Mrs Eliza Whitcher	wife, 35, fusee chain worker
Miss Ellen Corbin	dtr, unm. 19, fusee chain riveter
Miss Emma Corbin	dtr, 17, fusee chain wire maker

Mudeford
Miss Mary Vardy	lodger, 17, watch chain maker
	In the workhouse as a baby in 1833
	for six months with her two older
	sisters and mother. Probably another
	case of mother deserted or widowed.

Newtown (Highcliffe)
| Mrs Ann Cook | wife, 36, fusee chain maker |

Burton Common
| Mrs Eleanor Adey | wife, 30, fusee chain maker |

Stoney Lane, Burton
| Miss Ann Pitt | dtr, 17, watch chain maker |
| Miss Eliza Barnes* | dtr, 28, watch chain maker |

PETTY SESSIONS 1854: R v ELIZTH BARNES – MISBEHAVIOUR IN THE WORKHOUSE
<u>Jane Rogers</u> sworn: "On Tuesday the 6th June Elizabeth Barnes threatened to stab me as I passed the dining room tables: she jumped up and ran after me with a knife. She was sitting by the table as I passed – I went to the Master and told him. The women told her to sit down."
<u>Martha Brown</u> sworn: "On Tuesday night E Barnes took up her knife and called E Rogers a blasted bitch and said she'd be the death of her. She hit at her but Rogers started (?) back. She is constantly insulting and attacking Rogers. I never saw Rogers give her any reason for it."
21 days hard labour.
Eliza/Elizabeth Barnes ended up back in the workhouse in 1857 on account of being found insane, and also 'guilty' of 'misconduct', a euphemism for having an illegitimate child – she had two small daughters in with her, so presumably had offended twice before as she was unmarried according to the census. Two years later she was being maintained in the County Asylum at Fareham, Hampshire.

| Miss Elizabeth Keeping | dtr, 18, watch chain maker |

Burton
Miss Emma King	gdtr, 10, fusee chain maker
Miss Emily King	dtr, 17, fusee chain maker
Mrs Elizabeth Preston)	wife, 40, watch chain maker
Miss Sarah Preston)	dtr, 17, watch chain maker

225

Christchurch the Fusee Chain Gang

Mrs Sarah King	head, widower, 35, watch chain maker
Miss Selina Starks	dtr, 16, watch chain maker
Mrs Mary Edgell	wife, 47, watch chain maker
Miss Mary King	dtr, 22, watch chain maker
Miss Sarah Clark	dtr, 20, watch chain maker
Miss Charlotte Preston	gdtr, 20, watch chain maker
Mrs ? Holloway	wife, 28, watch chain maker

Waterditch
Miss Ann Brinson)	dtr, 23, fusee chain maker
Miss Sarah Brinson)	dtr, 18, fusee chain maker
Mrs Eliza Pitman	wife, 65, fusee chain maker

Neacroft
Miss Ann Osment)	dtr, 21 watch chain maker
Robert Osment)	son, 18, watch chain maker
Miss Mary Ann James	dtr, 21, watch chain maker

Winkton
Miss Mary Pope	dtr, 24, watch chain worker

Bockhampton
Miss Sarah Corbin	20, watch chain worker

Hurn Road
Miss Sarah Campbell	dtr, 23, fusee chain maker

Blackwater
Mrs Jane Scott	wife, 32, fusee chain manufacture

St Catherine's Hill
John Whatton)	head, mar, 33, fusee chain maker

PETTY SESSIONS 1850: R v BENJAMIN AND JOHN WATTON: TRESPASS IN PURSUIT OF CONIES
<u>James Collins</u> sworn: "I am a steward of Mr Clapcott of Littledown. On 21st February I saw Benjamin Watton and John Watton in Mrs Clapcott's cornfield. They were ferreting..."
Cross-examined: "They had a ferret and a line on to it and you drew the ferret out of the hole before me. This was half past 4 o'clock. John had a net on his head. It was tied over his head as if to keep his hat on..."
Both were convicted with the enormous penalty of 20s each and costs of 6s: equivalent to several weeks' wages.

Mrs Eliza Whatton)	wife, 34, fusee chain riveter
Miss Charlotte Troke)	visitor, 38, fusee chain maker
Mrs Charlotte Tarrant	wife, 39, fusee chain maker
Miss Eliza Tarrant	dtr, 14, fusee chain maker
Mrs Sarah Rabbits	wife, 41, fusee chain maker
Miss Sarah Rabbits	dtr, 19, fusee chain maker
Miss Thuiza Cullen	dtr, 16, fusee chain maker
Miss Figella Cullen	dtr, 15, fusee chain worker
Mrs Caroline Saunders)	wife, 33, fusee chain worker
	On parish relief by 1872
Miss Kezia Saunders)	dtr, 13, fusee chain worker
Mrs Mary Ann Saunders	wife, 26, fusee chain worker
Mrs Matilda Boreham	wife, 52, fusee chain worker

Appendix

Hurn
(Troublefield House)
Miss Sarah Evemy dtr, 18, fusee chain maker

Iford
Miss Elizabeth Budden 21, watch chain factory
Miss Butler 17, watch chain maker
Miss Amelia Butler 13, watch chain maker

Tuckton
Miss Ann Summers 15, watch chain maker

Wick
Miss Leah Parsons) 22, watch fusee chain maker
Miss Eliza Parsons) 18, watch fusee chain maker
Miss Eliza Pain) 29, watch fusee chain maker
Miss Maria Pain) 24, watch fusee chain maker
Miss Mary Bishop) 17, fusee chain maker
Miss Elizabeth Bishop) 11, fusee chain maker
Miss Elizabeth Rendle 21, fusee chain maker
Miss Jane Marshall 24, fusee chain maker (*mother, head of household, a pauper*)
Miss Eliza Fry watch fusee chain maker

Drove Gate, Littledown
Thomas Critch head, mar. 58, fusee watch chain maker
Miss Ellen Critch sister, 46, fusee watch chain maker

Strouden
Mrs Caroline Stickland wife, 28, fusee chain maker

Moordown
Miss Caroline Spencer gdtr, 15, fusee watch chain maker

Holdenhurst: (Corbins Farmhouse)
Miss Mary Eckton dtr (father parish clerk), 18, fusee chain maker

Letter in the *Salisbury and Winchester Journal* 1843
TO THE REV W F BURROWS, VICAR OF Christchurch
REV SIR,
It is with extreme regret that we, the undersigned, hear that our Parish Clerk, JOHN ECKTON, is about to resign his office as Clerk, which situation he has so ably, zealously and faithfully filled, together with Teacher in the Sunday School, which School (should he leave) we much fear will soon come to nought We trust that in the absence of our resident Minister (Mr Hamond), you will oblige us by calling a MEETING in this Parish, to give the said Clerk an opportunity there to endeavour to vindicate his character, which, in our opinion, has so unjustly been taken from him, by accusing him with shooting a Pheasant, and taking his son to swear it as a Pigeon, which latter we firmly believe to be the case, and we further regret that a Man who has served one Mistress faithfully for these last seventeen years, and has borne an unexceptional character from her and throughout the parish, should have his feelings wounded and his reputation lost by the very doubtful evidence of a mere youth; and we are sorry also that the evidence of his Son (a youth 14 years of age who has been a regular attendant at the Church Sunday School for the last nine years) was not allowed by the Magistrates to be taken, in consequence (as they said) of his *complete ignorance* of the nature of an oath. We do not mean to say that the man is

immaculate; but, as far as regards honesty, sobriety, integrity, and zeal in espousing the cause of *true religion and justice*, he stands unrivalled.

Signed by the two churchwardens and 23 others. The reply was swift and came the next week:

TO THE CHURCHWARDENS OF THE PARISH OF HOLDENHURST
SIRS,
A LETTER addressed to me, in the form of an Address, having appeared in the *Salisbury and Winchester Journal* of the 17th inst., to which you have, with many others, subscribed your names as Churchwardens, requesting me, "*in the absence of your resident Minister, to call a meeting in the parish of Holdenhurst, in order to give the late Clerk, Mr John Eckton, an opportunity to endeavour to vindicate his character*", I beg you will have the goodness to make known to those who agreed to sign the Requisition the opinion which I expressed to Mr Gold personally, at the late Visitation at Southampton, *six weeks since*, when he handed me a copy of the said Requisition.

I then distinctly said I did not approve of the proposed meeting, and at the same time I pointed out what I considered, under all the circumstances of the case, a more conciliatory and proper mode for Mr Eckton to adopt; and I have since repeated my opinion, both to the Rev Mr Hamond, your resident clergyman, and to Mr Eckton himself.

Mr Eckton had, previous to the requisition being drawn up, voluntarily tendered his resignation of the office of Parish Clerk; and after a mature consideration of the matter, and more particularly enquiries into the circumstances which had induced him to do so, I told him I thought it would be most advisable for him to retire from the situation, and that I would make arrangements accordingly, when Mr Hamond returned home, which I did.

Why it has been thought necessary, or by whom so injudiciously advised, to make the second appeal to me, through the medium of the public press, *after a lapse of six weeks, and when your resident Minister is not absent, – I have yet to learn.*

If Mr Eckton feels himself aggrieved, there are *lawful* means whereby to vindicate his character; and, as advised by the Chairman of the Petty Sessions, he could have appealed against the conviction, if he believed he had been unjustly treated.

The signatures of so many of the parishioners, and the tone in which the requisition is expressed, – *at least towards himself* – ought to satisfy him that he has not forfeited their good opinion. And as regards the performance of his duties while he held the office of Parish Clerk, I most willingly and fully concur with the Requisitionists in bearing testimony to Mr Eckton's efficiency and zeal; and the more regret that he has placed himself in a position which is as painful to his *real* friends as it is to his own feelings.

As I consider the case one of a private affair, and not involving a question for my official cognizance, I Must, with all due respect to those whose names are attached to the Requisition, beg to decline giving my sanction to a measure which would be to impugn the opinions and decision of the Magisterial Bench, and lead to no possible good.

I remain, Sirs,
Your obedient and faithful servant,
W F Burrows
THE VICARAGE, Christchurch. June 17th 1843

| Miss Mary Marshall | head, 38, fusee chainmaking schoolmistress. *An intriguing entry: was this lady teaching the pauper children of Christchurch how to make chains? Or was she supplementing her inadequate income from teaching in the village school?* |

TOTAL ENTRIES: EMPLOYEES 197 PLUS TWO RETIRED; MANUFACTURERS TWO, ONE WITH 150 EMPLOYEES

Appendix

Census 1861

Avon Buildings
Mrs Elizabeth Tizard) wife, 57, fusee chain maker
Miss Emily Tizard) dtr, 19, fusee chain maker
Miss Kezia Tizard) dtr, 24, fusee chain maker (*father rush dealer*)
Mrs Thirza Day wife, 28, fusee chain maker

West End
James O. Barrow)** head, mar. 63, watch chain manager (*born Aldgate*)
Miss Jane Barrow)* dtr, 28, watch chain maker
Miss Anna Barrow)* dtr, 24, watch chain maker
Miss Sarah Arney dtr, 21, fusee chain maker
Miss Ann Barnes* lodger, 54, fusee chain maker
Miss Elizabeth Barnes head, 38, fusee chain maker
Mrs Harriett Burgess head, mar. 27, fusee chain maker
Miss Mary Jane Pardy 19, fusee chain riveter

Barrack Road
Charles Wagg son, unm. watch chain maker
Mrs Ann Young wife, 31, watch chain maker
Mrs Maria Peckford wife, 51, watch chain maker

Bargates
Miss Sarah Coward) 18, watch chain maker
Miss Mary Ann Coward) lodger, 20, watch chain maker
Mrs Mary Starkes widow, 80 (formerly watch chain maker)

Miss Mary Ann Martin* head, 34, chain maker

Christchurch the Fusee Chain Gang

Betsy Sturgess pictured outside her Fairmile cottage, c. 1900 (courtesy Red House Museum).

Eliza Vey	dtr, 25, fusee chain maker
Jane Vey	dtr, 23, fusee chain maker
Leah Clarke	dtr, 15, fusee chain maker
Mrs Catherine Masterman)*	head, widow, 60, fusee chain maker
Miss Elizabeth Masterman)*	dtr, 33, fusee chain maker
Mrs Rebecca Best	head, widow, 35, fusee chain maker
John Bown**	head, mar. 39, watch chain maker
Mrs Ann Starks	wife, 39, fusee watch chain maker
	Parish relief by 1872: infirm
Miss Emma Blethman	head, 34, fusee chain maker
	Parish relief in 1857 through illness
Mrs Sarah Eyres	wife, 40, fusee watch chain maker
Miss Betsy Sturgess)*	sister, 34, fusee watch chain maker
	Petty Sessions 1871: Elizabeth Sturgess charged with 'clandestinely and fraudulently removing goods from house', for which her rent was in arrears. Cleared, as intent not proved.
Miss Mary Sturgess)	sister, 25, fusee watch chain maker
Miss Louisa Toms	dtr, 20, fusee watch chain maker
Miss Elizabeth Starks	dtr, 18, fusee watch chain maker
Miss Susan Toms)*	visitor, 22, fusee watch chain maker
Miss Elizabeth Toms)	visitor, 22, fusee watch chain maker
Mrs Charlotte Knippard	wife, 23, fusee watch chain maker
Mrs Matilda Ponchard	wife, 29, watch chain maker
Miss Sarah Starks	lodger, 20, watch chain maker
Miss Ann Harbin*	27, watch chain maker
Mrs Eliza Cutler	wife, 39, fusee chain maker

PETTY SESSIONS 1863: PAYNE V LANE

<u>Eliza Cutler</u> sworn: "I am the wife of George Cutler. I live at Bargates. I am sister to M A Payne.

230

Appendix

My sister was delivered of a bastard child in January 1855. In March Fred Lane used to come to her on Saturday night and I have seen him give her money, saying 'That's all I can give you now,' or something like that. About two years ago he promised to allow 2s a week for the child's maintenance. I never heard him say that."

Mary Ann Payne sworn: "My child was born 11th of June 1855. Fred Lane paid me money in March 1855 for its maintenance and continued to pay to the 7th of May last. He paid 1s 6d a week. Sometimes to give me and sometimes to Mr Sharp for me [*local solicitor*].'

Miss Sarah Edwards	30, watch chain maker
Miss Sarah Frampton)	dtr, 25, fusee chain maker
Miss Elizabeth Frampton)	dtr, 14, fusee chain maker
Mrs Harriett Carter)*	widow, head, 64, fusee chain maker
Miss Jane Carter)*	dtr, 27, fusee chain maker
Mrs Eliza Bagshot	wife, 24, fusee watch chain maker
Miss Anna M Brownen	dtr, 16, fusee chain maker
William Hart	head, mar. 49, fusee chain manufacturer employing 104 females and two men

Pit
Mrs Mary Ann Barnes	wife, 34, watch chain maker
Miss Love Ward*	27, watch chain maker

PETTY SESSIONS 1864: R v SARAH SCOTT: ASSAULT ON LOVE WARD

Love Ward sworn: "On 28 September Sarah Scott came and shook my door about half past nine in the evening. I saw her – she broke the mortar and splashed mud on the walls inside and outside. She came into the house and told me to go to Winchester [*i.e. prison*]. She threw a tea kettle at me twice in the passage. I threw it outside the door. She continued in tempting me all day…"

Louise Phillips sworn: "I saw her, Sarah Scott, … throw a kettle in our passage twice – it hit Ward's foot. The whole of the day she threw the kettle in about dinner time between 12 and 1. The row had been going on all the morning."

Elizabeth Hailey sworn: "I saw Sarah Scott throw stones into the passage and insulted Love Ward – she threw mud on the door…"

Elizabeth Brumby sworn: "When I went into Love Ward's last Friday she asked how this was likely to come off. I saw her at Mrs Spicknell's last Wednesday or Thursday, not before that. She was at Mrs Spicknell's Wednesday week… Mrs Spicknell [*Spickernell*] lives in Pit about three minutes' walk from Love Ward's … I saw her in the morning at dinnertime and in the evening."

Jane Goff sworn: "On the 28th Sarah Scott was at my mother's and on that day some boys threw a kettle at Love Ward's. Scott was at my mother's all day. I could see all the little boys and girls; Sarah Scott was not amongst them, not then."

Eliza Starks sworn: "On the 28th I saw three little boys throw a tea kettle into Ward's passage and some stones – this was between 9 and 10 – I only saw three boys, no girls; Scott wasn't there. I went in and heard the baby …"

Case dismissed.

Miss Eliza Fielding	head, 35, watch chain maker

PETTY SESSIONS 1854: R v SARAH ROGERS – ASSAULT

Eliza Fielding sworn: "On 12th August about 6 in the evening or a little later Mrs Rogers abused me about a line. I told her I did not wish to quarrel or bully with her. Then I told her she had no business in that part of the yard at all- we live in the same yard but there are two passages parting it. Mrs Rogers wanted to fight. I told her I shouldn't strike her if she struck – I was going towards my own door. She came and took me by the hair of my head. She held my hair with one hand and struck me with the other. Eliza Tarrant took me to take me away from her. Mrs Rogers struck me over the left eye and several times over the head. My head was swelled."

Cross-examined: "I did not threaten to run a knife through her. You said I was sorry I hung clothes on your line. I did not abuse you."

<u>Eliza Pack</u> sworn: "I live at Pit close to Mrs Fielding. Mrs Shambler sent to ask me to take clothes off the line. I did so. Eliza Fielding was offended because the clothes were hung on her line. She said she should cut the line. I saw Mrs Shambler strike Eliza Fielding. Eliza Fielding said she would go to the summons. I saw her in the evening. I saw a mark above her eye."

Cross-examined: " I said don't have a row."

<u>For defence</u>: <u>Keturah Jeffrey</u> sworn: "I live at Bargates. Mrs Rogers hung clothes on Eliza Pack's line. Mrs Shambler went to take in her clothes. Eliza Fielding said if she hung them there again she would tear them down and said I'll be d--- if I don't run you through with a knife. I saw Mrs Shambler strike her."

Outcome unrecorded in transcript.

Mrs Mary Mason	head, mar. 27, watch chain worker
Mrs Fanny Starks	wife, 29, watch chain maker
Miss Susanna Masterman)	head, 22, fusee chain maker
Miss Emily Masterman)	dtr, 13, fusee chain maker
Mrs Ellen Best	wife, 41, fusee chain maker
Spicer Street	
Miss Harriett Dixon)	dtr, 21, watch chain maker
	(*father a wheelwright*)
Miss Amelia Dixon)	dtr, 16, watch chain maker
Miss Sarah Dixon)	dtr, 14, watch chain maker
Miss Harriett Curl	20, watch chain maker
Mrs Mary Ann Tizard	lodger, widow, 28, watch chain factory
Mrs Maria Spickernell)	head, widow, 51, fusee chain maker
Miss Anna Spickernell)	dtr, 21, fusee chain maker
Mrs Jane Goff	wife, 27, fusee chain maker
	(*see court case Love Ward*)
Pound Lane	
Mrs Mary Barnes*	wife, 63, fusee chain maker
Miss Phebe [?] Moore	dtr, 19, fusee chain maker
Miss Louisa Stote*	head, 32, fusee chain maker
Miss Eliza Barnes	lodger, 27, fusee chain maker
Mrs Margaret Preston*	wife, 47, fusee chain maker
Miss Maria Payne	dtr, 28, fusee chain maker
Millhams Street	
Edward William Jennings*	lodger, widower, 78, formerly mechanic in watch chain manufactury
Mrs Jane Butler	wife, 39, fusee chain maker
Mrs Sarah Starks	wife, 21, fusee chain maker
Sopers Lane	
Miss Ellen Barnes)	dtr, 19, fusee chain maker
Miss Eliza Barnes)	dtr, 21, fusee chain maker
Mrs Sarah Ford	wife, 31, fusee chain maker
High Street	
Miss Lavinia Hext	dtr, 20, fusee chain maker (*father watch and clockmaker; in 1870 she married Fred Jenkins – thus linking once again*

Appendix

Price W. Cox	*the horological families*) son, 26, watch chain manufacturer (son of **Lt-Col Charles Cox**, head of household, 73 and blind, also resident, with wife Ann)
Wick Lane	
Mrs Ann Hyde*	52, fusee chain maker
Mrs Sarah Abbott*	head, widow, 57, fusee chain maker
Miss Mary Ann Sellwood*	head, 25, fusee chain maker
Harriet Porter	lodger, 20, fusee chain maker
Mrs Ann Hayter	wife, 42, fusee chain maker
Church Lane	
Mrs Elizabeth Beale[eau?]	dtr, 32, fusee chain maker
Mrs Mary Moyle	wife, 63, watch chain finisher *On parish relief by 1872, infirm*
Miss Malvena Bailey)	lodger, 20, watch chain maker
Miss Amanda Bailey)	lodger, 20, watch chain maker
Miss Elizabeth Day	visitor, 55, watch chain finisher
Miss Anna Maria London*	dtr, 25, watch chain maker
Whitehall	
Mrs Eliza Ford	wife, 31, fusee chain maker
Thomas R Barrow)	head, 33, fusee chain maker (*born Christchurch*)
Mrs Matilda Barrow)	wife, 29, fusee chain maker
Mrs Martha Page	wife, 23, fusee chain maker
Mrs Mary Phillips)	head, widow, 60, fusee chain maker
Miss Elizabeth Phillips)	dtr, 24, fusee chain maker
Miss Priscilla Phillips)	dtr, 21, fusee chain maker
Miss Ellen Phillips)	dtr, 15. fusee chain maker
Bridge Street	
Miss Jane Billet)	22, fusee chain maker
Miss Elizabeth Jones)	visitor, 14, fusee chain maker (*witness to the fatal gun accident at Jenkins' factory, 1863: see tex*t)
Henry T. Jenkins	head, 60, mar. fusee chain manufacturer employing 100 hands [*wife Mary, daughter Emily, servant and cook*]
Rotten Row	
Miss Mary Lampard)	lodger, 43, fusee chain worker
Miss Emma Lampard)	dtr, 20, fusee chain worker
Mrs Maria Bailey*	wife, 61, fusee chain worker
Mrs Burry*	wife, 38, fusee chain worker
Scotts Hill Lane	
Mrs Mary Ann Pitt)	head, widow, 65, fusee chain worker
Miss Mary Ann Pitt)	gdtr, 17, fusee chain worker
Mrs Charlotte [indecipherable]	wife, 28, fusee chain worker

Purewell

Mrs Eliza Ida Troke	25, fusee chain maker
Miss Ellen Hiscock	housekeeper, 25, fusee chain worker
Mrs Eliza Hicks	wife, 47, fusee chain finisher
Mrs Ann Troke	wife, 31, fusee chain maker
Miss Mary Scutt*	28, fusee chain maker
Mrs Catherine Clark	wife, 22, watch chain maker
Miss Ellen Boyt)	dtr, 24, watch chain maker
	Another 'misconduct' (bastardy) case in the workhouse in 1857, with her daughter of one month
Miss Hannah Boyt)	dtr, 19, watch chain maker
	On parish relief on account of illness in 1859
Miss Mary Barrow	dtr, 25, watch chain maker
Miss Eliza Hiscock)	dtr, 26, watch chain maker
Miss Emma Hiscock	dtr, 20, watch chain maker
Miss Sarah Jones)	gdtr, 17, watch chain maker
	(head: seaman, merchant service, pensioner of 77)
George Hicks)	head, 49, fusee chain maker
Miss Emily Hicks)	dtr, 15, fusee chain riveter
George Heales*	head, 27, fusee chain worker
	(Foreman at Jenkins' factory, killed by accidental discharge of gun at the factory in 1863: see text)

Park Place

Mrs Sarah Barnes	head, widow, 38, fusee chain worker
Miss Amelia Preston)	dtr, 21, fusee chain worker
Miss Julia Preston)	dtr, 18, fusee chain worker
Miss Fanny Abbott	dtr, 35, fusee chain worker
Miss Ellen Oxwith	lodger, 22, fusee chain worker
Miss Mary Harding	dtr, 32, fusee chain worker
William Burt *	lodger, unm. 23 fusee chain maker

Burton Road

Mrs Jane Edgell	head, widow, 63, fusee chain worker
Mrs Ellen Barnes	visitor, 30, fusee chain maker
Mrs Ann Starks)	wife, 46, fusee chain worker
Miss Mary Ann Starks)	dtr, 21, fusee chain worker
Miss Eliza Starks)	dtr, 18, fusee chain worker
	(see court cases Love Ward. In the workhouse by 1872)

PETTY SESSIONS 1861: R v GEORGE HASKELL: ASSAULT

Kate Clark sworn: "On the 24th of June at 6 o'clock in the evening I was having a few words with Haskett's brother-in-law near my mother's at Burton Road. I went to Starks' garden. George Haskett came through his mother's house; he said, 'You called me a rogue', and struck me in the eye. I fell from the blow."
Cross-examined: "I did not call him a rogue."
Eliza Starks sworn: "On the 24th of June I was stood at Mrs Edgell's door about 6 o'clock and saw George Haskett strike Kate Clark, and he said she called him a rogue. It was on my father's ground. She was struck in the eye; it was a violent blow and she fell. I was ten or a dozen yards off. She was stunned for a moment and called her mother."

Appendix

<u>Defence</u>: <u>Charles Haskell</u> sworn: "I am brother [?] to defendant. On 24th of June I came home from work. Her mother got out, bullying me and she sent her witness after the daughter to come and bully me. The daughter Stark came and called me a bloody rogue – she called my brother a bloody rogue and he stood by and heard it. He came and asked if she could prove him a rogue; she jumped about and said 'Take it out of that'. He gave her a left hander and knocked her down."
Penalty 10s.

Miss Harriett Starks)	dtr, 15, fusee chain worker
	(father farm labourer)
Mrs Maria Clark*	widow, 64, fusee chain worker
	On parish relief in 1857
Miss Fanny Toms	24, fusee chain worker
Miss Ellen Whitcher	lodger, 23, fusee chain maker

Stanpit
Mrs Mary Booker*	widow, 61, formerly watch chain maker
Miss Susan Booker*	sister, 39, watch chain maker
Miss Emma Corbin*	gdtr, 27, fusee chain maker
Miss Mary Barrow	dtr, 25, watch chain maker
MIss Emma King)	dtr, 25, watch chain maker
Miss Emily King)	dtr, 21, watch chain maker
Miss Edna King)	dtr, 16, watch chain maker
	(father aglab)

Burton
Mrs Lucy Keeping)	wife, 64, fusee chain maker
Miss Sarah H Keeping)	dtr, 23, watch fusee work
Mrs Elizabeth Cranford	dtr, 28, fusee chain maker
Mrs Mary Ramsey	dtr, 20, fusee chain maker
Mrs Mary Hussey	wife, 61, fusee chain maker
Miss Eliza Barnes*	dtr, 35, fusee chain maker
	Remarkably, appears to be the same person as was sent to the lunatic asylum in 1859 (see 1851 entry)
Mrs Kate Kentell	25, fusee chain maker
Mrs Charlotte Lambert	30, fusee chain maker
Mrs Sarah Reeks	dtr, 30, fusee chain maker
Mrs Selina Pittman	dtr, 23, fusee chain maker
Miss Eliza Paskett	dtr, 20, fusee chain maker

Neacroft
Miss Elizabeth Brown	dtr, 20, watch chain maker

Winkton Common
Miss Ellen Tuck	dtr, 18, fusee chain maker

Hurn Road
Miss Matilda Watton	21, watch chain maker
Mrs Matilda Purchase)	wife, 32, watch chain maker
	(Marsh House)
Miss Sarah Purchase)	sister, 17, watch chain maker
	(Marsh House)

St Catherine's Hill
Eliza Saunders — niece, 17, watch chain maker
Miss Jane Shave — dtr, 29, watch chain maker
Mrs Charlotte Campbell — wife, 42, chain work
Miss Tabitha Cutler — dtr, 22, fusee chain maker
Miss Rachael Rabbits) — dtr, 24, fusee chain maker

PETTY SESSIONS 1851: R v MARTHA SHAVE
Rachael Rabbits sworn: "On Saturday 5th July between breakfast and dinner I was at the well at Catherine's Hill dipping water. Martha Shave threw a jug of water over me and afterwards a bucket of water and tore my bonnet. She did not speak to me. I was not in the habit of speaking to her. I have not spoken to her for two months. My father had forbidden me. She was one side of the well and I the other…"

Caroline Bungay sworn: "On Saturday the 5th I stood at my gate and I saw Rachael Rabbitts and Martha Shave stood at the well. Martha Shave threw a bucket of water over Rachael Rabbitts. She took her bonnet from her head and beat it about her neck and head. Rachael Rabbitts stood and cried and sent her brother for her mother. When the mother came Shave said to her 'I'll serve you the same you old B--.' I was near enough to see what was done. Rabbits said nothing at all but stooped for water and whilst she was stooping Shave threw the water over her…."

Martha Shave sworn: "As I went to the well she tipped water over me. I caught her over the crown of her bonnet to fling water over her as she insulted me first …"
Case dismissed.

PETTY SESSIONS 1854: R v BETSEY COLEMAN AND ANN CUTLER. ASSAULT
Rachel Rabbits sworn: "On Tuesday 25th July I went to the well to get some water and Sarah Coleman came at the same time. She got there just before me. She wouldn't let me have any water – I asked her several times – she struck me at the side of my head just in my face with her hand with a pint cup and broke it in two. I had a pint jug in my hand – she took it away. Her mother came out and struck me and used abuseful language. I turned round to go indoors – Ann Cutler came behind me using threatening and bad language and struck me, followed me to the gate and came in and Cutler struck me several times and Coleman came in and struck me once. Cutler knocked me down and Mrs Long came to my assistance. There were several children in the common. Lucy Tarrant was coming. I had no bonnet on my head. I had no bruise. It was an earthenware cup."

Elizabeth Long sworn: "I saw Mrs Cutler on Tuesday 25 July strike R Rabbits over the gate. She went in a little way and put her child down and went in at the gate and struck her several times. Mrs Coleman went inside the wicket – I saw Mrs Coleman strike her and give her a push. I begged 'em to be quiet and come away."

Defence: Sarah Cutler sworn: "Ann Cutler is my daughter-in-law. I saw her go to Rabbits' wicket and hit Rachel Rabbits with her open hand – one blow I saw and no more. I went down the garden to get some leaves. The language was so profane on both sides that I came away."

Penalty: Ann Cutler 2s 6d. Costs 7s 6d
B Coleman 1s Costs 5s. Defendants to pay on 7th August – committed each 21 days.

Miss Ellen H Rabbits) — dtr, 15, fusee chain maker
Mrs Elizabeth Long — wife, 38, watch chain maker
(see above court case)

Mrs Lucy Tarrant — wife, 38, watch chain maker
(see court case above)

Iford
Levi Butler — 19, watch chain maker
Miss Elizabeth Budden* — 31, watch chain maker
William Rose — 21, watch chain maker (Dairy House)

Appendix

Tuckton
Miss Elizabeth Summers 18, watch chain maker

Wick
Miss Kezia Bungay 22, watch chain maker
Miss Pricilla [sic] Bungay 19, watch chain maker
Miss Elizabeth Rendle* 25, fusee chain maker

PETTY SESSIONS 1860: ELIZABETH RENDLE V HENRY READ: AFFILIATION ORDER

Elizabeth Rendle sworn: "I have been delivered of a bastard child, a boy now here. It was born on the 24th of August last; Henry Read is the father – he is a labourer. He lived at Wick; I live at Wick also. He came to visit me home, he kept company with me. The first time I had connection with him was the 21st October 1858; several times afterwards it happened. I had no connection with anyone else. I first found myself to be in the family way in the December following; my sister-in-law told him in my presence. He said I shouldn't be any the worse for him. He never gave me money. He gave me bread, sugar and biscuit for the child. He came to see the child. I told him the child wanted several things – he said the child should never want for anything. He came to see the child up to about six weeks' ago. He had promised to support the child…"

Harriet Bendle sworn: "I am the mother of Elizabeth Bendle. She lives with me. I know Henry Read. He never would leave her and he always came when he had done his work in the evening … He brought the child two cakes and half a pound of sugar. I said to him, 'Harry, if you do bring such dry cakes the child should have them.' About two months ago I went out to the barn to him. I asked him out in the field. He said the child should never have a farthing of his while he did bide with me. He kept company with my daughter till she was confined. They walked out together – he seemed very loving. I found out my daughter being in the family way: I went to him when she was confined; he said nothing. After that he often came to see the child. He carried the child out, he brought the child a loaf and some biscuit and half a pound of sugar."

Order: to pay 1s 6d per week from 12 May.

Holdenhurst
Miss Elizabeth Read dtr, 25, fusee chain maker
Miss Elanor Could head, 37, fusee chain maker

TOTAL ENTRIES: EMPLOYEES 172 PLUS THREE RETIRED; TWO MANUFACTURERS, ONE EMPLOYING 106 PEOPLE

Census 1871

Avon Buildings
Mrs Mary Ann Brownen wife, 60, watch fusee chain maker
Miss Harriet Carter mother-in-law, 73, fusee chain helper [? or presser]

Mrs Ann Plowman head, widow, 42, watch chain maker
Miss Emily Tizard* dtr, 29, chain finisher
Mrs Selina M Tizard wife, 21, watch chain riveter

Barrack Road
Mrs Sarah Abbott** head, widow, 61, fusee chain maker
Mrs Maria Pickford wife, 61, watch chain worker

Bargates
Miss Harriet Vey dtr, 17, watch fusee chain worker
Miss Elenor Kate Pope) dtr, 12, watch chain factory worker (*born Ringwood*)
Miss Ann Pope) dtr, 12, watch chain factory worker
Mrs Eliza Saunders) head, widow, 51, watch chain factory worker (*born Milton*)
Miss Mary Ann Saunders) dtr, 23, watch chain factory worker
Miss Elizabeth Saunders) dtr, 22, watch chain factory
Miss Eliza Ann Clench dtr, 18, watch chain factory
Mrs Ann Sophia Whittingham head, widow, watch chain factory

238

Appendix

Henry John Brownen	son, unm. 16, watch chain factory (*father letter carrier*)
Miss Charlotte Keith	dtr, 20, watch chain factory
Miss Mary Ann Martin***	head, 42, watch chain factory
Miss Sarah Starks*	head, 52, watch chain factory
Miss Nancy Taylor	dtr, 32, fusee chain maker
Mrs Elizabeth Barnes	widow, 40, fusee chain cutter
Miss Sarah Arney*	head, 32, fusee chain finisher
Mrs Sarah Hart)	head, widow, fusee chain manufacturer employing about 76 females
Miss Emily Hart)	dtr, fusee chain manufacturer (*son Edward, 22, taxidermist*)
Thomas Ray Barnes	head, mar. 42, fusee chain worker
Miss Elizabeth Masterman**	lodger, 40, fusee link cutter
John Bown**	head, mar. 50, fusee chain worker
Mrs Maria Spickernell)*	head, widow, 6-?, fusee chain maker
Mrs Jane Gough)	dtr-in-law, 38, fusee chain maker
Miss Marie Gough)	dtr, 17, fusee chain maker
Miss Laura Barnes	dtr, 15, fusee chain factory
Miss Ann Barnes*	head, 60, fusee chain factory
Mrs Elizabeth King	lodger, widow, 71, formerly fusee chain maker
Abraham Stonestreet)*	head, mar. 47, watch fusee chain maker
Mrs Mary Ann Stonestreet)	wife, 45, watch fusee chain maker
Mrs Susannah New	wife, 44, fusee chain maker
Mrs Elizabeth King	head, widow, 60, formerly watch chain maker *On parish relief by 1872, infirm*
Mrs Tabitha Remington	wife, 32, watch chain maker
William H. C. B. Pardy	godson, 9, watch chain maker
Mrs Emma Clarke)	wife, 40, watch chain maker
Miss Amelia Clarke)	dtr, 14, watch chain maker
Miss Eliza Starks	niece, 24, fusee chain riveter
Mrs Rachel Early	wife, 34, watch chain maker
Mrs Elizabeth Troke	wife, 24, watch chain maker

Pit
Mrs Ellen Best*	wife, 51, watch chain maker
Mrs Rebecca Best*	head, widow, 46, watch chain maker
Mrs Jane Dixon)	wife, fusee chain maker (*husband carpenter*)

PETTY SESSIONS 1862: R v JOSHUA DIXON: SURETY OF THE PEACE
Jane Dixon sworn: "On Sunday evening between 8 and 9 o'clock my husband John Dixon was at home. When he went upstairs he went to get in bed with his clothes. He threw his coat on the bed and I took a razor from his pocket and a knife. He had had a little drink – there was no doubt about it. He made no resistance to my taking the things from his pocket. When I gave him his coat he said, 'Damn your eyes: I will do for you.' He offered no violence. Yesterday he used abusive language to me. He made no threats. I cannot say from that he will do me some injury."
Dismissed with a caution.

Miss Sarah Dixon)*	dtr, fusee chain maker
Miss Harriett Dixon)*	dtr, 21, fusee chain maker
Miss Mary Jane Dixon)	dtr, 19, fusee chain maker

Christchurch the Fusee Chain Gang

Miss Alice Dixon) — dtr, 17, fusee chain maker
Miss Eliza Hiscock — head, 28, watch chain worker
Mrs Ellen Reeves — widow, 56, fusee chain maker
Miss Elizabeth (poss, Charlotte) Vey — dtr, fusee chain maker
Miss Maria Payne) — visitor, 43, fusee chain maker
Miss Ann Payne) — visitor, 15, fusee chain maker

Pound Lane
Miss Jane Butler) — dtr, 16, fusee chain worker
Miss Sarah Butler) — dtr, 13, fusee chain worker
Mrs Charlotte Drover — wife, 32, watch chain riveter
(*This is the lady described in the text in the interview with her daughter, Rose Andrews*)

Millhams Street
Miss Mary Harding — head, 40, watch chain fusee wire maker

Sopers Lane
Miss Charlotte Hiscock — gdtr, 11, fusee chain maker
(*living with grandparents of 87 and 79, annuitants*)

Mrs Jane Dixon — head, widow, 23, fusee chain worker

High Street
Miss Selina Hext) — dtr, 27, fusee chain maker
(*father, Giles, watch jobber*)

Fred Hart — head, mar. 30, watch fusee chain manufacturer
(*wife Mary, daughters Sarah Elizabeth (3), Louisa (2), William (5 months), servant*)

Thomas P. Cox — head, mar, 34, watch fusee chain manufacturer employ 130 women, one man *born Stockwell; in RH Cox house with wife, Mary, and one servant*]

Church Street
Mrs Lydia Perry — wife, 28, fusee chain maker

Wick Lane and Whitehall
Mrs Martha Page* — wife, 32, fusee chain maker
Miss Eliza Scott) — dtr, 14, fusee chain maker
Miss Ellen Scott) — dtr, 14, fusee chain maker
Mrs Harriett Sturgess* — lodger, widow, fusee chain worker
Miss Elizabeth London — dtr, 30, fusee hook maker
Mrs Ann Hyde** — wife, 62, fusee chain worker
Mrs Emma Vey — wife, 23 [poss. 28], fusee chain maker

Church Lane
Mrs Eliza Ford* — wife, 41, fusee chain maker

Appendix

Whitehall
Miss Mary Ann Sellwood** mother-in-law, 55, fusee
 chain maker

Bridge Street
Mrs Mary Jenkins head, widow, 70, watch chain
 fusee manufacturer
Miss Elizabeth Toms* lodger, 25, chain manufacturer

Bow Place/Rotten Row
Miss Harriett Seymour) companion, 24, fusee link cutter
Miss Emily Seymour) dtr, 28, watch chain wire maker
Miss Elizabeth Seymour) dtr, 19, watch chain wire maker
George Laidlaw)* head, mar. 49, *clock* chain maker
Mrs Sarah Laidlaw) wife, 32, *clock* chain maker

Scotts Hill Lane
Miss Harriett Starks dtr, 12, watch chain maker
Mrs Eliza Gardner wife, 37, worker in watch chain factory
Mrs Sarah Brewer wife, 53, chain maker

Purewell
Miss Eliza Boyt) dtr, 20, watch chain maker
Miss Louisa Boyt) dtr, 18, watch chain maker
Mrs Sarah Ford* wife, 42, watch chain maker
Miss Selina Necklen dtr, 19, watch chain maker
William Rose)* head, mar. 35, fusee chain maker
 *In 1859 was on parish relief through
 illness, at 18. (Witness in fatal gun
 accident at Jenkins' factory in 1863:
 see text)*
Mrs Kezia Rose) wife, 34, fusee chain maker

Park Place
Mrs Harriett Burgess* head, widow, 35, chain maker
Mrs Fanny Stride wife, 45, chain maker
Miss Mary Scutt* dtr, 39, fusee watch chain maker

Stanpit
Mrs Mary Booker** head, widow, 71, formerly watch
 chain maker

Burton
Miss Bessie Read dtr, 15, watch chain maker
 (father aglab)
Mrs Sarah Campbell wife, 32, watch chain maker
 (husband sawyer)

Neacroft
Mrs Sarah Brown wife, 36, watch chain maker
Miss Ann Saunders dtr, 24, chain maker
Miss Sarah A. Brown dtr, 32, watch chain maker

Christchurch the Fusee Chain Gang

St Catherine's Hill
Miss Susannah Tarrant dtr, 17, fusee finisher
Mrs Mary Saunders wife, 45, chain maker
 (husband labourer)
Mrs Caroline Saunders head, widow, 54, *clock* chain maker

Hurn
Mrs Eliza King wife, 50, fusee chain maker

Barrack Road
(Jumpers Lodge)
Mrs Elizabeth Sansom wife, 22, watch chain maker
 (husband aglab)

Tuckton
Miss Susan Summers dtr, 19, fusee watch chain wire maker

Holdenhurst
Mrs Mary Kerly head, widow, 36, fusee chain maker
 (born Stanpit)
Miss Ellen Critch* head, 65, fusee chain maker

Bournemouth (Commercial Road)
Miss Phoebe Moore) dtr, 29, fusee chain maker
 (born Ringwood)
Miss Mary Moore) dtr, 22, fusee chain maker
 (born Ringwood)

Moordown (Rose Gardens)
Miss Sarah Barnes dtr, 26, fusee chain maker
 (born Holdenhurst)
(Muscliff Dairy)
Miss Elizabeth Brewer wife, 34, fusee chain maker
 (born Throop)

TOTAL: 105 + 3 RETIRED; THREE MANUFACTURERS

Appendix

Census 1881

Excluding Bournemouth

Spring Gardens
Miss Jane P. S. Scott dtr, 22, watch chain factory hand (*mother, head, charwoman*)

Bargates
Mrs Eliza Saunders)* 'mother', wife, 61, fusee chain maker
Miss Elizabeth Saunders)* sister, 30, fusee chain maker watch

Miss Sarah Saunders) sister, 23, fusee chain maker watch
Miss Susan Butler) dtr, 19, fusee chain worker (riveter) (*father general dealer*)
Miss Elizabeth Butler) dtr, 17, fusee chain worker (riveter)
Miss Ann Butler) dtr, 14, fusee chain worker (wires)
Miss Mary A Martin*** head, 53, watch chain worker
Mrs Amanda Hard wife, 40, watch chain worker
Mrs Mary Vey wife, 20, watch chain maker
Miss Louisa Read dtr, 19, marker and cutter in Watch Chain Factory
Mrs Elizabeth King* head, widow, 69, watch fusee chain hook maker

Harry Trevis son, unm. 20, watch fusee chain maker

Mrs Sarah Hart head, widow, 67, fusee chain manufacturer (*in house alone with one servant; house that in front of fusee factory*)
Miss Charlotte Keith* dtr, 27, fusee chain maker

Christchurch the Fusee Chain Gang

Thomas Barrow*** head, widower, 52, watch fusee chain maker (*born Christchurch, living alone*)

John Bown*** head, mar. 59, foreman fusee chain factory

Pit
Miss Emma Preston	dtr, 20, watch chain maker
Miss Mary Dixon*	dtr, 28, fusee chain maker
Mrs Fanny Starks)*	wife, 50, watch chain maker
Mrs Frances Wilson)	dtr, 23, watch chain maker
Miss Rebecca Best)**	head, 54, fusee chain maker
Miss Emily Best)	dtr, 24, fusee chain maker
Mrs Charlotte House)	head, 21, watch chain worker
Miss Alice Hiscock)	visitor, 17, watch chain worker
Mrs Jane Dixon*	head, widow (*drunken and violent husband of 1862 court case now dead*), 32, watch chain maker
Mrs Eliza Bushnell	wife, 49, watch chain work (*husband bricklayer*)

High Street

Fred Hart head, mar. 40, fusee watch chain manufacturer employing 40 women (*wife Mary and five children inc. Fred (2) plus servant. House after Arthur Brown next Library and this was formerly Giles Hext's*)

Edward E. Clarke head, mar. 25, watch chain manufacturer (*born Kenilworth; wife Charlotte born Christchurch; next Ship Inn therefore Cox house. Daughter and servant.*)

Church Lane

Mrs Emma Vey* wife, 36, watch chain maker (*husband bricklayer*)

Whitehall
Miss Alice Tuck)	dtr, 24, fusee chain maker
Miss Annie Tuck)	dtr, 18, fusee chain maker
Miss Eliza Scott*	dtr, 24, fusee chain maker
Miss Mary Lampard*	lodger, 63, fusee chain maker
Miss Susan Summers*	dtr, 29, fusee chain maker
Mrs Elizabeth Marshall	wife, 34, fusee chain worker
Mrs Martha Page)*	wife, 43, fusee link cutter (*husband coach painter*)
Miss Louisa Page)	dtr, 15, fusee hook maker
Mrs Charlotte Drover*	wife, 42, watch chain riveter (*husband grocer and porter, and borough constable. This is the lady described by her daughter Rose Andrews in a taped interview in 1967.*)
Mrs Ellen Miller	wife, 69, watch chain maker
Mrs Rachel Early*	head, widow, 45, fusee chain maker

Appendix

No entries Avon Buildings, Pound Lane, Millhams St

Bridge Street
Miss Catherine Hayward) dtr, 17, riveter, watch etc
 (*born Farnham*)

Bow Place
William Jeans head, mar. 41, fusee chain manufacturer
 employing 35 women and two men.
 (*Last house before Rotten Row*)

Rotten Row
Miss Elizabeth Drover dtr, watch fusee chain maker
 (*father labourer*)

Scotts Hill Lane
Mrs Eliza Gardner* wife, 63, watch fusee chain maker
 (*husband bricklayer's labourer*)

No street name: next Hengistbury House, so Purewell)
Miss Elizabeth Toms** lodger, 30, watch chain maker
(2 Clifton Villas
Miss Louisa Boyt dtr, 28, watch fusee maker
 [Henry Jenkins, 55, builder
 and decorator]

Purewell
William Rose** head, mar. 41, fusee chain maker
Mrs Kezia Rose)* wife, 45, fusee chain maker

Park Place
Mrs Frances Stride)* wife, 53, watch fusee chain maker
 (*husband general labourer*)

Mrs Elizabeth Clarke) dtr, 23, fusee chain maker

Burton Road
Mrs Sarah Haskett wife, 47, fusee chain maker
Miss Anna Hall dtr, 19, works at the Watch Chain
 Factory
Miss Emily Warn dtr, 21, watch chain factory

Winkton Common
Mrs Mary Andrews wife, 45, watch chain maker

Portfield Road
Mrs Harriet Spickernell wife, 41, watch chain maker
 (*husband bricklayer's labourer*)

St Catherine's Hill
Miss Annie E Clench lodger, 28, fusee chain maker
Mrs Eliza Saunders head, widow, 64, watch chain maker

TOTAL: 55; TWO MANUFACTURERS

CENSUS 1891: most women do not have occupation entered

No St Catherine's Hill entries

Barrack Road (Cross Keys Inn)
MIss Emily Best* lodger, 35, fusee watch chain maker

Bargates
Mrs Susan New* head, 59, fusee chain maker (retired)
Mrs Annie Byford) head, 24, fusee chain maker (retired)
Miss Harriet Payne) mother, 48, fusee chain maker (retired)
Miss Sarah Starks* head, 78, fusee chain maker (retired) -
 factory closed?
Mrs Elizabeth King** head, widow, 80, fusee watch chain
 maker
Fred Hart head, widower, 50, fusee chain
 manufacturer. (Daughter Sarah, sons
 Fred (12) and Robert (9), brother-in-
 law and servant)
John Bown**** head, mar. 69, retired watch fusee chain

Pound Lane

Mrs Sarah Eyres mother-in-law, widow, 70, fusee watch
 chain maker
Miss Annie Forse ?Fowe] dtr, 22, fusee watch chain maker

High St: Robert Burnie after Henry White, ironmonger, where Cox was

246

Appendix

Church Street
Mrs Lydia Perry* head, widow, 50, watch chain maker
Miss Loui[s]e Boyt** boarder, 38, watch chain factory employee

Whitehall
Mrs Charlotte Drover)** wife, 52, watch chain riveter
Miss Rose E Drover) dtr, 15, watch chain hook maker
Last of the fusee chainmakers: her taped interview is published in full
Miss Susan Summers sister, 36, fusee watch chain maker

Waterloo Place (Bridge Street)
William Jeans head, mar. 51, watch fusee chain maker
Mrs Louisa Jeans) wife, 41, fusee chain maker

Purewell
William Rose*** head, mar. 51, fusee watch chain maker (wife no occupation given)
Miss Eliza Toms*** head, 40, fusee watch chain maker
Mrs Fanny Clark** head, widow, 52, fusee watch chain maker

Park Place
Mrs Fanny Stride** lodger, widow, 65, retired fusee chain maker

TOTAL: 13 PLUS 6 RETIRED; TWO MANUFACTURERS

Census 1901

A limited scan of the census shows how the closure of both Cox and Hart's factories has left but a scattering of workers in the chain industry. Old, they are true remnants of a past age:

Charlotte Drover, in Wick Lane, has ceased to be a chain worker, turning her hand instead to work as a skirt seamstress.

Bargates
Lydia Perry** widow, 60, fusee watch chain maker

Waterloo Place, Bridge Street:
William Jeans 61, fusee watch chain manager

Scotts Hill Lane
Sarah Button widow, 60, worker at fusee watch chain factory

Purewell
William Rose 60, fusee watch chain maker, employer
Edith Toms boarder, 40, fusee watch chain maker

There is not likely to be any more in this census, so we end our tally with a last few stalwarts, waiting for the inevitable end of their industry.

BIBLIOGRAPHY

Anon., *Historical and Descriptive Account of the Town and Borough of Christchurch* C. Tucker, 1837
Anon., *The Workwoman's Guide*, c. 1839
Anon., *The Book of Trades or Circle of the Useful Arts*. 1818
Anon., *Beauties of England*, 1764
Anon., *Moments in Time Vol 1*, The Coventry Watch Museum Project Ltd, 1999
Baker, T. A., *Companion in a Tour Round Southampton*, 1794
Beeson, C. F. C., *English Church Clocks 1280 – 1850*, Brant Wright Associates Ltd, 1977
Bell, Nancy, *From Harbour to Harbour*, G. Bell and Sons, 1916
Bennett, Paul, *Time*, Ticktock Publishing Ltd UK, 1999
Bingley, Revd W., History of Christchurch, 1813 (unpublished ms)
Brearley, Harry C., *Time Telling Through the Ages* Doubleday, Page & Co., 1919
Britten, F. J., *Watch and Clockmakers' Dictionary and Guide*, W. Kent and Co., 1884
Bush, Sarah, *The Silk Industry*, Shire Publications, 2000 (Second Edition)
Chapman, Derek H., *A Farm Dictionary*, Evans Brothers, 1953
Child, Melville T. H., *Farms, Fairs and Felonies: Life on the Hampshire-Wiltshire Border 1760-1830*, 1967
Chilver, Kathleen M., *Holdenhurst Mother of Bournemouth*, Bournemouth Local Studies Publications, 1980 (First published 1956)
Clock and Watchmakers, Apprentices and Dealers in Hampshire, 1969
Cookson, Mrs Nesfield, *The Costume Book* Herbert Jenkins Ltd, 1934
Coultas, Cynthia, The Fusee Chain Industry of Christchurch, Hampshire, 1790-1851 (unpublished ms)
Cowan, Harrison J., *Time and its Measurement*, The World Publishing Company, 1958
Cross, D. A. E., *The Story of Ringwood's Industries*, 1963
Cupples, Mrs George, *The Stocking Knitter's Manual: A Handy Book for the Work-Table*, Edinburgh n.d.
Cutler, Joseph, *Autobiography*, c. 1890
Daniel, Christopher, *Sundials* Shire Publications, 1986
Defoe, Daniel, *Tour thro' the whole Island of Great Britain ... by a Gentleman*, 1724
Diderot et D'Alembert, *Encyclopedie ou Dictionnaire Raisonne des Sciences, des Arts et des Metiers, par une Societe des Gens de Lettres*, 1765

Dodd, George, *British Manufactures* Charles Knight & Co., 1844

Driver, Abraham and William, *General View of the Agriculture of the County of Hampshire with Observations on the Means of Improvement,* 1794

Druitt, Herbert *Christchurch Miscellany,* Christchurch Local History Society reprint, 1996

Druitt, Herbert Diaries (unpublished), Red House Museum, Christchurch

Eyre Bros, *The Watering Places of the South of England,* 1877

Farrell, Jeremy, *Socks and Stockings,* Batsford, 1992

Great Exhibition Official Catalogue Classes V-X Machinery

Grove, R. A., *Marine Landscape Scenery in the Neighbourhood of Lymington, Hampshire,* 1832

Hammond, J. L., and Barbara *The Village Labourer,* Guild Books, 1948 (first published 1911)

Hampshire Repository, 1798 & 1801

Hartley, Marie and Ingilby, Joan, *The Old Hand Knitters of the Dales,* Dalesman Publishing Company, 1951

Hickson, Edna, *Macquarie's Ten Gentlemen,* Nepean District Historical Society [Australia] 1990

Humphries, N. A., 'The Incorporation of Christchurch' (private collection)

Jones, John, *Sketch of the History and Principles of Watch Work,* London, 1840

Kent, David, *Popular Radicalism and the Swing Riots in Central Hampshire,* Hampshire Papers, 1997

Kevill-Davies, Sally, *Yesterday's Children,* Antique Collectors' Club, 1991

Lane, Marjorie P., *Christchurch* n.d.

Lavender, Ruth A., *A Thousand Years of Christchurch* Bournemouth Local Studies Publications, 1990

Lavender, Ruth A,. *The Farmers of Winkton Tithing 1855-1875*

Leadbetter, Eliza, *Spinning and Spinning Wheels,* Shire Publications, 1995

Levitt, Sarah, *Victorians Unbuttoned,* George Allen and Unwin, 1986

Lippincott, Kristen, *The Story of Time,* Merrell Holberton Publishers Ltd, 1999

Lodge of Hengist, 1890

Marshall, George, Now and Then: The Times and the Last 60 Years (ms), 1915

Mercer, Frank, *Mercer's Chronometers,* 1976

McKay, Chris, *The Turret Clock Keeper's Handbook,* The Antiquarian Horological Society, 1998

Newman, Sue, *The Christchurch and Bournemouth Union Workhouse* (2nd edition) 2000

Newman, Sue and Tizzard, Mike *The Christchurch Commons,* 2007

Norgate, Martin *Hampshire Clockmakers Directory,* 1993

Pelham, R. E., *The Agricultural Revolution in Hampshire,* Hampshire Field Club

Pocock, Dr Richard, *The Travels Through England* Camden Society, 1753

Postlethwaite, Malachi, *Dictionary of Trade and Commerce,* 1774

Roberts, P. P., *Richard Roberts, Flax-Spinner,* Proceedings of the Dorset Natural History and Archaeological Society, 1977

Slee, Ivan, *The Chainmakers,* Antique Clocks Magazine Vol 12 Dec 1989 No. 7

Spence, Margaret, *Hampshire and Australia, 1783-1791 Crime and Transportation* Hampshire Papers, 1992

Stratton, J. M., *Agricultural Records AD 220-1977,* John Baker 2nd Edition, 1978 (First Edition 1969)

Street, Roger T. C., *Victorian High Wheelers: The Social Life of the Bicycle: where*

Bibliography

Dorset meets Hampshire Dorset Publishing Co., 1979

Tomlinson, Charles, *Illustrations of Useful Arts and Manufactures Society for Promoting Christian Knowledge,* 1858

Trenchard, David, *Dorset People Involved in the Growing of Hemp and Flax 1782-1793,* Somerset & Dorset Family History Society, 2000

Tucker, William, *Reminiscences of Christchurch and Neighbourhood,* Bournemouth Local Studies Publications, 1979

Vancouver, C., *General View of the Agriculture of the County of Hampshire,* 1810

Victoria County History: *Hampshire,* 1911

Warner, Revd Richard, *Literary recollections,* 1830

Watney, John, *The Mystery of Time* Pitkin Unichrome Ltd ,1999

Weiss, Leonard, *Watch-Making in England 1760-1820* Robert Hale, 1982

Welch, Kenneth F., *Time Measurement: An Introductory History,* David & Charles, 1972

Wells, F. A., *The British Hosiery Trade,* Allen & Unwin, 1935

Wells, N. M., *Time,* Collins Gem, 1999

White, Allen, *The Chainmakers,* Allen White, 1967

White, Allen, *Square House,* Allen White, c. 1970

Williamson, J., *Contents of the Mainland of Hampshire,* 1861

Wood, E. J., *Curiosities of Clocks and Watches From the Earliest Times,* E. P. Publishing Ltd, 1973 (First published 1866)

Woodward, B. B., *General History of Hampshire*

Wymer, Norman, *English Country Crafts A Survey of their Development from Early Times to Present Day,* Batsford, c. 1950s

Ye Worshipful Company of Framework Knitters, *Ye Historie of ye First Pair of Silk Stockings made in this Country and worn by Queen Elizabeth,* John Alexander, 1884

Young, J. A., *Bournemouth and The Christchurch Enclosure Act 1802,* Bournemouth Local Studies Publications, 1999

INDEX

The Census Appendix can also be searched for by individual names, most of which have not been included in this index.

Adams, Sarah, 9
Agriculture, 200f
Aldridge, George junior, 72
Aldridge, George Olive, 212
Aldridge, John, 180f
Andrews, Rose, 68f, 170f
Arnold, John, 106
Association for the Protection of Property, 64
Avon Brewery, 207
Ayles, Messrs, 186

Bailey, Joseph (qv Bayly), 58
Baker, Mr, 11, 12, 73
Banks: Penny Savings Bank, 43
Bargates Farm, 200
Barracks, 31, 59, 64, 69, 72, 221
Barrow, James Oliver, 143f, 152
Barrow, Thomas, 143 et seq, 165
Bayly, John, 55
Bayly, Joseph (qv Bayley), 55
Bayly, Samuel, 195
Beech House, 21
Belbin, Mary, 188
Belbin, Moses, 185
Bemister, Mr, 169, 212
Bingley, Revd W., 28, 157, 180
Blake, William, 211
Blanchard, James, 181
Blanchard, Pittman, 181
Blind House, 64, 65, 69, 70
Boldre Workhouse, 139f
Bone, Henry, 60f
Bore, Catherine, 221

Bore, Michael, 196
Brander, Charles, 35
Brander, George Frederick, 42, 72
Brander, Gustavus, 72
Brander, Henry Augustus, 72
Brenton, John, 60
Brixey, 60
Burden, Joseph, 185
Bure Farm, 200
Burry, John, 77
Burt, Edward, 185
Burt, Miss, 188
Butler, Betty, 74, 76, 77
Butler, Caleb, 29
Butler, Elizabeth, 188
Butler, George, 58, 218
Butler, James, 73, 74, 82
Butler, John, 80
Butler, Mary, 218
Butler, W., 58
Button, Elias, 32
Button, George, 59
Button, Sarah, 248

Caleb's Row, 83
Campbell, Henry, 58
Carpenter, Samuel, 58
Carter, Harriet, 68, 219, 231, 238
Chewton, 146f
Cholera, 19, 22
Christchurch Agricultural Society, 43, 205
Christchurch Brewery, 208, 211
Christchurch Priory, 11, 24, 30, 61,

Index

102, 144, 198
Christchurch Steam Brewery, 212
Christchurch Workhouse, 20, 22, 27, 29, 45f, 61, 69, 70, 133, 134, 135, 136, 137, 138, 139, 141f, 158, 181f, 192f, 208
Church, Theodore, 58
Clapcott, Mr, 58f 226
Clarke, David, 58
Clarke, Ernest Edward, 155f
Clarke, Nicholas, 185
Clarke, William, 154
Clingan's Charity, 28, 141, 185, 195f
Cloth manufacture, 27
Cobbett, William, 48
Colgill, John, 102
Commons/Common Rights, 12, 15, 37f, 53, 58f, 69, 73
Congregational Church, 24, 130, 150
Cook, John, 32, 198, 207f
Coulon, Charles, 127
Court Hall, 64
Court Leet, 17, 39, 73
Coward's Marsh, 39, 48
Coward, Walter, 74
Cox & Co., 124f, 150, 156, 161
Cox, Ann, 129, 144f
Cox, Ann Maria, 146
Cox, Anthony Joseph, 149
Cox, Charles, 147f
Cox, Harry, 148, 151f
Cox, Henry, 151
Cox, James, 127f
Cox, Jane, 144
Cox, Jenny, 124f, 126, 144
Cox, Mathew Dillon Thomas, 151
Cox, Robert, 124
Cox, Robert Harvey, 124f, 129f, 148f, 152, 155f, 181, 213
Cox, Thomas Price Wynne, 152f
Cox, William, 126, 128
Cram, Mrs, 188
Cranston, B, 188
Cranston, M, 188
Cranston, Mary, 188
Cray, Jeremiah, 208f
Crispin Inn, 209
Croucher, Eli, 212
Crumpler's, 46

Cusse, William, 72
Cutler, Joseph, 24
Cutler, Thomas, 59

Da Vinci, Leonardo, 112
Daw, Jacob, 195
Daw, Thomas, 72, 211
Daw. Ambrose, 211
De Vick, 102f
Dean, Mr, 58
Defoe, Daniel, 179
Dent, Villiers, 56
Derham, James, 58
Diderot, Dennis, 115f
Dollin, 21
Dolphin Public House, 208f
Drover, Charlotte, 170, 240, 244, 247, 248
Druitt, Alan, 170
Druitt, Herbert, 155, 157, 159, 170
Druitt, Philip, 21f
Dudmore Common, 58
Dudmore Farm, 202
Duke, 21

Earnshaw, Thomas, 106
Eaton, Catherine, 188
Edwards, John, 73
Eggs, Charlet, 61
Eggs, Mary, 61, 63
Eggs, William, 61f
Eight Bells, 198, 207
Ellinger, Israel, 61
Elliott, John, 211
Enclosures, 47f
Eyres, William, 62

Fairs, 205
Farr, Mr, 58
Ferrey, G. H., 155
Ferrey and Son, 210
Fishery/fishing, 196f
FitzHarris, Lord, 55
Fitzmaurice, Mr, 151, 218
Flax-spinning, 134, 191
Footner, 46
Fordingbridge, 45, 47, 51, 60, 140f
Fordingbridge Workhouse, 141-146
Friendly Societies, 43

Gale, Nicholas, 185
Galileo, 103
Game Laws, 53f
Gattrell, Joseph, 61
Gattrill, Moses, 33
George Inn, 65, 209
Gervis, Sir George/Tapps, 42f, 59
Gillingham, Thomas, 45
Ginn, William, 31
Glovemaking, 27, 29, 184f
Goddard, Dr John, 21f
Gooby, H., 58
Good, Mr, 186
Graham, George, 104f
Great Exhibition, 167f
Grove Farm, 200
Gruet, 112
Gubby, John, 65
Gum, Thomas, 45
Gunn, Revd Daniel, 150

Habgood, Jim, 122
Harben, William, 65
Harris, Anthony, 65
Harris, Capt E. A. J., 166
Harrison, John, 105f
Harrow Lodge Farm, 202
Hart, Edward, 56
Hart, Emily, 171f
Hart, Fred, 154f, 164, 169f
Hart, Henry, 56
Hart, Marmaduke, 164
Hart, Mary, 160
Hart, Sally, 175
Hart, Sarah, 168f
Hart, William, 151f, 160, 164f
Harvey, Jenny, 124
Harvey, Robert Holloway, 124
Head, Soloman, 58
Heales, George, 161, 223, 224, 234
Hendy, Hannah, 186
Hengistbury Head, 12, 29
Henlein, Peter, 107
Hicks, Charles, 72, 204
Hickson, Richard, 58
Hinxman, Justice, 46
Hiscock, William, 83
Hoby, Thomas, 196
Holliway, Mrs Elizabeth, 28

Holloway, John Edward, 40
Holloway, Richard, 16
Hooke, Dr Robert, 104
Hordle Workhouse, 186f
Horse and Groom, 71, 74, 208
Hubborne Farm, 200
Hugmans, 70
Hulbert, John, 185
Humby, Mr, 73
Hurn Farm, 202
Huygens, Christaan, 103f

Iford Farm, 200
Ingersoll, Robert, 110

Jackson, Revd William, 31
Jeans, Mr, 171f, 182, 192
Jeans, William, 161f
Jeffrey, James, 41
Jenkins & Co., 157f
Jenkins, Ann, 159f
Jenkins, Catherine, 159
Jenkins, Elizabeth, 159
Jenkins, Emily, 161
Jenkins, Henry, 145f, 151, 157f
Jenkins, Henry Treasure, 158f, 166
Jenkins, Mary, 161
Jenkins, Thomas, 159
Jordan, John, 20
Joy, Edward, 198

Keay, 181
King's Arms Hotel, 31, 50, 207
King, George, 185
King, James, 61, 211f
King, Joseph, 211f
Kitch, 181
Kitch, Thomas, 195
Knapp Farm, 202

Lamb Friendly Society, 43
Lamb, Charles, 214
Larder, William, 20
Latch Farm, 200
Lawrence, George, 58
Lean, 45
Lemmon, Joseph, 73
Lemmon, Noah and William, 67
Lighting and Watching Inspectors, 64

Index

Lockyer, James, 65
Lockyer, Mrs, 74
London Brewery, 207

Malmesbury, Earl of, 30, 41f, 44, 55, 57f, 206f
Manley, Mary, 73
Mansion Brewery, 207f
Mantua-making, 28, 196f
Manuel, Joseph, 52
Marsh Fair, 39
Mathews, 21
Mercer's Chronometers, 163f
Mesher, James, 74
Milford Workhouse, 192f
Millhams, 12, 39
Milton Workhouse, 133, 138f, 145f
Mitchell, William Wing, 42, 49, 211
Mudeford, 25, 29, 43, 52, 198f, 205f, 213
Mudeford Farm, 200, 205

Neave, Jane, 144, 147
Neave, Joseph, 144
Newfoundland, 27f, 41, 45, 125
Newman, John, 72
Newman, William, 18
Norman, John, 126f
Normanton, Lord, 51
Norris, Mr, 21
North, Mrs (Ann), 188
Nuisances, Inspectors of, 19

Ogber, 39, 48
Orestes, 53
Osment Eli, 58f

Pain & Sons, 25
Pardy, William, 68
Parley Court Farm, 93, 204
Peerman, John, 210
Pelley, Mary, 184 (footnote)
Penleaze, James, 50
Perry, Lydia, 240, 247
Perry, Sarah, 63
Pest House, 20
Phillips, Edward, 196
Phillips, Henry, 59
Pike, James, 82

Pillgrem, John, 31f, 50, 129, 181, 196
Pit site, 22, 69f, 145, 166, 212f
Plowman, Herbert, 58
Pocock, Dr Richard, 27
Pope, George, 63
Portfield, 48, 73f
Preston, Henry, 59, 183
Price, Joseph, 185
Priory House, 73
Purewell Farm, 200

Quomps, 18

Rabies, 22
Raikes, Robert, 24
Railway, 24
Raindle, John, 180f
Read, Job, 55
Reeks, Susannah, 209
Rickman, John, 64, 214
Ridout, Richard, 196
Ringwood, 50, 54, 186
Ringwood Workhouse, 143
Roberts, Richard, 194
Rogers, Richard, 210
Rose, Miss, 163f
Rose, Mr, 171f
Rose, William, 236, 241, 245, 247, 248
Rose, Sir George, 31, 43, 198, 214
Rose, Sir George Henry, 41, 52
Rose, William Stewart, 198f
Rowden, Henry, 211
Rushford Common, 48

Schools – Congregational, 24
Schools – Grammar, 24
Schools – National, 24
Seymour, Mary, 71
Shambler, John, 75
Sharp, Risdon, 169
Shave, Francis, 57
Shave, John, 58
Shick, Frederick, 131
Shick, James, 131
Shick, William, 131
Short, John, 135
Short, Joseph, 63
Silk stockings, 27, 177f
Simmonds, Stephen, 61f

255

Slatter, Thomas, 20
Slaughter, Thomas, 20
Sleat, Luke, 181
Sleat, Moses, 61, 180f
Sloman, John, 72
Smallpox, 20f, 42, 134f
Smuggling, 29f, 37, 38, 42, 45, 52f, 65, 132, 180, 210f
Somerford Farm, 200
Somerford Grange, 73
Somerley, 54f
South Avon Agricultural Society, 44, 205
Southey, Robert, 214
Spicer, John, 32, 41, 73, 74, 82
Spicer, Samuel, 210
Square House, 32, 198, 207f
St Catherine's Hill, 20, 39, 161
St Mary Magdalen, Hospital of, 40
St Michael's Loft, 24
Stanley, James, 61
Stanpit Farm, 200f
Staple Cross Farm, 200
Starks, J., 59
Steele, Edward, 58
Steele, Henry, 58
Stickland, Sarah, 66
Straw bonnet-making, 186f, 200
Straw-plaiting, 135, 189f, 212
Summers, William, 79
Swift, William, 62
Swing Riots, 52f, 207

Tamlyn, Mary, 188
Tamlyn, Mrs, 188
Tapps, Sir George, 41f, 57
Tarrant, James, 76, 178
Tarrant, Robert, 33
Taylor, Joseph Henry, 186
Taylor, Philip, 41
Tilley, Harriet, 191
Tithe Report, 15, 198, 206
Tompion, Thomas, 77
Tory, Edward, 73
Town Common, 39
Transportation, 49, 54f, 61f, 126
Treasure, Fanny, 159
Trevis, Elizabeth, 61
Trevis, Harry, 156

Troke, Charles, 58
Troke, Mary, 59
Troke, Thomas, 71
Troke, William, 65
Tuck, George, 63
Tuck, Robert, 63
Tuck, T. H., 193
Tyneham House, 181

Upjohn, James, 127
Upjohn, Rebecca, 127, 148

Vales of Avon and Stour Farmers' Club, 205
Vey, Benjamin, 62
Vick, Henry, 161
Vivian, John, 57

Walker, Edward, 147
Walkingshaw, James, 49
Walton, Andrew, 59
Walton, Levi, 59
Warner, Revd Richard, 25, 30
West, John, 185
Whatton/Watton etc, Andrew, 59
Whatton/Watton etc, Benjamin, 59
Whatton/Watton etc, Joshua, 59
Whatton/Watton etc, Levi, 59
Whitcher, Thomas, 48
White's Charity, 40
White, Allen, 146, 159, 170, 173
White, William, 46
Wick Farm, 200
Willis, Revd James, 41, 44
Wimborne, 69, 103, 124f
Wimborne Workhouse, 137f, 144f
Winkton, 43, 59, 186, 211
Winters, Nelly, 143, 163
Wood, Mary, 35
Woolls, Ann, 128
Wools, Mr, 149
Wright, Richard, 196
Wynne, Thomas Price, 147f

Young, E., 188
Young, Richard, 187

Zech, Jacob, 112